The Art
of Medieval Technology

The Art
of Medieval Technology

Images of Noah the Shipbuilder

Richard W. Unger

Rutgers University Press
New Brunswick, New Jersey

Library of Congress Cataloging-in-Publication Data

Unger, Richard W.
 The Art of medieval technology : images of Noah the shipbuilder / Richard W. Unger.
 p. cm.
 Includes bibliographical references (p.) and index.
 ISBN 0-8135-1727-3
 1. Christian art and symbolism—Medieval, 500–1500. 2. Noah's ark in art.
3. Noah (Biblical figure)—Art. 4. Art and technology.
I. Title.
N8180.U54 1991
704.9′484—dc20 91-2362
 CIP

British Cataloging-in-Publication information available

For Emily Unger

Contents

List of Illustrations

Preface

Charles Wilson, the renowned historian of the European economy, is reputed to have said that history is making the past dull in order to get it right. There is a great danger that in dissecting the way artists showed Noah building ships in the Middle Ages and the Renaissance that some of the fun of the art, some of the play inherent in making pictures, has been lost. The task itself, though all too long in coming to fruition, has not been dull.

My work on Noah began as part of a search for new illustrations of ships and shipbuilding in the Middle Ages. In the process I found material both for my own study of the history of technology and for art history. What has emerged is an effort to understand how artists in medieval Europe understood and approached technical matters. The example of Noah the shipbuilder is no more than an example of the more general phenomenon. What I found was not consistent with what historians of technology, historians of ideas, or art historians have said in the past. In this case it may be that matters were more simple than they appear. The artists were influenced by what they saw, by what went on around them.

The study of Noah relies very heavily on my earlier work on the history of Dutch and European shipbuilding in general. The examination of European shipbuilding was planned as a synthesis of new knowledge about the design of medieval ships from archaeological data and the economic history of the period. While the two may seem to those who know and appreciate ships to be a strained combination, the original motivation was to understand the sources of improvements in output in the economy. The improvements made a contribution to the long-term development of the European economy. The economic circumstances of the period also in many instances directed shipbuilders and shippers in their choices of

which technique to use. The result was an interplay of economic and technical forces that led to long-term improvements in ships and the continuing presence of a wide range of techniques, many old and some new.

Most illustrations of shipbuilding in the Middle Ages prove to be pictures of Noah building the ark. By using Noah as a guide to illustrations it became clear that there was a pattern in the way that European artists depicted Noah the shipbuilder. The pattern, to the eye of the economic historian interested in technical change, turned out to be based on the way ships were built and the way shipbuilding was organized in different parts of Europe.

Over the years I have tested my conclusions before and with a number of others working on the Middle Ages. I am indebted to the organizers of the meeting of the American Historical Association–Pacific Coast Branch and especially to Mavis Mate for giving me a first opportunity to air my views. The program committee of the College Art Association and specifically Isabelle Hyman and Carol Lewine were kind enough to allow an historian into their midst and to give me the best possible forum for trying out my ideas. The receptivity of the program committee and of art historians in general should serve as an example to other disciplines.

The method of presentation is borrowed largely from art history. Since I am not trained as an art historian it is difficult for me to duplicate that approach. A number of friends and colleagues have, through the years, given me a chance to learn something of art history from excellent teachers. Ruth Mellinkoff and Walter Horn, members of the Medieval Association of the Pacific, have been my mentors both in print and in person. I am especially grateful to Ruth Mellinkoff and also to Christian Villain-Gandossi for comments on an earlier version of the manuscript. In the history of technology and maritime history I owe a great debt to the late Lynn T. White, jr., the late Archibald Lewis, and Tim Runyan. Sarah M. Horrall has been a helpful correspondent.

At the University of British Columbia the annual Medieval Workshop has for two decades been a fertile ground for learning about the work of medievalists in many disciplines and especially in art history. Janos Bak introduced me to the implications of art for politics and thought in the Middle Ages. Sharing teaching with Mary Morehart has been both a pleasure and extremely helpful. Marc Pessin has always been very willing to offer comments and suggestions.

The original research on the iconography of Noah was only possible because of the Index of Christian Art. The presence of that excellent catalogue of medieval art, its organization and the high standard of scholar-

ship that it represents, is the only reason studies such as this one are feasible. I am especially grateful to Rosalie Green, to Ira Ragusa, and also to the staff at the Index in Princeton for their support and assistance while I was there and in subsequent years. I have also had the assistance of Nancy Bonacich and others who kindly gave me access to the copy of the Index at University of California–Los Angeles when it was necessary to do some further work.

Because of many other burdens and projects the research on Noah has been done in stages and often with the help of research assistants. They have each brought their own unique talent and knowledge to bear on the problems. They can never be thanked properly for their efforts in finding new material and explaining the mysteries of art historical citations. Jill Wade laid the groundwork in the early stages. In the middle of the project Barbara Lewis searched for some new material on pictures of the patriarch. Pat Anderson had the task of dealing with all the loose ends and going through the art historical literature. Helen Jones helped in producing an interim version. Shannon Parker is responsible for many of the details seen to for producing this final result. All were of great help; it is certainly true that I completed the project only because of their assistance.

The University of British Columbia (UBC) supplied the funds to send me to the Index of Christian Art and to pay for part of the salary of the research assistants. The remaining funds came from the governments of Canada and British Columbia. The research support of UBC and funds administered by it has been the only source of funding for work on this project. It is a case of sustained support in small sums over a number of years, yielding extensive and positive results.

The efforts of these scholars and assistance could not save me completely from the errors of a neophyte. My skills remain, despite all the effort, those of an economic historian. All those who offered their expertise and aid are exonerated from the errors of omission and commission. Also exonerated are my wife, my daughter, and my friends, who have tolerated talk of Noah for much too long. My gratitude to them all can only be partially repaid through this book.

Vancouver, British Columbia, Canada
April 15, 1991

*The Art
of Medieval Technology*

1
Art and Technology: Noah the Shipbuilder

Examining the medieval illustrations of Noah building the ark yields diverse, valuable, and often unexpected results. The number and variety of those illustrations is small but, despite the scale and scope of the corpus of medieval works showing the patriarch building the ship, the images can help in understanding a great deal about the Middle Ages, about the history of technology, and about the relationship between art and technology.

The pictures demonstrate not only the close and complex connection between what artists do and what technologists do, but also the character, quality, and value of art as a source for the history of technology. They represent part of a much larger pattern of change in the way artists showed technology. Most important, though, the pictures reveal the sources of inspiration—the reasons for the choices made by artists when they depicted technology, or for that matter when they depicted anything—in the Middle Ages.

The marriage of technology and art both pre- and postdates the Middle Ages. Technologists do not normally set out to create works of art, and nor do artists normally set out to illustrate technology. Yet both end up doing exactly that. The ties between art and technology are so strong that not even scholars can sever them. The intimate nature of the relationship makes the discussion of art and technology extremely difficult. The two are simply too closely intertwined, a situation especially obvious in efforts to discuss art as a source for the history of technology.

Depictions by artists generally provide the principal source for the history of medieval and early modern European technology. Illustrations are absolutely vital to the study of the evolution of European shipbuilding. Thanks to many sources it is now known that European ship design

1

went through major changes in the course of the Middle Ages. That evolution was critical to the long-term economic and political development of medieval and early modern Europe, in some cases in a dramatic way. New information has been added from other sources but the base for any understanding of the development of ships, and for that matter virtually every other technology, is the images created consciously or unconsciously by artists. These pictures of ships also serve as an excellent example of the long-term development of the approach to depiction of technology among artists. Nevertheless, as with any source there is the constant question of how reliable it is. Consideration of this problem raises the related issue of the nature of the inspiration of artists who depict technology.

Technical change did inform medieval art. The long popular view that there was no technical advance in the Middle Ages has now been put to rest; it is time also to give up the idea that artists were not conscious of the technical change that was going on around them. The ideas that circulated among theologians and philosophers certainly informed what artists did. The development in those ideas must be explored in order to understand changes in style, both in general and in the way artists dealt with particular topics. The traditions of art, the past practice, informed what artists did as well. Earlier models or earlier artistic programs have to be explored to find potential models, to understand what artists may have had in mind. Noah carried symbolic meaning for medieval thinkers and so for artists. The iconography of Noah, the role of Noah as a symbol, is just a small part of what can be found in going through the series of pictures of the patriarch at work in creating his ship. In addition to influential ideas and past practice, developments in technology informed what artists did, although the artists themselves may often have been unaware of such influences. As a bonus, and probably without being aware of it, artists also showed the changes in social relationships that grew out of those changes in technology.

The study of illustrations of Noah building the ark may be a good example of what can be gleaned from the analysis of medieval artistic representation of technology, but it is also a good example of all the pitfalls and dangers involved in that analysis. It is difficult to discuss the numerous facets of the study of pictures of Noah separately or in isolation. All the varied aspects of the study of art history and the history of technology must be kept in mind while looking at each of the efforts by medieval and Renaissance artists to show Noah building the ark. It is equally necessary to realize how intertwined each aspect of the study is with one or more of the others. If nothing else, the history of the way artists dealt with Noah as

a shipbuilder makes obvious the interdependence of the two worlds of art and technology.

The productive examination of images of Noah the shipbuilder is possible only because of earlier work on European shipbuilding. Archaeology has contributed significantly to knowledge in recent years. It is now clear that an interplay of economic and technical forces led to long-term improvements in ships and the continuing presence of a wide range of techniques, many old and some new. The process of identifying the technical changes in European ship design from the early Christian era down to the final days of sailing ships requires careful examination of the many surviving illustrations of ships. Oddly enough, the number of illustrations of shipbuilding quite generally is, in contrast, rather small. Most of these pictures, it turns out, are pictures of Noah building the ark. The illustrations show that there was a pattern in the way that European artists depicted Noah the shipbuilder. The pattern was based on the way ships were built and the way shipbuilding was organized in different parts of Europe.

To examine the pictures of Noah building ships is, for most scholars, to identify the meaning of such works. Such iconographical studies carried out by art historians lead them to try to find out as much as they can about related works and about history, literature, mythology, and folklore (Mellinkoff 1970, vii). To grasp what artists were doing it is necessary, in the traditions of art history, to examine ideas about Noah among intellectuals, churchmen, and scholars, as well as ideas about Noah in popular culture as they showed up in medieval drama. It is, however, equally necessary to know about the way shipbuilders built their ships during the Middle Ages and the Renaissance in order to grasp what artists were doing. All this evidence marshalled together should support the hypothesis that artists did illustrate technology, that despite their many other goals they showed Noah building ships as they were built at the time the artist worked.

Art and Technology: The Connection

The tie between art and technology is such a strong and unbreakable one that it is virtually impossible to define one while ignoring the other. It is not just the influence of one on the other, though there has been and remains strong influence in both directions. Artists turn to technology for tools of expression as well as inspiration. Technologists turn to artists for ideas and for the identification of problems to be solved. The connection between the two is much more than that, however. The bond is forged by the similarity of the artistic process to technological activity. The creation

of a work of art is an act of a technologist. If the act were a commonplace one, if the artist just did what many people can do and do in fact do ordinarily, then the result would not be a work of art. The development of a new artistic style must be an illogical act of discovery, out of the ordinary, generated by "aesthetically motivated curiosity" (Smith 1981, 325) and that act is the same for the technician as it is for the artist. "[T]he attitudes, needs and achievements of artists have provided a continuing stimulus to technological discovery and, via technology, have served to bring to a reluctant scientific attention many aspects of the complex structure and nature of matter that simplistic science would have liked to ignore" (Smith 1970, 494).

Technology—often without the technologists being conscious of doing it—generates works of art. The distinction between improving ways of doing things and creating beauty is, perhaps, only to be found in the purpose originally laid down for carrying out the task. Technological advances are more likely to come in an environment where beauty matters. Technicians have often tried to beautify, to make more appealing what is only utilitarian, and in the process have made things for humans to enjoy. In the process they have come close to that imaginary line that divides technology from art (Smith 1970, 500–501, 527–528; 1979, 32, 37; 1981, 325, 330). One might go even further: "the engineer has found a rewarding inner satisfaction in artfully creating his works, with limited tools and limited know-how in the face of the infinite complexity and power of nature, in order to solve the problems society has thrust upon him." (Hughes 1964, 2). The tendency of the late twentieth century to see technology as the application of science in order to solve immediate problems ignores a critical distinction in the approach of scientists and applied scientists. Both artists and technologists think quite differently from philosophers and, therefore, differently from scientists. "In specific cases it can be shown that technologists display a plastic, geometrical, and to some extent non-verbal mode of thought that has more in common with that of artists than that of philosophers." (Layton 1974, 36). Aristotle noticed the affinity of art and technology, and throughout the Middle Ages and the Renaissance there was virtually no distinction between the two. Not only did the same individuals often practice both art and technology, they borrowed from one activity for the other. That connection continued up to the sixteenth century, when specialization took hold and the art and the artist began to become separated from technology and from science (Gille 1969(a), 21–22). The rift between art and technology grew in the follow-

ing years, and finally the connection was all but lost with the Industrial Revolution.

Until the advent of the Industrial Revolution the subject of labor played only a minor part in European painting. The first industrial themes turn up in paintings during the Reformation and largely in the Low Countries. Scenes of ordinary life became acceptable, including still lifes and landscapes, sometimes depicting men at work, along with the machinery they used. In many instances the artisans were put in classical surroundings, which remained a practice from the sixteenth century through the nineteenth. At the close of the eighteenth century, though, painters such as Joseph Wright in England, Pehr Hilleström in Sweden, and Leonard Defrance in the Low Countries brought industrial themes into the orbit of fine arts (Klingender 1968, 51, 55–63).

With the rise, first, of an industrial society, and then one dominated by technology, artists no longer sought beauty or even meaning (Ellul 1979, 805). Since the Industrial Revolution painters, musicians, poets have rejected the machine and have sought instead to use art to assert individuality and the strength of the human spirit in the face of the advance of technology (Mumford 1986, 350). Though impelled to give a sense of order to what they do by the growing and pervasive penetration of scientific thinking, artists have resisted and, after exploring possible reconciliation with technology, declared art to be a lofty activity above and opposed to the deforming character of industrial labor and the machine (Ellul 1979, 808–811). They have also asserted their independence. The independent artist, with complete freedom to create untrammeled by any other force, is an ideal pursued and idolized since the sixteenth century (Bell 1976, 16–17). Since the late eighteenth and especially the mid nineteenth century the tendency has been to move further away from and even to reject industry. In the twentieth century the divorce has become almost complete. Most artistic representations have lost all documentary value. The ends and goals of society have been swamped by the means of reaching those goals, by the technology itself. Many theorists of art maintain that in the process art itself has become devoid of a sense of purpose. Without goals there is no longer a teleology of art (Ellul 1979, 827; van Beylen 1961, 150).

The study of the history of technology confirms, however, that the divorce of art and technology is a product of developments since the Industrial Revolution. In the past, in the years before mechanization and mass production, the two shared a thriving union. In folk culture there was a

close relationship between the tools and the aesthetic sensibility that guided both art and technology (Ellul 1979, 821). The Greek term *technē* did not distinguish between the production of symbols and the production of practical objects (Ovitt 1987, 9–10). The idea that technology is simply applied science was just as inaccurate in the Middle Ages as it is now, but in the Middle Ages no one thought to utilize so narrow a category. "The conscious separation and classification of an activity or viewpoint as science, technology or art is recent and came about rather slowly." (Smith 1970, 533). It would be wrong to impose this recent distinction on the past, especially on the period before the Renaissance, where such distinctions were not only unheard of but were, in every sense, wrong. The inseparable character of art and technology in the past means that "neither art nor history can be understood without paying attention to the role of technology; and technology cannot be understood without history or art." (Smith 1981, 331). History of technology must depend on knowledge from art but, equally important, history of technology has a contribution to make to the history of art.

The Discipline of the History of Technology: The Sources

The study of the history of technology began during the late Renaissance with the first published lists of inventions, lists that included a wide range of discoveries. It was not until the end of the eighteenth century that such records became less purely taxonomic. After 1800 authors started to produce more than just collections of reports on different inventions, writing general histories of technology in which they connected one discovery to others (Multhauf 1974, 1–2). It was biographers of inventors and engineers or economic determinists who typically produced these early works (Hughes 1964, 1). Throughout the nineteenth century the greater interest in technology in general, the growing interest in history among some technologists, the efforts of archaeologists and technicians to reconstruct ancient technology under the patronage of prominent figures such as Emperor Napoleon III, and, lastly, the effort of some writers to expand the history of technology into something global, all led to the integration of the field into larger efforts to understand the past. At the end of the century this led to the opening of museums devoted to the history of technology and publications to go with them. While there was little enthusiasm for a study of earlier techniques after the First World War, after World War II history of technology enjoyed new popularity and finally emerged as a discipline. The post-1945 exuberance was expressed in the founding of a

number of museums and journals, in the publication of a series of general
histories of technology, and most of all in new directions taken in the field
(Gille 1978, 5–8). On the one hand there has been a successful effort to
discredit the view that technology is applied science, since only scientists
can and have expanded knowledge (Layton 1974, 31–33). On the other
there has been a less successful effort to find the sources of advances in
technical knowledge, and to find them not just in acts of individual ge-
nius. At the same time the field has expanded. The history of "tech-
nological change is not [any longer] the history of machines but the whole
history of human beings adapting, and adapting to, the natural world."
(Ovitt 1987, 49).

Historians of technology now seek to escape the older approaches of
collecting and cataloguing inventions and of economic history, which im-
posed its own methods and themes. Both approaches failed to comprehend
fully the evolution of technology, either the sources of change or the im-
plications of change. In its new form in the late twentieth-century history
of technology seeks to understand the internal logic of technical change
(Daumas 1976, 95–100; Gille 1978, 22–23). Only in that way can it es-
cape from its older limitations and also begin to assess and measure the
social implications of technical change. After all, "[t]echnology is of no im-
portance except as it becomes part of culture and society." (Smith 1979,
34). To impute elaborate and enduring effects to political or economic
events or changes is not novel in the study of history. To impute such
effects to technical change is unfamiliar, and creates problems for histo-
rians of technology trying to make such connections in a reasonable and
convincing way. The function of history of technology as it has evolved is
now to establish a technical history of techniques, to evaluate the role of
science in technical advance and vice versa and, lastly, to place techno-
logical activity in the context of other human activities (Daumas 1976, 89;
Gille 1978, 4).

To complete these tasks the first step is to understand technology, to
understand how men and women carried on their work. A necessary if
burdensome precondition but a critical first step is the documentation of
what actually did happen. Historians are faced, as a result, with the need
to carry out certain studies because of the internal necessity of the field
rather than out of a desire to answer pressing questions. Much of the work
of the historian of technology is devoted to understanding how things
were done, to making sense of various sorts of documents. Sources may be
abundant but often their value to the history of technology has not been
recognized, so that they have received inadequate scholarly treatment

(Hall and West 1976, 1–2). Much of the work is then of necessity anti-quarian (Price 1974, 45), an antiquarianism that requires special and specific skills, as dictated by the character of the documents at hand.

For the nineteenth and twentieth centuries documentation is both various and abundant. A society conscious of the importance of technology and concerned about the economic benefits—both public and private—to come from technical advance institutionalized the recording of technological change. For the Middle Ages the opposite was the case. Information about technology is incidental, either turning up accidentally in works devoted to some other purpose, or coming from physical objects, tools or products of those tools. Each type of source presents intractable problems of interpretation. Written works produced before about 1500 on technological matters are notorious for their unreliability. Early medieval texts tended to repeat late classical works. Later, writers tended to produce recipe books and, at best, short treatises devoted to a single topic (Gille 1978, 80–81).

Technologists are not known for their literacy even in the twentieth century. In the Middle Ages such men typically relied on others to record what they did, so that descriptions, if they exist, are usually second- or thirdhand and often done by people who knew nothing about the technology. The chances of works on technology surviving were also slim, compared, for example, to books on ideas, including scientific ideas (Smith 1970, 528; 1979, 35). Scientific works were in Latin, while works on technology were typically in vernacular languages and thus were less likely to be read, circulated, and preserved. Since technological innovations were private property and could yield benefits to their owners there was initially no incentive to divulge or even to record that knowledge (Beaujouan 1975, 443–444, 469). There are exceptions such as the treatise on painting, glassmaking, and metalwork produced in the early twelfth century by a monk using the name Theophilus. The work is realistic and detailed, and discusses many different processes. It is a recipe book, it is true, but it went beyond that tradition. It is not only a detailed and balanced manual, but also is designed to disseminate information, especially to young workers (Theophilus 1963, xv–xviii, xxix–xxxi). It is an excellent source, a document that has been a popular one for study, but it is virtually unique. Informative both about techniques and about the time in which it was written, it still stands virtually alone.

Indirect sources such as poems or stories or tales of folklore or commercial documents can be extremely helpful as well. Generally they are highly reliable, ironically enough because the information is not central to the

authors' purposes. Such sources must, however, be used with some care, since their purpose was other than to describe technology (Gille 1978, 88–92).

Artifacts themselves are the most valuable and reliable sources in study-ing the evolution of techniques. The products of the machines or tools and the tools themselves can reveal a great deal about methods but also about the technician (Gille 1978, 97–98; Smith 1979, 36). At the same time the effective interpretation and the proper methods for making such inter-pretations are difficult to establish. The archaeology of such artifacts, the simple task of determining what artifacts looked like and how they were used, often presents insurmountable problems.

Images as Sources in the History of Technology

Illustrations are at one and the same time both the most abundant source of information about technology and the most problematic. The difficulties with using iconographic evidence are vast and diverse (Gille 1978, 92). The images often present questions that are impossible to an-swer. The sparseness of documentation on works of art, questions of dat-ing, location, and influences makes it difficult to use the material. For example, artists typically traveled, making it often impossible to say what place the image was designed to represent. Artists influenced other artists, but establishing those influences reliably is rarely easy (Gille 1978, 92–95).

Typically in the Middle Ages any illustration of a technical object was incidental. The reliability of any image must be in doubt, since artists often did not comprehend what they were showing. The more complex the object, the less trustworthy the image. What interests the art historian in the images may not be what interests the historian of technology. The latter ignores aesthetic considerations: a work can be highly prized for the accurate depiction of a tool or machine and be a poor work of art (Husa et al. 1967, 12; Beaujouan 1975, 470). Images of interest to historians of technology have often not received the attention of art historians, the re-sult being that some essential questions of provenance, filiation, author-ship, and even dating have not yet been answered.

Works devoted solely to recording technical design first appeared in the tenth century in Byzantine manuscripts. The first time such illustrations appeared in the West is in the work of Villard de Honnecourt in the second half of the thirteenth century (Gille 1978, 95). After that books on technol-ogy became more common. During the two hundred years after 1400 transmission of technology through memory and oral or manual teaching

came to be supplemented on a large scale by written works and also by drawings or sketches. This came at the same time as the shift from written to printed works (Hall 1979, 47). The role of art and its relationship to technology changed in the process.

Art now had a clear function. Artists were to transmit precise information, information it was difficult to present in other forms. In the sixteenth century only a few technical manuals with abundant illustration appeared, so that not many industries received the treatment that, for example, Agricola in his *De Re Metallica* gave mining or Biringuccio in his *Pirotechnia* gave metallurgy (Gille 1969a, 29–30; Hall and West 1976, 3; Klingender 1968, 57, 72). Works such as theirs, though, were certainly the models for the future. It was not really "until the sixteenth century that a significant body of technical literature written in the vernacular languages by and for workers and engineers began to appear in Europe" (Ovitt 1987, 166). As technologies became more complex the need increased for handbooks on a single trade or field, with precise information written in straightforward prose by a professional and with proper illustration (Rifkin 1973, xxi–xxii). By the closing years of the century extensively illustrated books began to appear which did more than simply summarize existing knowledge. They went further, communicating new information. A family of such works served to disseminate technical improvements in the following two centuries (Hall and West 1976, 4).

The establishment of the printing industry created both a method for reproducing accurate illustrations of technology and circumstances for the satisfaction of the expanding market for technical information. There was at the same time an increase in the accuracy of drawings of technical devices, aided by improved techniques, such as the use of woodcuts. Subsequently, in the seventeenth and eighteenth centuries copper plate engraving permitted even greater delineation of all kinds of apparatus (Daumas 1976, 94; Husa 1967, 23; Smith 1970, 530–532). Illustrated books on technology found a market not only among practitioners but among intellectuals, lawyers, and bureaucrats. Producing such books was costly; only well-to-do dilettantes could afford to buy the books out of curiosity. Not surprisingly, the character of the market had an effect on the contents of the books. Authors, in addition to describing techniques, commonly justified what they were doing, explaining themselves to the powerful and wealthy.

Treatises became more accurate both in illustration and description. They also became more self-conscious and thus more theoretical (Hall 1979, 48–52). Among many other things, "the Renaissance bridged the

gap which had separated the scholar and thinker from the practitioner" (Panofsky 1962, 134–135). Changes in technical literature reflected one way in which that gap was bridged. Artists came to make a conscious effort to be accurate in depicting technical objects. The result was an art deeply effected by technology and an accuracy of illustration that makes art, at least from the seventeenth century, a much more reliable source of evidence for technical advance. The combination of changes in artistic representation and the development of accurate technical illustration makes the task of the historian of technology from the seventeenth century on, if not easier, at least very different.

The depiction of the technology of ships is only one case, but an excellent one for example, that demonstrates both the evolution in art and in technical treatises. While in the sixteenth century some artists might have taken pains to show ships accurately, others, for various reasons, exaggerated or varied the vessels in their works. A few artists in the Low Countries, for example, clothed their ships in ancient garb, surrounding the standard vessels of their day with Roman castles and ornaments. In the seventeenth century this changed. Some artists came to specialize in seascapes and former sailors such as the Dutch painter and drawer Reiner Nooms, who was also called Zeeman, depicted ships with an accuracy that could only come from having worked on board. Nooms was the first reliable maritime artist whose work is certain to be technically accurate. That tendency toward accuracy eventually extended to all painters, whether specialist or not (van Beylen 1961, 126–140).

The tendency was even more obvious in technical treatises devoted to shipbuilding, works that first began to come off the printing press in the late sixteenth century. Manuscript works with sketches had been known for more than two centuries, but the first printed book, which appeared in 1587 (Tate 1941, 191–195), began for shipbuilding the process that had already started for other technologies. Shipbuilding and ship design were topics for scientific treatises, but there illustration was only incidental and often sketchy. Seventeenth-century books on shipbuilding were often descriptive, filled with line drawings of vessels of various types, some fanciful but usually highly accurate. On the docks shipbuilders began to produce models of their ships before construction to help guide them in the building. They started at the close of the seventeenth century to translate those models into draughts, sketches of the principal lines of the ships. This was both for their own use and in order that potential buyers might have a sense of what they would be getting.

The development of the theory of shipbuilding, relying on mathematical

proportions and geometry, was the basis for the final change in illustration in the eighteenth century. Drawings now became standardized and idealized. By applying the theoretical advances of other scientists, men like the French physicist and navy inspector H. L. DuHamel Du Monceau could produce books showing how to draw plans and to use those plans to calculate important attributes of the final product. Frederick Chapman's book on shipbuilding published in 1768 was, in a sense, the culmination of the process (Unger 1986, 21–23). Illustration was highly accurate and precise, but showed the principal physical properties of an idealized ship in an abstract manner. It did not show what a ship in fact actually looked like. This was real industrial design—a product of the eighteenth century (Gille 1978, 97; Klingender 1968, 74). The evolution in works on shipbuilding reflected the change in knowledge about the trade. That evolution changed the character of illustration.

The Function of Medieval Art

Art gained a different function and, in the process, a very different place as a source for the study of technology. Before 1500 art works did not show precisely what ships looked like or how they were to be constructed. The pictures were not to help in the building of ships, in developing plans of how to proceed. They were not even to satisfy a market for pictures of ships. In the sixteenth and especially from the seventeenth century on men who sailed bought paintings, so that artists, commissioned perhaps to produce a picture of a ship, had to pay attention to the technology (van Beylen 1961, 124). For the medieval artist and for the consumer of art in the Middle Ages the picture of a ship or of any other technical object had a different function. Historians, therefore, have to exploit the images created by those medieval artists in different and more varied ways.

In the Middle Ages it was not necessarily the purpose of art to recreate reality. In the twentieth century the precise reproduction of what man sees is denigrated and often not even considered art. To be art a work must add something to the obvious, to what can be and is seen by anyone and everyone; indeed it is this addition that makes a work art. But in the Middle Ages, and especially the early Middle Ages, artists had other purposes in mind. First, in the great majority of cases artists set out to show scenes from the Bible, to show events far removed from their own time. Since the Bible was not understood to be an historical work, there was no need to depict a concrete historical past. There was no sense of anachronism (Husa 1967, 12–14). Second, artists inherited the late antique

view that they were living in a world of symbols, where every object reflected imperfectly some perfect form. The search was not for the particular in an object but rather for its symbolic meaning. "Inevitably such a view of the world produced a shadow-art, an art that distorted natural forms the better to indicate their supernatural meaning." (White 1978, 28) Art became otherworldly, introspective, contemplative. Its function was to educate and illuminate. There was a teleology of art, with each work carrying a message. Artists sought the glorification of God and self-perfection. This was true even of those engaged in sophisticated technical processes, such as Theophilus. Work and therefore technology typically appeared in an idealized, symbolic form.

While this might not have been universally the case and was in fact not so throughout the entire period from the later Roman Empire through the fifteenth century, there was a surprising uniformity in the goals and purposes of medieval artists and thus a uniformity in the way they treated all aspects of technology, including the technology of shipbuilding. Since artists used technical objects as symbols, they did not have to depict them with great accuracy. At the same time, however, objects had to be recognizable as symbols. There had to be both some theological purpose in showing a technical object and at the same time some item in the world around them that would be recognized in the work by anyone looking at it. Thus art, though symbolic, did have to imitate reality in one way. While artists could take liberties, the essential form and essential relationships of complex or even simple technical objects had to conform enough to the known world so that their contemporaries could recognize and interpret the symbol. Artists did not try to recreate some objective measurable reality, at least not until the Renaissance, with efforts in that direction beginning possibly in the twelfth century. Even so, artists throughout the Middle Ages did rely on reality for their symbols. Those symbols when transferred to paintings, sculpture, or mosaics had to have a form and essential features that could be understood.

Art of the Middle Ages can serve as a source for the history of technology for both obvious and seemingly perverse reasons. Illustrations often make clear the meaning of words and give essential information about the nature and functioning of equipment. The technical detail may be hard to interpret, especially for works from before the twelfth century, but the images are almost invariably better than descriptions in texts, which present their own more complex problems.

Works of art have a value beyond the depiction of technical detail because the artists had in mind more than just showing how things worked.

Taking the history of technology in its broadest sense as the study of economic, social, and intellectual change, medieval illustrations can help with understanding the social repercussions of technical advance. Such representational data also aids in assessing the effects of technical change on ideas, especially ideas about nature and man's place in the natural world. Man was condemned to work after being driven from the Garden of Eden. Labor was Adam's curse. As an essential condition of life, labor could and should have been shown in art. There was some reluctance in the earliest of Christian art to depict work, but the condemnation of humans to labor did become a favorite iconographic theme in the Middle Ages (Klingender 1968, 55–56; LeGoff, 1980, 76–77). Labor was thus worthy of attention for its symbolic value. The particulars of the labor, however, were of no interest (Ovitt 1987, 171–173): it was left open to artists how they chose to show labor and the tools people used to carry it out. A greater concentration on the part of artists on things, on objects of daily life, can and does demonstrate in the central and late Middle Ages a change in what Europeans thought was important (Dresbeck 1979, 97–98). The images of technology show, even more effectively than texts or even surviving tools, what people thought about technology.

2
Ideas, Technology, and the Artist's Task

Artists could not avoid the ideas about *technē* that circulated among thinkers in the Middle Ages. Theologians and philosophers discussed the place of the mechanical arts in the hierarchy of knowledge, the place of work quite generally in man's role on earth, and, even more generally, the relationship of man to nature. Their conclusions in the long term shaped and formed artists' decisions about what they did. The development in those ideas not only set the limits for artistic interpretation but also informed the style of art, both general and particular. Critically important to the depiction of Noah at work on the ark was, first, what thinkers had to say about technology in general and, second, what they had to say about Noah in particular.

Theology and the Mechanical Arts

Technology was a topic of discussion among late antique philosophers and theologians of the Christian Church from almost the earliest days of the acceptance of Christianity in the Roman Empire. After all, God had created the world and the creative acts of people in some way mirrored that original act. As a result human productive activity always carried with it some religious significance (Chenu 1968, 40). Gradually the church developed an ideology of technology, an ideology that changed significantly over time. Manual labor might not have been a common topic among late antique intellectuals, but speculative thinkers did discuss the classification of sciences. Such attempts at classification necessitated answering the question of where to place the mechanical arts, that is technology, in the hierarchy of human endeavors (Beaujouan 1975, 438).

The goal of the Christian, and thus the purpose of Christianity, was salvation. Technology, along with everything else, was always subordinated to that concern. While Christianity did assert the ascendancy of man over nature, there was still the question of the form of that domination, the specific uses man was to make of nature. These ideas grew out of contemporary social and economic conditions, altering over time as the European economy was transformed, in part by advances in technology (Ovitt 1987, 16, 20, 86–87).

The earliest of Christian monks made manual labor a part of their devotion. Their work was always to improve the religious life of the brothers, manual labor being subordinated in all cases to the *opus Dei*. Beyond that the best that could be said for labor was that it served an economic function of keeping the monastic community viable (Ovitt 1987, 94–97, 100– 106; White 1978, 183–184). Monasticism, in its Benedictine form in the West, did understand work as a positive act and not something socially denigrating. While it is doubtful that St. Benedict alone through his Rule was the cause of the change in thinking about technology that separated the classical from the modern world, monasticism did present theologians with an issue that perforce they had to confront, and confront in a positive way. Work was, no matter how one might look at it, practical activity, exterior or external to the soul. That undeniable fact placed it low in the hierarchy of human activity.

An additional degrading factor was found in the recognition that mechanical arts were usually practiced by ordinary people, people of the lower sorts. There remained some sense among writers of trying to distance themselves from trades and therefore from technology. There remained as well a parallel and reinforcing fear of technology, created in part by the aristocratic social origins of most monks. Their background separated them from mundane technical questions. Any anxiety in the face of technology was enhanced by its occultation, which went on through the early and high Middle Ages. Machines were often viewed as possessing magical powers, and Christian intellectuals were concerned that such magic might compete with the magic of their religion. For those same men there was also an apparent need to defend thinkers, the cultural leaders of Christianity, from work. What interest they showed in labor was typically incidental (Allard 1982, 15, 20–25; LeGoff 1980, 72, 108).

Augustine had a long-lasting effect on much of Christian thought, his attitude toward work being no exception. The theoretical framework within which he formulated his assessment of the value of labor generated an ambivalent result. He saw labor as a good thing, but condemned cer-

tain arts as superfluous and possibly dangerous. He was able, however, to see a connection between material and moral progress: work was recognized as being superior to idleness, and with work it was possible to practice charity and thus generate spiritual benefits. For Augustine gaining sovereignty over nature was like gaining sovereignty over one's intractable self. Nevertheless, his view and that of other early medieval Christian writers was less one of domination of nature and more one of "cooperative partnership" (Ovitt 1987, 52–55, 85, 98–100; White 1978, 246–247).

Through Boethius medieval thinkers inherited a classification of learning from the ancient world. Writers felt compelled to offer a hierarchy of the arts. Cassiodorous marvelled, as did Augustine, at what the mechanical arts might accomplish, but did not explore them or try to systematize them. Craftsmanship alone did not qualify an activity as a mechanical art since crafts were not subject to any particular set of rules, but were merely informal or traditional practice (Ovitt 1987, 111–114). For Augustine, as for most other early Christian writers, issues surrounding technology were not perceived as important, which meant that there was little discussion of the place of the mechanical arts in this world. Other matters were much more pressing.

Augustine and, following him, John Scotus Eriguena held that Creation had been instantaneous. From that fact they drew the conclusion that God was not a craftsman. God, therefore, could not be compared to a human worker, and the labor of a human being could not for them be glorified as an imitation of the work of God. Both inside and outside monastic communities, work was invariably subordinated to its function for salvation. In the ninth century there were at least the beginnings of some interest in agricultural technology as well as the first appearance of the notion of mechanical arts, separate from and even perhaps equal to the liberal arts (LeGoff 1980, 80–81, 85–86; Ovitt 1987, 65–66, 115–117). It was not until the twelfth century, however, that thinking about the mechanical arts was fundamentally transformed.

The Church in the era after the Gregorian Reform established a greater separation of the roles of clergy and laity than ever before. In the long run, this led to an increase in the perceived value of a secular life. The concentration on the Eucharist, another change wrought by the Gregorian Reform, meant that God revealed himself in a specific way under precisely defined conditions. This reduced the expectation that he would reveal himself suddenly in any object or event. The pursuit of the apostolic life brought religious men and women as well as religion into everyday life. Monasticism, and Christian thinking with it, was no longer completely

separated from daily secular activity and thus became less other-worldly (Bynum 1982, 9–12). These changes were combined in the twelfth century with the recovery of the works and ideas of a number of classical authors, most notably Aristotle. The influence of his logical precision led to a concentration on calculation and observation. If possible, rational and quantitative analysis were to precede action, a directive that included action by the artist as much as it did the technician or the thinker (Crombie 1980, 234–235).

In the early twelfth century an increasingly rationalist, critical mode of thinking developed, a mode of thinking associated by scholars since the late nineteenth century with the school of Chartres and with a number of prominent theologians. There grew up in the period a new form of humanism, one probably not in fact localized to a single cathedral school but rather developed among a generation of European thinkers (Southern 1970, 61–85). Men such as William of Conches, Thierry of Chartres and Adelhard of Bath wanted to apply critical analytical thinking to all natural phenomena. They perceived themselves as generating an intellectual revolution (Stiefel 1985, 187–189).

The transition from Romanesque to Gothic art, beginning around 1140, came just as there was among those men a change from an indifference to nature to an interest in investigating it more fully (White 1978, 23–27). Those who showed an increased interest in the physical world began to show an appreciation of technology and its potential for creating a better society. The change in view may well have been a product of the economic and technical advances made over the previous century or more that by the mid twelfth century had generated clear and obvious improvements in welfare. The changes in production and commerce altered material life, thus perhaps altering the way people thought about the world and in turn the ways they represented that world in art. God became a true maker of the world, an artisan, in the minds of many theologians, a shift in perspective that enhanced the significance of human productive activity (Beaujouan 1975, 438; Chenu 1968, 39–40; Dresbeck 1979, 91, 102–103).

One sign of that different understanding was the emergence and enhanced status of professional groups. These groups were in search of dignity and of assurance that what they were doing was not sinful, that their work would not lead to eternal damnation. The idea of labor as a positive means to salvation, and now labor in any form, gained rapid acceptance among the new professionals, merchants, traders, and craftsmen (Legoff 1980, 112–115). Labor, in the process, became secularized, no longer counted among the active concerns of the church. This was, in a way, a

product of the new specialization, the new and much more extensive division of labor. In the twelfth century theologians clearly defined in their own minds the relationship between labor, technology, and society. Their conclusions were to have an influence stretching beyond the end of the Middle Ages (Ovitt 1987, 137–143, 149–155, 160–165).

For one author, Bernard Silvester, who wrote in the mid twelfth century, matter was the central force in Creation. According to Bernard, God manifested himself through matter. Reform in the world was generated not only by the proper ordering of the elements but also through human accomplishment, through learning the secrets of nature (Stock 1972; 11, 233–235). While he was a unique thinker, Bernard was not alone among twelfth-century theorists in taking a new view of man's role in the world, in the relationship of humans to God and to nature (Stock 1972, 3–5, 64–65). Other contemporary writers, most notably John of Salisbury, defended the new learning and especially the trivium of grammar, rhetoric, and dialectic (Ovitt 1987, 134–136). With the rise in logical rationalism came an increasing emphasis on the quadrivium, that is on geometry, arithmetic, music, and astronomy. This change certainly was not yet the modern science of the seventeenth century, but it did signal a new interest in nature, an interest that came in a different form.

Hugh of Saint Victor (1096–1141), writing at an Augustinian monastery in Paris somewhat earlier in the twelfth century, changed the classification of the arts handed down from Boethius and changed it permanently. No previous classical or medieval thinker had found a place for the mechanical arts in his division of learning. That was left for Hugh. For him mechanics was a form of knowledge that included all methods of the production of all things (Layton 1974, 33). In his *Didascalicon* he made the study of techniques, the perfecting of the mechanical arts, one of the four fundamental divisions of philosophy. The mechanical he also called the adulterate, since it had to do with human labor (Hugh of Saint Victor 1961, 55–56, 62). In his system of the classification of all the arts Hugh set up seven mechanical arts to parallel the seven liberal arts (Lusignan 1982, 33). For him the mechanical arts were textile and leather work; weaponry and manufacture in wood, stone, and metal; shipping and trade; agronomy and husbandry; game hunting, fishing and food preparation; medicine and the art of entertaining. He developed within those mechanical arts a trivium that had to do with external things and quadrivium that had to do with internal things (Hugh of Saint Victor 1961, 74–79; Rifkin 1973, xv). The mechanical arts were indeed to mirror the liberal arts. In general—and not just for Hugh—ideas about the importance of techniques came as

much from contemporary events as from earlier thinkers such as Augustine, Boethius, and even Cicero and Aristotle.

Hugh and his fellow Victorines wanted to comprehend Scripture through the study of numerical relations and their symbolic value. That led him, among other things, to discuss at some length the problem of the shape and form of Noah's ark (Beaujouan 1975, 438–439, PL 167, 627– 629). He seemed to be following the cosmologists from Chartres in his belief in the orderly nature of the universe, though the similarity may in fact be coincidental (Lusignan 1982, 39; Stiefel 1985, 194–195). Hugh and others did see the mechanical arts as a danger, since they might divert the mind away from loftier activities. For Hugh of Saint Victor one produced artificial works with the mechanical arts, reforming or transforming what was natural, adulterating nature. The transforming of nature required no contemplation. That view led some writers in the next generation, most notably John of Salisbury, to urge an education for aristocrats that specifically excluded the mechanical arts (Allard 1982, 17–19, 25–29).

Hugh of St. Victor regarded the mechanical arts as valuable because they relieved humans from necessity, freeing them to pursue more important things. The mechanical arts also had some intellectual value in and of themselves (White 1978, 246–248). The almost contemporary work of Theophilus carries some of the same ideas, ideas about the relationship between technical knowledge and theology (White 1978, 100–101). Writers for much of the rest of the Middle Ages continued Hugh's classification, thereby recognizing the value of technical knowledge. In the final analysis, though, for Hugh and the theologians that followed him, the mechanical arts and, for that matter, all learning still had as its primary function assisting in salvation (Ovitt 1987, 108–111, 117–121, 124–126).

In the thirteenth century the positive view of science became a positive view of experiment as well. The scholar-craftsman gained a more important role as cooperation increased between the learned and those who worked with their hands. There were now scholars of the mechanical arts who, logically, came more and more to appreciate technology. The world became more conscious of mechanisms and more men wrote in a way to suggest that nature was to some degree penetrable (Chenu 1968, 43–44). In his spirituality Francis of Assisi took an interest in the animal and natural world and so introduced among his followers a willingness to examine more carefully the physical environment. The world was not, he maintained, composed necessarily only of symbols that required interpretation; it was all right to examine nature to some degree, objectively (White 1978,

38–41). The tradition of Hugh of Saint Victor continued in a number of works, including that of Vincent of Beauvais, who carried on Hugh's classification scheme. Roger Bacon, the most renowned of the experimental scientists of the century and a truly unique figure, was concerned with improving human life through knowledge. The knowledge was to be technological and practical. He was interested in moving from theory to the specific, to the utilitarian (Allard 1982, 29–31; Beaujouan 1975, 441–442), so that there was a tendency for the sciences to move closer to technology (Gille 1969(b), 570). Despite Bacon's best efforts, however, few manuscripts were produced on the mechanical arts, which in turn hampered speculation about their nature and function (Lusignan 1982, 35, 46–47).

The renowned thirteenth-century theologian and professor at the University of Paris, Thomas Aquinas, more than anyone else set the standard for the late Middle Ages. For him all natural and mathematical sciences were subordinated to metaphysics (Jordan 1986, 79; e.g. Thomas Aquinas 1963, 16–18). His understanding of the hierarchy of studies did rely, it is true, on Boethius. His devotion to higher matters, however, meant that even the liberal—let alone the mechanical—arts received little consideration. Even medicine and alchemy for Thomas Aquinas were relegated to a lower level than the liberal arts because they involved bodily activity and so related to the side of human nature that is not free (Thomas Aquinas 1963, 12). He believed that the liberal arts were not legitimate intellectual pursuits in themselves, but rather were only preparation for taking up philosophical questions. Such rudimentary and obvious matters did not deserve his serious consideration (Jordan 1986, 42). It should be added that Thomas Aquinas gave the mechanical arts diminished status not only because of their purpose but also because of the social status of the practitioners.

Another natural philosopher writing in the thirteenth century, Robert Kilwardby, shared many of the same views. He wrote a description of the ordering of all the arts and sciences, presumably on commission, with the work to serve as a handbook for younger fellow Dominicans. Though the divisions are similar to those of Hugh of Saint Victor, the work is original in taking up a variety of issues, including metaphysical issues, about aspects of each of the topics discussed. The work is also important because it is virtually the last of such treatises in the Middle Ages on the classification of the sciences. For Kilwardby the mechanical arts, like ethics, were part of the subdivision of human things called operative or practical. This gave the seven mechanical arts the lowest place in the

hierarchy (Weisheipl 1978, 478–480). Kilwardby did, however, urge closer ties between practical and theoretical knowledge, between speculative and human matters.

Changing economic conditions in the twelfth and thirteenth centuries led to greater recognition of tradesmen. The guilds they formed were both concrete manifestations of a recognition of their place in the social order as a separate estate, and institutions for them to use as agents to change the understanding of work from that of penance to that of a noble calling (Ovitt 1987, 15–16, 42–43). The guilds chose patron saints to advance themselves spiritually as well as socially. Labor did not lose the mark of servility but it did gain something of the merit that comes with performing a worthwhile and productive task (LeGoff 1980, 68, 118–121). Yet the mechanical arts never did overcome the stigma of not being speculative, of being associated with the body and the physical world. They were evaluated not in terms of their products, but rather in how carrying them out affected the practitioners. A secularization of the mechanical arts had started in the twelfth century, and though far from complete, labor could now at least be other than spiritual, communal, and inner-directed (Ovitt 1987, 127–129, 133–136, 162–163). By the end of the thirteenth century there was an emerging interest in nature, which showed up in a naturalism in art, as well as in a confidence in the power of humans to develop new techniques to solve their problems. A priest delivering a sermon in Florence in 1306 could say, "Every day new arts are discovered" (Cipolla 1980, 175). The confidence suggested in that observation generated in the Renaissance an even more positive view of technology.

The Renaissance fascination with the classical past led to greater division than before between the speculative activity of the philosopher and the practical activity of the artisan (Cipolla 1980, 243). Architecture and engineering especially flourished, coming too from imitation of the great successes of the antique world. There was, over time, a merger of experimental science with the mechanical as well as plastic and visual arts. All such arts were seen to be carried out through the imposition of reason, of some form of analysis that preceded action. This analysis was to be made through mathematics. There was an idea about, which came from the Pythagoreans through Plato, that nature had a mathematical order and that the natural order could be understood through the effective use of the intellect (Crombie 1980, 235–240). Technologists writing in the sixteenth century repeated the theological justifications of the twelfth and thirteenth centuries for what they were doing. At the same time they tried to

show their own connection with the oldest of sciences, mathematics. They also made a great deal of their usefulness to society or individuals in society.

In the fourteenth century, just as lay topics became more acceptable, so too naturalistic forms became acceptable for illustration. The search for precise relations, the search for simplicity in nature, led to an accuracy in depiction that gave artistic works a new value as sources of knowledge about technology (Husa 1967, 18–20; Rifkin 1973, xxxvi; Smith 1970, 534–537). Renaissance illustrations might well have been based on medieval traditions but they were much more numerous and were devoted to reproducing in pictorial form the technology itself (Gille 1978, 81–83). The introduction of Italian and Flemish realism to art, the insistence on perspective painting, made more illustrations better, though not necessarily in any artistic sense. They were better in that they showed what the technologist wanted to show. The illustrations could and indeed did transmit more information, and more accurate information, about their subjects (Hall 1979, 53–57). The works that came from the cooperative efforts of artists and technologists supply accurate reports of how things were done. Such works effectively serve the antiquarian purpose of the historian of technology. That is even more the case with efforts from the seventeenth century and afterward, as men such as Francis Bacon, Robert Boyle, and many others tried to break down the distinctions between science, art, and technique, in favor of a unified pursuit of useful knowledge (Cipolla 1980, 244; Ovitt 1987, 23). Their efforts to reduce the gap between intellectuals and technologists were not completely successful, but they accomplished more than any of their predecessors from the classical or medieval past.

The Artist and the Value of Technology

The pattern of change in theology and in theologians' views of technology were not necessarily mirrored in the changes in the way artists dealt with technology. Other forces could be and were at work in directing artists. There were many traditions on which artists could draw, and not just theological traditions, to influence the way they dealt with techniques. The virtue of temperance went from being the lowest to the highest of the cardinal virtues from the time of its recognition in the ninth century to the thirteenth. The transformation can be attributed to the belief in its value among the largely inarticulate aristocracy, to Aristotelian concentration on the golden mean and to the gradual identification of temperance with

knowledge. By the fifteenth century artists' representations of temperance showed her covered with symbols of recent technological advances such as eyeglasses, a clock and a mill. By the mid fifteenth century temperance was the preeminent virtue and had come to be clothed in the new technology of the Middle Ages. The change in the depiction of temperance does show, as the historian of technology Lynn White, jr. argued, that technology had come to gain new respect and a virtuousness unknown before in Europe and not known elsewhere in the world (White 1978, 187–203). The evolution of the depiction of temperance, the new and more positive attitude toward technology at the end of the Middle Ages, may coincide with a new and more positive view among writers. The evolution in what theologians said about labor and the mechanical arts in the twelfth and thirteenth centuries only slowly came to be reflected in what artists did with temperance, and for that matter with technology in general.

The works of artists can, as in the case of depictions of temperance, show more than what appears in the manuscripts generated by speculative thinkers or even the recipe books of practitioners. There is more in the illustrations than just the devices and methods people used. Developments in technology led artists to represent the world in the way they did just as changes in the economy led theologians to adjust their views of the mechanical arts. Whether they realized it or not, artists showed the changes in the relationship of the laborer to his work and his tools, which grew out of changes in technology. At the same time, and again perhaps without realizing it, artists represented the ideas people held about work, about technology, and about the mechanical arts. The vision presented by medieval artists may be more difficult to interpret, but it is as strong as that of the theologians.

Using works of art as sources for an understanding of technology requires more than simply not taking too much for granted. The usual interdictions, the standard caveats about dealing with sources, though they do apply, are not enough. It is not possible even to expect medieval depictions to yield the technical detail that comes from the technical treatises of the seventeenth century that were produced by the cooperative efforts of artists, technologists, printers, and publishers. Medieval artists typically were not intimately familiar with what craftsmen did. The craft they knew and understood was their own. Artists might have understood the functional meaning of an object, but the modern observer might not be able to perceive what went on. Originality was not valued the way it would be later in the Renaissance, so that even if an art historian can give an accurate date for a medieval work of art, that date may not be a correct one for

the technology depicted. If the artist copied earlier depictions, now lost, the beginning date for the technology cannot be established with certainty from the art work.

In assessing the use of visual representation as data for technological innovation, the two naive options of either saying that nothing can be reliable or that everything must be taken at face value are equally unacceptable (Husa 1967, 15–18). Since images are the best source for the study of medieval technology, much of what they have to offer has to be treated seriously. Nevertheless, a wide margin of error must be tolerated in the works of medieval artists who treated technical detail. "The importance of the cumulative nuance as distinct from a brutally clear and simple statement is what much of art is about" (Smith 1981, 385). The artist is not a slave to reality, but in the freedom created by his concentration on the symbolic rather than the realistic value of an object the medieval artist revealed a great deal more than just how something worked.

The incidental character of the depiction of technology often led the artist to show not only something about what was done but also how people carried on their tasks and how they perceived them. There are many such illustrations unknown to historians of technology because art historians have studied works for what the artist thought to be important rather than for what can be gleaned from the work about technology. Artists did, in their works devoted to Christian symbolism, reveal what they and their contemporaries thought of the value of technology, its place in society, and the economic implications of technology. The symbols can serve to clarify the meaning of ambiguous words, as well as help in understanding what people thought of themselves and how technology would change them (White 1978, 182, 185–186).

To understand medieval art, to comprehend the meaning of what artists showed both incidentally and centrally in their works, it is necessary to know about the history of technology. It is not a matter of finding out about the technology of painting itself. The concentration on the tools, the media, and the processes of art at the expense of an understanding of the content of art is indeed a result of technological advance in the years after the Industrial Revolution (Ellul 1979, 811–812). What an artist uses does, it is true, affect the way he deals with a subject, but the subject itself and how the artist chose to treat it is always the critical question for the historian of either art or technology. Only by knowing what the original object was like is it possible to assess what the artist did and to begin to understand his purpose. In the case of technical objects it is the raw material, the objects themselves, that must be appreciated in some sense, even a

superficial one, before it is possible to appreciate artists' actions. Since medieval artists did not reconstruct reality but rather constructed something unique in their art, they transformed reality in some way and for some purpose. Neither the way nor the purpose can even begin to be understood without some knowledge, preferably precise knowledge, of what that reality might have been.

The Example of Noah

The example in this case is the patriarch Noah and how medieval artists showed him building a ship. The catalogue of depictions of Noah in the act of constructing the ark is not necessarily a long one but may, by its very nature, become unexciting. Works are included so that the list below can be virtually complete rather than because they are, by some measure, intrinsically pleasing. There are few medieval depictions of shipbuilding, but virtually all of them from before the fifteenth century are of Noah building the ark. Thus the catalogue given here is also a nearly complete set of images of medieval shipbuilding. It is rare to be able to draw together virtually all the depictions of one technical activity, of one form of work over a long period.

The full range of depictions of Noah building the ark demonstrates how art changed and did not change over time. The varying style of representation follows in a general way the known phases of European art from the late classical period through the Renaissance. The catalogue establishes the relationship of each work to other works of its time, place, and style, and shows how artists relied on other artists, on their predecessors, in their treatment of this singular subject. There is a thread of continuity in the changing technology and the treatment of that technology by artists. There was also invention and originality among the artists who took up the problem of representing Noah building the ark. The catalogue isolates those novel artistic contributions. Changes in depiction also show how the technology of shipbuilding changed over time, since the art did reflect the advances in technology, as well as changes in the ideas people held about technology.

In the twelfth century, when ideas about the mechanical arts and about nature were changing, so too were the visual arts. Art was to achieve a likeness to nature, to be more objective (Stock 1972, 240; White 1978, 26–27, 29–37). The new view of nature and of God turned up in the work of many artists. Writers and theologians increasingly came to laud work in any form (LeGoff 1980, 61–64, 68–70; Ovitt 1987, 13–14). In late antique

art God the Creator was a fabricator, but as early as the tenth century he became more than that. Artists made him into a master mason, complete with compasses and a pair of scales. By the thirteenth century the scales disappeared but the compasses were the contemporary symbol for the engineer (Ovitt 1987, 58–59; White 1978, 65–66). The idea of God the Clockmaker, which became a commonplace of self-styled scientists in the eighteenth century, was prefigured in medieval artists' depiction of God measuring and building the world.

Other figures went through changes, not as dramatic or as important. Joseph was unheard of in the early Middle Ages, but by the fourteenth century he was making the transition from being the butt of humor as the deceived husband to being a hard-working artisan and the patron of carpenters (White 1978, 184–185).

Noah too went through a long-term change in the way artists chose to show him and what he did. The ideas of the classical world about work, about creative acts by people and God, and about Noah building the ark did not disappear in the early or high Middle Ages. The depictions of Noah throughout the Middle Ages recall those classical views. They also reveal the long-term shift in ideas about technology and about the relationship of people to nature. Noah, for example, did not miss the change to greater naturalism typical of the rise of Gothic art. Knowledge about ideas of nature and ideas of technology are extremely helpful in interpreting trends in artistic representation of technology. With Noah, however, what historians say about views of technology, gleaned from reading theology, is not consistent with what medieval artists did. They treated Noah differently, and the difference must be explained by the unique nature of the evolution of shipbuilding technology. Labor may have become secularized in the ideas and writings of the theologians of the eleventh, twelfth, and thirteenth centuries (Ovitt 1987, 201). That may have been a result of the changing context of work in the expanding economy of the period. The depictions of Noah do not reflect any such dramatic transformation in ideas. In the depiction of Noah, it was not merely a matter of mundane labor showing up in some theological context, such as was the case with the depicting of the labors of the month, a popular topic from the time of Charlemagne. Nor was it merely a matter of secular scenes put into some theological context by donors who were also craftsmen (Rifkin 1973, xxxiv–xxxvi), though in fact Noah did receive that treatment, as, for example, a window at Chartres Cathedral reveals.

The artistic representations of Noah have something more in them than the evolution of European art and changing ideas about technology

and man's relationship to nature. They also demonstrate the evolution of technology and the social relations transformed by that technological change.

Artists in medieval Europe could and did draw on a wide variety of sources of inspiration in treating the theme of Noah building the ark. This fact combined with the changes in ideas and in the technology of ship-building make the study of illustrations of Noah constructing the ark a good example of what can be done with art for understanding the history of technology, and in turn what the history of technology can do to help in comprehending the art of the Middle Ages. The combination reveals, in turn, both how people in medieval Europe dealt with problems of getting jobs done and what those people thought about what they were doing.

3
Noah in Early Christian Thought and Art

Noah is one of the most popular Old Testament figures in Christian Art (Réau 1956, 2:1, 104). Almost every part of Europe, both East and West, and almost every period knew illustrations of the patriarch. One thing among many others that artists chose to show was Noah building the ark. There were three principal sources for the ways artists depicted Noah the shipbuilder. The first and the most important was what artists themselves saw in their own daily lives. The second was what theologians wrote, what they said about the place of Noah in Christian history. The third was past artistic practice, established artistic tradition. The combination of the three sources produced the collection of more than one hundred separate western Christian illustrations of Noah building the ark from the end of the classical era to the seventeenth century. There was a pattern in those illustrations, a consistency dictated by the Bible story and by contemporary thought, but also by the way medieval shipwrights built their ships.

While medieval artists did often follow tradition, the artistic treatment of Noah was more influenced by what contemporaries thought of him, by how they understood his place in history, in Christianity, in folk traditions, in literature. With any individual depicted in medieval art, including Noah, the ideas held about them help to explain many of the features of the art. Thought created the framework within which artists could work, and set the limits for the influence on artists of contemporary technology.

The Biblical Noah

All writers on Noah turned ultimately to the Bible. Noah first appears in Genesis as the son of Lamech, the son of Methusaleh (5:29). Noah was

five hundred years old when he begat his three sons; Ham, Sham, and Japheth (5:32). God, seeing the wickedness of humans and the corruption of the earth, decided to destroy humans along, with the earth. Noah, however, was found worthy of being saved in the eyes of God. Noah is described as a just man, one who walked with God. God told Noah that He planned to destroy the earth and directed him to build an ark (6:5–13).

> Fac tibi arcam de lignis laevigatis: mansiunculas in arca facies, et bitumine linies intrinsecus et extrinsecus.
>
> Et sic facies eam trecentorum cubitorum erit longitudo arcae quinquaginata cubitorum latitutdo, et tringinta cubitorum alititudo illius.
>
> Fenestram in arca facies et in cubito cosummabis summitatem eius: ostium autem arcae pones et latere: deorsum, coenacula, et tristega facies in ea.

That is the way St. Jerome translated Genesis 5:14–16 in the Vulgate. It was in that version that readers in western Christian Europe were introduced to the building of the ark, from at least the fifth century on.

The King James version of the passage is as follows:

> Make thee an ark of gopher wood; rooms shalt thou make in the ark, and shalt pitch it within and without with pitch.
>
> And this is the fashion which thou shalt make it of: The length of the ark shall be three hundred cubits, the breadth of it fifty cubits, and the height of it thirty cubits.
>
> A window shalt thou make to the ark, and in a cubit shalt thou finish it above; and the door of the ark shalt thou set in the side thereof; with lower, second and third stories shalt thou make it.

God went on to tell Noah that he would establish a covenant with him. Noah was to enter the ark with his sons, his wife, and his son's wives. God directed him to bring two of every sort of living thing into the Ark, a male and a female of each. They would be kept alive. God told Noah to gather all types of food that were eaten for himself, his family, and for the animals (6:18–21).

God ordered Noah to enter the ark since, he said, he had seen that Noah was a righteous man. God then made specific the directive regarding, the animals of the earth: Noah was to take on board by sevens the male and female of every clean beast and by two, male and female, of beasts that were not clean. God promised that in seven days he would make it rain. The Deluge would last for forty days and forty nights, and would destroy every living thing from the face of the earth. Noah did as he

was commanded. The Bible reports Noah's age as six hundred years when the Flood began. The waters lifted the ark free from the earth and the whole earth was covered by the Flood to a depth of fifteen cubits. All living things were destroyed and only Noah and those who went with him in the ark remained alive. The Flood lasted for one hundred and fifty days (7:1–24).

Seven months and seven days had passed when the ark came to rest on Mount Ararat. After a time Noah sent out a dove, but the bird could find no place to light and returned to the ark. Seven days later he sent the dove out again and the bird returned with an olive leaf, which Noah took to mean that the waters had abated. Seven days later he sent the bird out again and it did not return. Then Noah took off the covering of the ark and saw that the ground was dry (8:4–13). God then spoke to Noah, telling him to bring his family out of the ark along with all the living things so that they could breed and increase their respective species. Noah did as he was told, and then built an altar and made burnt offerings on it (8:15–20).

Though there were different sources for the Biblical story of the Flood, in its final version it has a unity and a formal coherence. The epic tradition in the hands of priests was given dramatic movement, with rising chaos followed by a receding of the waters and then finally rest. The goal clearly was to inspire and involve the reader or listener. No matter the origins of the tale or the form it finally took, it was in this coherent and didactic unity that medieval and Renaissance writers and artists learned about Noah (Anderson 1978, 29–38).

The story of Noah ends in Genesis 9. God told Noah and his sons that they would eat meat and that they would be the dread of all animals. He again ordered them to breed abundantly, and made a covenant with them that there would never be another flood to destroy the earth, putting a rainbow in the sky as a token of this covenant (9:1–17). There is one further episode in the story of Noah, which frequently occurs in medieval representations in conjunction with depictions of the building of the ark. After the Flood Noah became a farmer and planted a vineyard. He got drunk on his wine and lay naked in his tent. Ham saw his father naked and told his two brothers; they then covered him, walking backward with the garment so that they did not see their father's nakedness. Noah cursed Ham for what he had seen, saying he would be a servant to his brothers. Noah lived three hundred and fifty years after the Flood, dying at the age of nine hundred and fifty (9:20–29).

Noah is mentioned again in the Bible, serving as an example of righteousness in the Old Testament (Exech. 14:14, 20; Eccl. 44:17). In the New Testament the theme is repeated (II Peter 2:5). He also functioned

as a man of exemplary faith (Heb. 11:7), but above all Noah was the ex-
ample of one saved by God. The analogy of the coming of the Son of Man
and the Flood is spelled out clearly in words attributed to Jesus when he
spoke on the Mount of Olives (Matt. 24:36–39). Before the Flood eating,
drinking, and marrying went on until Noah entered the ark. Then the
Flood came and destroyed all worldly activity; it would be the same, it was
said, with the coming of the Son of Man. The same message is repeated in
Luke 17:26–27. In I Peter 3:20–21 the author points out that Noah and
his seven relatives were saved by water as is the case symbolically with
baptism, which gives people salvation through the resurrection of Jesus
Christ. The Flood in which the world perished is mentioned again in II
Peter 3:6.

Early Exegesis on the Building of the Ark

Early commentators on the Bible took the building of the ark as part of
the larger story of the Flood and of Noah's survival. It was logical that they
saw Noah as a type of Christ. Early on Christians accepted the use of ty-
pology, the most completely developed aspect of biblical exegesis, which
related the Old Testament to the New (Mellinkoff 1970, 66). Exegetes saw
the Old Testament as prophecy, as allegory, and as typology, but the three
approaches often merged into one (Tonsing 1978, 67–68, 81–82). The af-
firmation of the unity of the two parts of the Bible functioned as a reply to
Jews. Behind this lay the theory that God's counsel, unknown in the past,
had now been made known in Christ (Lewis 1968, 112–113).

The Church Fathers set themselves the task of explaining what had
happened historically and what Noah's action represented. While in the
second century A.D. there was as yet little concern for systematic exegesis
of the Flood narrative, certain ideas did already recur, such as that of Noah
being a righteous man (Guillaume 1981, 381–383), the Flood as a type of
baptism (Daniélou 1956, 75–77; Daniélou [1947], 103–106), the Flood as
a type of the end of time (Lewis 1968, 113–120) and Noah as prefiguring
Christ (Tonsing 1978, 92, 97–98).

Many of those themes that did recur among the Church Fathers found
their origins in the work of the Hellenized Jew Philo of Alexandria (also
known as Philo Judaeus), who wrote in the first half century of the Chris-
tian era (Goodenough 1962, 2–9 and passim). His was the first effort to
explain what was said in the Bible through the methods of classical philol-
ogy. Philo interpreted Noah's ark as a figure representing the body; the
form of the vessel was like the human form and the windows were like the

caverns of the senses: eyes, ears, nose and mouth (Daniélou 1958, 133–134, 143; Lewis 1968, 163; Tonsing 1978, 152–158). Using the same methods as Philo, early Christian thinkers searched for symbols in the Old Testament of what was to come in the New.

Early in the third century Tertullian discussed Noah as a type of Christ. He went further, noting a first beginning with Adam, a second with Noah, and then the final beginning with Jesus Christ. During the same period Cyprian even said that the story of Noah was a type of the Passion of Christ (Daniélou 1977, III: 300–301). His contemporary Origen and Ambrose a century later both made Noah a second root of the human race (Daniélou [1947], 102–103). The former talked specifically of Noah prefiguring Christ (Lewis 1968, 158–160; Tonsing 1978, 185). Augustine in his *De Catechizandis* said that there were six periods in the history of the world, the first starting with Adam, the second with Noah, and so on until the start of the sixth, which began with the arrival of Jesus Christ (PL 40.338). Philo of Alexandria long before had called Noah an end of things past and a beginning of things to come (Daniélou 1957, 85).

Noah's name means "rest," a point repeated by a number of Church Fathers, and this philological observation strengthened the analogy of Noah to Christ and Noah's association with salvation (Stichel 1979, 25– 27). Though the Old Testament did not say that Noah preached, this activity was associated with him early, first in the New Testament and then by certain Church Fathers. The very construction of the ark was seen as serving as a proclamation for the need for penitence, so that Noah's activity represented a type of preaching (Guillaume 1981, 383–384). The ark carried those who were saved and thus was like a sarcophagus. The ship as a female symbol, as the vessel completing the life cycle by carrying a corpse back on the waters of labor to the mother's womb where the foetus floated in amniotic fluid, is a symbol that appears in a number of forms, both Christian and non-Christian (Schnier 1951, 60–63). It also can be found lurking in the symbolism of various burial practices found in both Judaic and Christian tradition. Philo had said that the ark was the image of the soul moving toward blessedness (Daniélou 1964, 67).

The ark had a second and more important meaning for the early Church Fathers: it was a haven of safety, the vehicle for the saved. Since all outside were to perish, the ark prefigured the Church (Cyprian 1958, 100). The claim goes back to the beginning of the third century, and may have Greek or Jewish antecedents (Daniélou 1964, 58–67). It was repeated by Tertullian, Jerome, and Augustine, among others (Daniélou, 1956: 83; Leclerq 1924, 1:2, 2710). Augustine called the ark "a figure of the city of

God sojourning this world; that is to say, of the Church, which is rescued by the wood which hung the Mediator of God and men, the man Christ Jesus" (Augustine 1950, 516). The connection of the wood of the ark with the wood of the cross was a recurring theme, and there was a tendency to make every mention of wood in the Old Testament a symbol of the cross. Augustine went on to claim that the window in the side of ark signified the wound in Christ's side when crucified, the way believers enter the church. Just as Noah built the ark, so did Christ establish the church as the only means to salvation (Bechtel 1911, 88; Daniélou 1964, 69–70; Guillaume 1981, 384–385).

There were for these writers other particulars of the ark that were signs of the features of the church (Augustine 1950, 516). According to Jerome, the variety of animals in the ark symbolized the variety of those in the church (PL 23. 185; 23. 247). The perils of the church in the world were seen by both him and Augustine as analogous to the waters of the Flood (e.g. PL 40. 334). For most, including Cyprian, Ambrose, Justin, Tertullian, Jerome, and Augustine, the waters of the Flood were the waters of baptism (Tonsing 1978, 167, 178–179).

The major themes of the Church's Flood typology were "a calamity to destroy the sinful world, a delay due to the mercy of God which corresponds to the present age, and the building of the ark—the church—in which some would escape to the rest given by the spiritual Noah." (Lewis 1968, 170). Philo had been concerned about the measures of the ark, and both Ambrose and Augustine, like Philo, noted that the proportions were exactly those of man, the form in which Jesus Christ came (e.g. Ambrose, PL 14.387–388). Thus the ark symbolized matters relating to the soul's salvation. The dove of the Noah story was seen as a symbol of the Holy Spirit, exactly like the dove that descended to Christ when he was baptized. The return of the dove to the ark, to the symbol of the Church, was seen by Tertullian and later Ambrose, Jerome, Chrysostom, and others as a sign of hope for a new life. "Of all Noachic themes propounded by Church Fathers, the idea of the Flood prefiguring Christian deliverance receives the most attention" (Tonsing 1978, 184). It is not surprising then that the event was commemorated in a number of early Christian works of art (Lewis 1968, 162–175).

Incidentally, the Deluge story is a very old one: the Biblical story of Noah is apparently related to other such narratives not part of the Judaeo-Christian tradition, including the Gilgamesh epic (Westermann 1974, 1, 563–564). In Akkadian, one of the two languages of Babylonia, the source of the Gilgamesh epic, the word for the type of wood used in building the

vessel is *gipar,* which means a reed. The Arabic word is *guffah.* The connection with Mesopotamia explains why, in the Bible, Noah is said to have built his ship of gopher wood (Lewis 1968, 4, n. 1). An emendation of the Hebrew text suggested by the Old Testament scholar, Edward Ullendorff, that changes the pointing of the consonantal skeleton would eliminate the instruction to Noah to build small rooms, compartments, or bird's nests in the ark. Instead the text would read that God told Noah to build the ark of timber and then use reeds to finish the construction. The change in the reading does make the text internally consistent. Moreover, reed boats were built in the ancient Near East and papyrus boats are still used on the Nile (Ullendorff 1954, 95–96). Since reeds were certainly available when the Bible was written, it would have seemed reasonable to talk about gopher wood. In the Septuagint the term is translated as quadrilateral wood, in the Vulgate, smoothed wood, but the King James version reverted to calling it gopher wood (Cassuto 1961, 2:61; Murphy 1946, 79–81). While there may have been good philological reasons for the choice of the terms, the original Hebrew and the Latin translation caused some difficulty for illustrators in later centuries.

The views of the Church Fathers secured Noah a place in medieval Christian thought. By the end of the fourth century the Flood had an established place in Christian teaching. It was a sign of deliverance, followed by a new Creation, a new start for all people. Noah, like Christ, was the first of a new generation. Some of the early Christian theologians, especially those from Alexandria, meditated on the mystery of the geometry of the ark, but most were satisfied with simply interpreting the ark as prefiguring the Church, the Flood as prefiguring baptism and Noah as prefiguring Christ (Tonsing 1978, 194, 207–211). The discussion guaranteed that Noah would be seen favorably.

Noah's depiction in art was, however, not common and even less common was any depiction of his building the ark. The typological view perceived other events in Genesis 6–9 to be much more important. God's announcement of his covenant with Noah, the entrance of the animals two by two, the ark riding out the Flood, the return of the dove with the olive branch, the exit from the ark, and the burnt offering were all more important in prefiguring events of the New Testament or in carrying a moral or spiritual message than was the job of building the ark. The themes of resurrection and of the Last Judgment, perceived as critical in the story of Noah, not unexpectedly come little to the fore in the scenes of the construction of the ark. This focus helps to explain why when the actual construction did appear it was generally as part of a series of works about

Old Testament patriarchs or as incidental illustration of the book of Genesis. This late classical pattern persisted throughout the Middle Ages and the Renaissance. The exegetical method of the early church, the search for allegory, dictated the principal topics for artists, and Noah's building the ark was not one of those topics.

Although Noah was a center of discussion among Christian theologians in the second through the fifth century the interest in him waned in subsequent years. During the high Middle Ages there was among Christians a declining interest in the Old Testament. The focus shifted to the life and teaching of Christ and, after the twelfth century, to the life of the Virgin Mary. "Medieval attitudes toward the Old Testament can be described as confused, ambivalent, and often contradictory" (Mellinkoff 1970, 125). The value of the Old Testament came to be solely that it prefigured the New. Along with the rising interest in the New Testament, the Old became denigrated because of its association with Judaism, with Jews, and with the synagogue. The increase of anti-Semitism in the high Middle Ages was reflected in a negative attitude toward the Old Testament and the principal figures in it. Moses, for example, was increasingly shown wearing the distinctive Jew's hat, which must have created a negative response among Christian viewers (Mellinkoff 1970, 128–133). The same can not be said of Noah the shipbuilder, although he did always have a long beard, increasingly a distinctive features of Jews in the late Middle Ages, and he was once shown with a Jew's hat. The general hostility toward Jews and the scholarly disinterest in the Old Testament meant that ideas about the place of Noah in Christianity remained largely unchanged from their earliest formulations. Heavy reliance on the early Church Fathers continued; there was little new from theologians to influence or direct artists.

Efforts to Show the Noah of Early Christian Thought

The ideas laid down in Christianity's early years certainly dominated the understanding of Noah through the eleventh century and into the high Middle Ages. Those ideas in turn inspired or constrained artists in what they did, but there were other forces acting on them as well. The medium artists used placed limitations on what they could do. Often skills were poor, most notably in the early Middle Ages, so artists' ideas had to conform to sometimes severe technical constraints. There were also artistic traditions established in the late Roman Empire that provided examples, patterns for artists to follow. Contemporary technical practices functioned as another source of inspiration, one that served to define for

the artist how he was to deal with a biblical figure as much or more than what Jerome, Augustine or Chrysostom said. In the case of the depiction of Noah building the ark, shipbuilding practices informed the work of many artists.

Medieval artists had no concern whatsoever for historicism. They did not want to recreate a picture of what life was like in the time of Noah, Christ, or any figure for that matter. For them as for the Christian typologists there might well have been an historical component to the Biblical texts, but the allegorical component, the moral and theological message, was much more important. The image was, in the first instance, to represent a type rather than the specific manifestation of the type. This is not to say that all medieval thinkers agreed on the question of realism or that medieval art always remained the same. Nevertheless, since most artists for much of the Middle Ages aimed at typological representation rather than at depicting the object within its historical context, they remained free to show the object in the form most familiar to them, the form it took in their own time. Visual representations of any form most typically reflected contemporary practice, not merely the clothes but also the equipment and furnishings conforming to what was in common use in the artist's own days. Thus when depicting Noah building the ark, artists showed how shipbuilders built ships at about the time the work was executed. For details of technology, and especially technology in an unfamiliar field, artists would usually turn to what was around them.

Caveats necessarily abound in making such an assertion. Artists did understand how contemporary clothes were worn and often how they were made, but usually did not understand what shipbuilders were doing or how ships worked. They were not interested in depicting precisely the practice of shipbuilding but rather in depicting generally the type of such work. Since medieval artists rarely understood accurate representation of any object—ships in particular—to be their primary or sole aim, illustrations of maritime and, for that matter, any technology are rarely unequivocal in meaning. Interpretation can be a serious problem (Farrell 1979, 227, 244). The lack of knowledge of ships among artists may have led them to stylization and conservatism. Moreover, their work may be much removed chronologically from the original inspiration (Farrell 1979, 238). This occurred often with mosaics, for example, which tended to be the result of many copyings.

In the case of Noah building the ark the Biblical text did set some constraints on what artists could include. The ark had to have three stories, whether contemporary ships had three stories or not, because Genesis was

precise on that feature of the vessel. Despite all of the pitfalls in trying to extract information about technology from medieval works of art, it is still certain that practice on the shipbuilding wharf and the way artists showed Noah building the ark did conform loosely to one another. Great changes in the way ships were built and in the ways shipbuilding work was organized should have been reflected—albeit not necessarily immediately—in depictions of Noah. Thus knowledge gleaned from archeology about construction methods shipwrights used in the Middle Ages is of significant help in interpreting the iconography of Noah.

Since Noah prefigured Christ he was akin to the Saviour in type. The ark brought salvation to the just person, salvation from the waters of the Flood; so too could the ark be a symbol of the salvation of the deceased. That is why for about one hundred years after the mid-third century Noah was a popular figure for paintings in the catacombs, and more significantly popular for paintings on sarcophagi. After that he slowly disappeared from works of art (Tonsing 1978, 29–30). Noah in the ark was one of the first pictures from the Bible that supplanted symbols such as fish and flowers in early Christian art. Undoubtedly Noah's popularity was connected to his place in Christian thought.

In the catacombs there are forty-one paintings and thirty-three representations on sarcophagi of the ark (Fink 1955, 39, 44–45). The ark was in fact allegorized as a sarcophagus, which influenced the choice of a box to represent it in all catacomb paintings. The Hebrew, Greek, and Latin texts all use words meaning box or chest to describe the ark. There is no question that the Biblical narrative meant a parallelepiped and not a ship (Cassuto 1961, 2:59–61; Tonsing 1978, 257–259). In one case, incidentally, the buried individual replaced Noah in the box (Pfister 1924, 15–16). Noah lifting the lid of the sarcophagus recurs as a theme in the early Christian images (Fig. 1). The Old Testament analogue is clear: Noah lifted the lid of the ark after the Flood had ended and saw that the ground was dry (Genesis 8:13). Allegorically this was precisely what the deceased hoped to do, to have a new beginning (Fink 1955, 107; Lewis 1968, 161–162). Noah thus was unquestionably a symbol of resurrection in the catacomb paintings (Morey 1953, 63).

The same motif appears in a series of coins from Apamea in Phrygia dated to the first half of the third century A.D. On the obverse the coin shows Noah and his wife in a box with their heads emerging (Fig. 2). There is a dove on the lid of the box and a second flying in with an olive branch. The Greek letters on the chest make it clear that the man is Noah (Fink 1955, 9; Mangenot 1912, 926). He and his wife appear again on the

same side of the coin, advancing forward. The depiction, just like those in the catacombs, follows Philo of Alexandria in understanding the figure of Noah as a symbol of one who escapes from the body to communion with God. The coins are consistent with and probably come from Hellenized Jewish sources (Goodenough 1953, 2:119–120). The Apamea coin may have been copied from a mural painting showing scenes from the Old Testament. Since coins are highly portable it is not unlikely that the method of representation of Noah and the Old Testament events that came from the Jewish colony in Apamea had a direct effect on the early Christian art of the catacombs (Grabar 1951, 9–14; Tonsing 1978, 271–272). The character of contemporary Jewish art such as that at the synagogue at Dura in addition to the overwhelming proportion of Old Testament themes in the catacomb paintings further suggest Jewish influence on early Christian artists (Kraeling 1979, 399–400).

For some scholars the Noah of early Christian art is a symbol of atonement or penitence. For others Noah is a symbol of baptism. The former emphasize the ark as a symbol of the redeeming Church, and point to the appearance of Noah in pictures with Daniel and Job. Cyprian had made the connection between the three in discussing penitence; some illustrations were indeed intended to show that Noah was a just and a penitent man (Tonsing 1978, 16–27). On the other hand Tertullian had noted the presence of the dove at the baptism of Christ in the Jordan, and thus the presence of the dove in pictures of Noah might serve to emphasize the connection with baptism, with individual renewal. Since early Church Fathers regarded baptism as the path of entry to the Church, the baptismal symbolism is logically connected to the symbolism of the Church (Franke 1973, 171–182; Hooyman 1958, 113–135).

The first Christian artists did not think of Noah as a shipbuilder, nor was the ark even a ship. There was little figurative art in the early Middle Ages, especially in areas removed from the orbit of classical cultural. The withdrawal from realism in art paralleled that in literature, artists and writers alike tending to deny the importance of man and replace it with the importance of God and life after death. The Church, to counter a variety of what it regarded as primitivism, replaced pagan realism with a mass of signs and symbols (LeGoff 1980, 91). This left little room for pictures of Old Testament patriarchs.

One late Roman picture of a shipbuilder is known to have survived. It is a work in gold glass, a part of the drinking vessel sixteen centimeters in diameter, dating probably from the third century and possibly from the late second. Broken, it was restored—not very well—in 1731 and is now in

the collection of the Vatican Library (*Museo Sacro* Inventory #345). It shows the builder, Dedalius by name, in the center, with six representations around him of carpenters doing different jobs with different hand tools. One is working with an adjustable bow saw, his board set on a trestle. Another is seated using an adze. A third is using a bow-drill, another a hammer and chisel, and another a plane. Five of the six workers are young men wearing tunics, which indicates that the sixth, who is holding the finished ship, is older. The inscription PIE ZESES was a contemporary toast and appears on glass work of all types of the period. The central figure is beardless, wears trousers and shoes, and holds a long rod that rests on the ground in his right hand. He was presumably a master carpenter or shipbuilder (Morey 1959, 23, pl. 16; Vopel 1899, 33–37, 80–82, 98). This specific work was not a direct inspiration to the artists who later did pictures of shipbuilders, but it does have many features that recurred in medieval depictions of the trade. The tools in particular reappeared with varying frequency and in different forms throughout the Middle Ages in illustrations of Noah.

Up to about 400 A.D., when Old and New Testament themes were put together in the same work, emphasis in Christian art was on the hope for salvation, as in the case of the catacomb painting where Noah appears coming out of a box. Artists were concerned with depicting Old Testament patriarchs who prefigured Christ (Bergman 1980, 5). While the ark was usually shown as a box, representing a sarcophagus, the fourth century saw a major change: the ark became a boat (Lewis 1968, 161–2). The first signs of that change come from a picture at El Baghawat, which showed the ark as a vessel (Leclerq 1924, 1:2, 2713–2715; 2723–2724, 2726). In the fifth century two separate sources or artistic traditions completely absorbed this change to understanding the ark as a ship. Unfortunately those traditions are only known from later sources. It is impossible to say with certainty what the inspiration was for the original works or to date them precisely. It is only possible to reconstruct what the first works may have looked like, working back through intermediate steps from later examples.

The two traditions formed the basis for a complete change in the treatment of Noah. In both cases illustration was used to clarify and explain the Old Testament. The first is associated with manuscripts of the Octateuch and is known from some five surviving manuscripts all dating to the eleventh, twelfth, and thirteenth centuries (Dalton 1911, 464). That form had its principal impact in the East.

The second is usually called the Cotton Genesis tradition after a Greek Old Testament from the second half of the fifth century. Done in Egypt possibly at Alexandria or at Antinoë, it contained some 500 separate episodes in 360 framed miniatures (Herbert 1911, 17–18; Morey 1953, 74–76; Weitzmann and Kessler 1986, 30–35). "The CG [Cotton Genesis] cycle, with its dense sequence of miniatures presenting the story of Genesis in an elaborate iconography and authentic classical style, was a source mined throughout the Middle Ages. Especially during artistic revivals, in Carolingian Gaul, eleventh-century Amalfi, or thirteenth-century Venice, its imagery attracted artists intent on presenting the Old Testament text as a historical narrative. Each artist fashioned something new out of the materials quarried from CG" (Weitzmann and Kessler 1986, 43). The artists paid attention not only to the story but also to the theological significance of what they were showing. They also used extra-Biblical sources such as popular stories, some of which originated in Jewish traditions.

The Cotton Genesis probably derived from some earlier work that had more Jewish elements and fewer of the Christological features, which dated from after about 200 A.D. The style is Roman, with Old Testament figures clothed in Roman fashion. After being given to King Henry VIII of England in the early sixteenth century the manuscript ended up in the collection of Sir Robert Cotton less than one hundred years later. A fire destroyed the manuscript at Ashburnham House in 1731 and only charred fragments and two copies of illustrations remain. Of the panel showing Noah building the ark only an area at the bottom of the page survives. The ark in the Cotton Genesis was represented variously as a box with a wicker design and with zigzag lines; it has been suggested that the artists had access to a technical treatise on shipbuilding that provided them with guides to the technical details of Noah building the ark (Weitzmann and Kessler 1986, 6–7, 32–39), though such as assertion goes perhaps too far in its zeal to reconstruct a concrete context for the artist's work.

The Cotton Genesis had its principal impact in the Latin West (Bergman 1980, 12–13). The new approach to Noah and to Old Testament patriarchs was already known when the Cotton Genesis was finished, since the same sort of program had already appeared in the decoration of Roman churches. It was from those buildings that medieval Italy knew about the major change in the late antique iconography of Noah building the ark.

It was probably during the pontificate of Leo the Great (440–461) that the Old Saint Peter's in Rome had a program of Old and New Testament scenes painted along the nave of the basilica. The church has long since

been destroyed, but surviving drawings and reports suggest that the depictions of patriarchs on one side were meant to show the prefiguring of Christ. The program of scenes showing sacred history from Creation, part of the same tradition as the Cotton Genesis, was apparently an inspiration for later church decoration. Such prominence would not be surprising given the importance of Saint Peter's and its place as the goal of many pilgrims (Bergman 1980, 5–7). The mosaics that lined the fifth-century basilican church of Saint Paul's Outside the Walls in Rome were apparently very similar to those at Old Saint Peter's. Along one side of Saint Paul's there was a series of mosaics of major events of the Old Testament, one of which showed Noah building the ark. Like so many other scenes it fell into disrepair until Pietro Cavallini restored it in the mid 1280s. Cavallini was a Roman, a pupil and disciple of Giotto who worked with Giotto at Assisi and was one of the most important painters of the early Renaissance (Vasari 1912–1914, 1:161). While he left some of the mosaics at Saint Peter's untouched he subjected others to extensive change. Some work was done on the Noah panel, but the result was, it appears, very close to the original. Although the church was destroyed by fire in 1823, a number of artists, most notably those commissioned by Cardinal Francesco Barberini in 1634, recorded the mosaic (White 1956, 84–85). The second-hand sources that have survived must be assumed to be very close to the fifth-century original.

Noah appears twice (Fig. 3), enthroned and at an angle to the viewer. In the frescoes God the Father is set apart from the universe, a detached director of the forces of generation (Ovitt 1987, 58–59). Noah is treated in something of the same way. The second time Noah is shown, just to the left, he is in an attitude of prayer (Stern 1958, 179). The active figures in the mosaic are placed at different depths within the picture and are joined one to the other by a series of diagonals of movement and attention, possibly a result of Cavallini's restoration. By the time he did this work of restoration Cavallini had already mastered and even surpassed fifth-century skills, so that he made some innovative additions (White 1956, 88–89). In the panel on the right is a man with an ax and in the middle next to the praying Noah are two men sawing a large board with a frame saw. The thin, narrow, flexible blade is held in place by a rectangular frame. Such saws, when large, were usually called pit saws, since it was standard practice for one man to stand on top of the board pushing the saw down while the second man would work below in a pit pushing the saw back up (Mercer 1960, 17–18).

The presence of three workers in the scene suggests that Noah's sons were the ones who did the physical labor of building the ark. There is no statement in the Bible that the sons or anyone else worked on the ark; God commanded Noah to build it. Some Talmudic scholars did say that the ark built itself, an idea that came from a misreading of the Hebrew text. Most rabbis agreed that Noah built the ark as God commanded (Lewis 1968, 133–137). It is apparent that in the Christian tradition, however, by the fifth century the idea that others, possibly the sons, had done the work was already accepted. Some commentators, including Augustine, being concerned about Noah's ability to finish work on the ark by himself in just 100 or 120 years, maintained that he hired many workmen (Allen 1963, 72). Since the presence, number, and identity of assistants was not stated, this was for the artist to decide. Importantly, it was not Noah but others whom the late antique artists show using the tools. Noah is an observer and perhaps an overseer.

There is no question that the surviving Octateuch manuscripts are based on a late antique and probably fifth-century source (Henderson 1962, 174). Two surviving manuscripts (Constantinople: Library Seraglio, 8, fol. 57v.; and Rome: Lib., Bibl. Vaticana, gr. 746, fol. 53v.) very closely resemble each other. The Vatican manuscript is in much better condition (Fig. 4). The story of the Flood begins (fol. 53r.) with a nimbed Noah receiving instructions from God, whose hand alone is shown coming out of a cloud. On the right are Noah's three sons. In the next scene (fol. 53v.) Noah, without the nimbus, stands to the left. He is slightly larger than the other figures and is bearded in this as in all other illustrations of building the ark. Though beards came to be associated with Old Testament patriarchs quite generally, it seemed especially appropriate as a reference to the fact that Noah had already reached the advanced age of five hundred when he started work on the ark. Noah appears to be holding something in his folded hands. Three men—not his sons—are working on a boat that is very sharply curved. They have already put in the bottom planks, and there is a rib in place, as well as a plank running the length of the ship at about the height of the gunwale, the highest of such planks. Two of the three unbearded men have small hatchets or hand adzes. One is speaking to Noah, perhaps receiving instructions. The third is heating pieces of wood over an open fire, the standard way to make planks pliable in order that they could be bent to shape on the hull. There is no question that Noah and the three men are building a real boat. In a second panel on the same folio Noah, his sons, and all their wives are shown together inside

the ark surrounded by a number of animals. The family group, which also recurred in medieval depictions of the Flood, is a symbol of the body of the Church, an extension of the allegory of the ark as the Church (Allen 1963, 170).

Noah in Northern European Illustrations

Two English manuscripts of the eleventh-century picture Noah building the ark very differently. Both of the manuscripts belong to a group filled with iconographic changes and inventions. Culturally England in the eleventh century was a center of novelty, not only in art but also and perhaps particularly in technology (White 1978, 65). The period before the Norman Conquest was one of originality and of creating new conceptions of traditional themes. As one scholar put it, "There is little doubt that eleventh-century England represented a time and a place when the earlier conventions were no longer adhered to. New versions of old themes appeared" (Mellinkoff 1970, 18). The English manuscripts were not the only manifestations of breaks with iconographic tradition in the eleventh century; there are other examples throughout western Europe (Mellinkoff 1970, 21).

There is no mistaking the late antique influence in the two English manuscripts, definitely in the tradition of the Cotton Genesis. The two probably are derived from the archetype of that manuscript but were subjected to many iconographic and compositional changes, some of which were most likely the result of intentional improvisation (Weitzmann and Kessler 1986, 17) to suit specific needs and contemporary conditions. Certainly the artists who depicted Noah introduced a significant change from the original, a change that can be explained in part by the cultural novelty of eleventh-century England but that must also be explained in part by the then dominant technology of shipbuilding.

The earlier of the two is a collection of poems, some of them attributed to Caedmon (Oxford: Bodleian, Junius 11). Although it probably dates from the second quarter of the eleventh century, a late tenth-century date has also been suggested (Pächt and Alexander 1966–1973, 3:5; Rice 1952, 203; Temple 1976, 76–78). The artists worked in the style of the Utrecht Psalter; the work has nevertheless been associated with the Winchester school (Herbert 1911, 118) and may also have been subject to Scandinavian influence (Kendrick 1949, 105; Mellinkoff 1970, 51). It was done at Canterbury or possibly at Malmesbury. All these eleventh-century influences notwithstanding, it was also based on some late antique manu-

script, the primary affiliation with the Cotton Genesis tradition having been established (Henderson 1962, 172; Weitzmann and Kessler 1986, 24). Included are illustrations for a number of stories from Genesis. On one page Noah is shown both receiving his instructions from God in the upper half of the panel and working on the ark in the lower (Fig. 5). God is perfectly erect while Noah leans slightly forward, almost as a suppliant. Below Noah is alone. He is working on the ark, wielding a large polless broadax with a straight handle. It is impossible to tell if it is chisel- or knife-edged but the end of the metal tool curves upward sharply at the forward end. In fact, it bears a strong resemblance to a Norse battle-ax (Moll 1930, 164). The ark has one opening, is double-ended and has ornamentation at both the bow and stern.

Aelfric the Grammarian (c. 955–c. 1020), abbot of Cerne and Eynsham, wrote his *Paraphrase of the Pentateuch and Joshua* in about 1000 at the request of a nobleman, in order to give instruction in the Bible to village priests and the lay nobility. The paraphrase into Anglo-Saxon was based on the Vulgate. It was a simplified version of the text, leaving out detail but retaining the principal flow of the story. This rather elliptical manner of narration tended to focus attention more on those details that lent themselves to illustration (Mellinkoff, 1970:24–25). The art historian Ruth Mellinkoff notes, "The very development of vernacular prose stressed the concrete as against the vague, the literal as against the metaphorical" (p. 26). The surviving illustrated manuscript (London: British Museum, Cotton MS. Claudius B.IV) was probably done at Saint Augustine's, Canterbury, about 1050. All illustrations are by the same hand, and are usually considered inferior to those in the Caedmon manuscript. They lack landscape and atmosphere, never attempting either beauty or naturalism (Herbert 1911, 118). One of the striking features is the nonnaturalistic coloring, such as the use of blue for the hair (Rice 1952, 206–207). The art historian T. D. Kendrick called it a "cheerful but plodding copywork unlivened by any Saxon genius" (Kendrick 1949, 24). The artist's goal appears to have been solely to illustrate the text. Yet these manuscripts show a freedom from convention, a freshness, and an "iconographic inventiveness" that sets them apart from other Anglo-Saxon manuscripts (Mellinkoff 1970, 16). The Aelfric Paraphrase and the Caedmon manuscript both depict the ark in a similar way. It is a double-ended boat, sharply curved and looking much like contemporary Scandinavian long ships. Inside the boat there are three stories (Rice 1952, 204). The illustrator of the Aelfric Paraphrase drew extensively on some elaborate Greek source, probably a prototype shared with the Cotton Genesis rather than a

manuscript in the Octateuch tradition (Henderson 1962, 196; Weitzmann and Kessler 1986, 17, 25).

Once again Noah receives his instructions from God and goes to work in the same panel (Fig. 6). God has a book in his right hand and his left is raised toward Noah. Noah is then seen using both hands to wield a large long-handled polled broadax. It is curved at the forward end. Noah rests the ax on a board that he straddles with his legs. When listening to God Noah wears a dark, flowing robe and dark stockings, but when he is working he wears a much lighter, simpler, and closer-fitting garment. The illustration is clearly directly associated with the text and designed to help the reader understand the text. The juxtaposition of Noah receiving instruction and going to work follows the Biblical text and allowed the artists to insist on the patriarch as a symbol of industry, obedience, probity, and even patience.

Noah in Southern European Illustrations

In southern Europe the eleventh-century Noah was different not in his symbolic but in his technological function. The Salerno ivories have an extensive program, showing universal sacred history from Creation to Pentecost in a series of forty major figurative pieces (Goldschmidt 1975, 36–39). They were intended as decorations for doors placed inside the church at Salerno (Bergman 1980, 102–108). The interweaving of panels showing New Testament scenes with those showing Old Testament scenes strongly suggests the force of the typological thought that so dominated early Christian thinking about the Bible in general and about the story of Noah in particular. Done probably at Amalfi in the 1080s, the Salerno ivories depend on earlier inspiration. The source could well have been the new basilica dedicated at Monte Cassino in 1071, which in turn possibly got the plan for its iconographical program from Old Saint Peter's. That church was apparently part of a general effort based at Monte Cassino in the late eleventh century to rekindle the spirit and resurrect the glories of early Christian Rome. For some two hundred years after the dedication of the basilica the scheme of decoration became quite common for churches in central and southern Italy, including the Capella Palatina in Palermo, the Cathedral at Monreale, the Baptistry in Florence and San Francesco at Assisi (Bergman 1980, 6–8, 116–118).

In style the Salerno ivories borrow at least their general tone from Middle Byzantine art. Though they were not copied from the Cotton Genesis, they were derived from an archetype of that manuscript. The exact

pattern of the inheritance is not clear, nor is it possible to establish the precise connection. There was a second source for the ivories: a Byzantine Octateuch. In this case artists merged the two traditions, but not with the scene of Noah building the ark. There the affiliation with the Cotton Genesis is unmistakable (Bergman 1980, 11–14; Weitzmann and Kessler 1986, 17, 22–23). The artists were still starting something entirely new, first because there was no figurative carving of any sort in southern Italy at the time, and second because they brought together many different styles in a unique way (Bergman 1980, 79–81, 84–91).

The Noah of the Salerno ivories appears in the fifth plaque, where God commands him to build the ark. Noah has long hair and a long beard. God is an anthropomorphic figure rather than a hand emerging from a cloud, as in the Vatican manuscript depiction (see p. 43). The same Creator appears in earlier scenes and continues on in the later scenes of the ivories. On the other half of the panel Noah is on the left, as usual, facing right and gesturing with both hands (Fig. 7). The position of his right hand suggests both that he is giving orders and also that he is an imitation of the Creator, of the God who gave orders to Noah. On the right of the panel six men work on the ark, four on the ground hammering with a long-handled hammer, cutting with a large two-handed ax, and sawing with a frame saw. The sawyer above has his left foot planted on the plank being cut. The remaining two workmen are busy on the roof of the ark, which has a window and in general bears little resemblance to a ship (Bergman 1980, 24–25). The house-like ark reappeared in southern Italian art well into the fifteenth century. Noah is at least three times the size of the workmen and his dress is very different, surely a most emphatic means of depicting the superior directing men at work.

Two Artistic Traditions

Already by the eleventh century two distinct traditions within Europe in the illustration of Noah building the ark had arisen. Late-antique artists showed Noah with workmen under him, directed by him and following his commands. Although fifth-century and, indeed, all late-antique depictions of Noah building the ark have been corrupted in one way or another, such as through copying, there is an undeniable impression that in the closing years of the Roman Empire and perhaps in Byzantium as well Noah was the man in charge of building the ark. The workers were added in light of theological discussion, not because the Bible said that there were other workers. The tradition continued in southern Italy.

In northern Europe, on the other hand, the Anglo-Saxon manuscript tradition turned to late antique and probably Greek sources in the development of novel forms of illustration. When it came to showing Noah building the ark those English artists deviated from the tradition. They discarded assistants, workers, or sons using tools to make the ark. Noah receives his instructions from God and then turns to do the work himself, alone. Even the wood-working equipment was different in the English manuscripts from that which appeared in the southern European pictures.

There must have been some good reason for the English illustrators to make this break with the past. One feature of the novelty of the eleventh century was a general respect for labor, a respect not limited to the agricultural sphere. In the early Middle Ages any job not connected directly with the land was almost without exception condemned. There were few artisans, only a small fraction of whom enjoyed any prestige. From the ninth through the thirteenth century economic expansion and urbanization was accompanied by—perhaps in part caused by—an increasing division of labor. Many new trades grew up and tradesmen insisted on respect and recognition. The decrease in the number of forbidden or disgraceful professions was the intellectual counterpart to the increase of skilled workmen and the increased respect they enjoyed. Increasingly too the idea became current that work was a good thing (LeGoff 1980, 59–64, 77–79).

By the eleventh century it was thus considered acceptable to show men at work, even to depict a patriarch like Noah doing manual labor. Nevertheless, even if shipbuilding was a more acceptable trade in the eleventh than in earlier centuries, this fact does not explain why depictions of Noah changed in northern Europe while in southern Europe they maintained completely the late-antique mold. In northern Europe Noah built ships with his hands, wielded an ax, and worked alone. In the South he was enthroned, the master builder, the director of operations, an employer of others, giving them advice and orders, a figure larger than those he oversaw. The ultimate source for the program and composition of the cycles in which Noah the shipbuilder appeared, may have been the same, but in the hands of eleventh century artists the results were very different in the two parts of Europe.

The German art historian Raimund Daut in passing noted the division in the two traditions but offered no explanation for it. He did mention some examples and said that the former type of representation was found up to the end of the Middle Ages, the implication being that the latter type disappeared (Daut 1972, 4:614). Daut was unique in noticing those two distinct traditions, and though his observations brought no response from

art historians, nevertheless there can be no question that the differences did and do exist. There must have been reasons for the two distinct ways artists depicted Noah and why one way dominated the other when it did. The best explanation for that division comes not from artistic traditions or from general views among theologians and artists about the nature of work and of technology in general, but from the two very different traditions of shipbuilding that had developed in Europe in the early Middle Ages.

4
European Shipbuilding Technology

Shipbuilding technique was by no means static from the end of the Roman Empire to the seventeenth century. The reputation of shipbuilders for conservatism was justly deserved, but men did make changes in the kinds of ships they built and the way in which they built them when conditions dictated adjustments. That over a period of more than 1200 years there should have been changes is not surprising. On the other hand, the persistence of some aspects of the technology confirms both the reluctance of shipbuilders to meddle with what appeared to work, and their realization of the high cost in goods and in human life that could result from even small mistakes.

Trying to establish the character and extent of change is a difficult task. The tremendous variety of vessels constructed over that long period in Europe alone makes it almost impossible even to categorize the designs of ships and the methods ship carpenters used to execute the designs. Shipbuilders were concerned with successful vessels, caring little about standardization of designs or types. Categories were created in the Middle Ages for the convenience of customs officials and merchants, and in recent years for the convenience of historians. The rig of ships, the way they were propelled, might be a good basis for classifying sailing vessels. Unfortunately all of what is known about rig comes from illustrations, which are often ambiguous, and there is not enough evidence on the rigging of classical and medieval ships to speak with certainty about types in anything more than the most general way. There is, however, more concrete information about hull design and construction, the volume and reliability of which is increasing rapidly. The improvement comes from the successful work of nautical archaeologists in the last five decades. Taking advantage

in most cases of the newly developed scuba gear scholars have found, investigated, and even reconstructed a number of ships. Archaeology reveals a great deal about the form and construction methods used for hulls, a most fortuitous circumstance, since it is the hull of the ark that artists showed Noah building in medieval and Renaissance illustrations. Using evidence from archaeology and from illustrations of ships, it is possible to categorize medieval and Renaissance ships on the basis of the essential approach to construction (Basch 1972, 15–17). Understanding such basic distinctions is critical for effectively interpreting what artists showed Noah doing when he built the ark.

Categories of Ships

Medieval ships relied on either their external skin or their internal frames for strength. Skeleton building, with internal ribs carrying the strain, was a relatively late development. During the early Christian era ship carpenters typically used shell construction, where the exterior planking not only kept out water but also maintained the structural integrity of the ship. The external planks had to be tightly and securely joined, and builders had two principal ways of connecting them. In northern Europe standard practice was to have the planks overlap and then rivet them together (Fig. 8) in what was called clinker-building or lapstrake construction. The result was a very plastic, flexible hull (Brøgger and Shetelig 1971: 77–78).

In southern Europe the approach was different. Greek and Roman shipbuilders put together planks so that they abutted with no overlap. They were connected by many mortise and tenon joints. The quality of the work was high since it took a great deal of care to cut the mortises properly and make the tenons to fit tightly. Wooden pegs, dowels driven through the planks and the tenons, held the entire hull firmly in place. The shipwright inserted the ribs after the hull was finished. He had to cut and shape the ribs to fit precisely against the shell planks already in place (Fig. 9). Roman shipbuilders used mortise and tenon construction for all parts of their vessels, even the decks. They used the same construction method for vessels of all sizes, from small skiffs to big government grain carriers. The Romans could and did build very large ships, rising in some cases to as much as 1200 tons. It was not until the sixteenth century that vessels of that size were built again. At the height of the Roman Empire, when the quality of workmanship was at its best, the tenons were placed close together and there were so many mortises that they formed an almost

continuous wall along the top and bottom of each of the planks (Casson 1959, 195, 215; 1971, 201–208).

The classical approach to boatbuilding created a rigid, stiff hull. While this type of hull might be very durable and sturdy it was not necessarily good in heavy seas; but classical vessels were built for use in the Mediterranean, where conditions were typically less rough than in the open Atlantic. Moreover, classical sailors did not go out in the winter, largely because of the navigational problems in the cloudy and stormy months of the year. Their ships did not even have to face the worst dangers the Mediterranean had to offer. In storms Roman ships could have serious difficulties, as Saint Paul learned (Acts 27:9–44). Northern European hulls with overlapping planks were, on the other hand, highly flexible. They were made more so as the length of individual planks was shortened when builders introduced the scarfing of hull planks, a fourth- or fifth-century innovation. The largest of northern boats in the classical period were much smaller than even the normal cargo carriers of the Roman Empire. Classical shipbuilding techniques were in general much superior to those of northern Europe, though some Celtic shipbuilders did produce vessels that were the match of Roman ships in the open ocean. Romans in fact seem to have used vessels of Celtic design for carrying cargoes along the northern coasts of their Empire (Marsden 1972, 118–123; 1976, 51–54). Despite that exception the Roman method of shipbuilding, at least in the opening years of the Christian era, produced the best type of ship.

Innovations in northern European shipbuilding in the first millennium A.D., most notably by Scandinavians improving the Germanic rowing barge, created a seaworthy vessel capable of long voyages across the Atlantic. In the early Middle Ages northern Europeans proved themselves capable of improving the clinker-built boat, but this capability only partially closed the technological gap with the South. At the same time Mediterranean shipwrights made important discoveries that led to the development of an entirely new and even revolutionary type of hull construction.

The great breakthrough from shell to skeleton construction came in the early Middle Ages in the Mediterranean. Whether it was Byzantine or Italian shipbuilders who first tried the idea will never be known. The process of change was a slow one, with many intermediate steps as ships were built combining both shell and skeleton construction. Such combinations continued to exist down into the twentieth century (Christensen 1973, 138–143; Greenhill 1976, 60–64; Hasslöf 1963, 166–172). A fourth-century and a seventh-century ship, both excavated at Yassi Ada along the coast of Turkey, show such combinations. Byzantine builders held on to

many of the old classical techniques. Mortise and tenon joints, for ex-
ample, held some of the planks to others, but the tenons were fewer in
number, placed farther apart, and some planks had no mortises or tenons
but were simply pinned to the internal frames (Christensen 1973, 143–144;
van Doorninck 1976, 121–123). In shell building the hull is built first and
then the ribs are added, put inside almost as an afterthought. In skeleton
construction the reverse is the case: the ribs must be set up first. Since the
builders of the Yassi Ada ships had to have the ribs in place before putting
on some of the hull planks, a major step had been made toward skeleton
building (Kreutz 1976, 104–107).

The surviving manuscripts of the Octateuch tradition show a type of
shell construction, a step along the way made in early Middle Ages. By the
end of the first millennium A.D. the conversion was complete. A wreck
found in the harbor of Serçe Liman in southern Turkey and dated to about
1020 shows absolutely no sign of mortise and tenon joints. Strength and
support for the hull came from the ribs rather than from the hull itself
(Bass and van Doorninck 1978, 119–123, 131). Shell construction rapidly
became the standard in the Mediterranean for vessels of all types. Ship-
builders found a number of advantages in the new approach, such as
shorter building times, lighter weight for each meter of length, and less
wood needed for each ton of carrying capacity. They exploited those ad-
vantages, handing on to ship owners lower costs of transporting goods.

In the high Middle Ages, in the eleventh through the fourteenth cen-
turies, European shipbuilding was sharply split. In the South, in the Medi-
terranean basin shipbuilders set up their frames first and then attached
the planks. They used this method for building all types of ships, including
oared galleys—vessels very long relative to their width—and round sailing
ships intended to carry bulky cargoes. In the North the variation in types
was much greater, but the essential building method was everywhere the
same: all vessels were shell-built. For Scandinavian ships, Viking long-
ships, and also cargo ships, the hulls were clinker-built of overlapping
planking (Fig. 10a). Ribs were added afterward. In fact, as late as about
900 the ribs of longships were not even nailed into place but rather tied to
the hull planks. The hull construction of the Scandinavian ship was the
typical form in northern Europe for much of the high Middle Ages. Keels,
descendants of the early Viking raiding vessels, became common carriers
of both goods and soldiers along Europe's Atlantic front.

Northern European builders also constructed cogs (Fig. 10b). Based on
a Celtic design, the type may predate Roman expansion into Gaul and
Britain. The cog had a hull with a flat bottom, where the planks were

placed edge to edge. The sides formed a sharp angle with the bottom and planking on the sides was overlapping. Though cogs might not be entirely clinker-built they were still shell-built, the ribs being added after the planks (Basch 1972, 41–43). This remained the case even when cogs, after the addition of a keel, came to be the large bulk carriers of the Baltic and North Seas in the thirteenth and fourteenth centuries.

Northern shipwrights also executed another and less important Celtic design, the hulk (Fig. 10c). The planks overlapped but the hull form was almost like that of a banana. The shape presented problems at the bow, since all the planks had to be brought together there in some way to guarantee strength. In the eleventh century hulks were river craft that made occasional forays out into the North Sea. They too grew in size, so that by the late fourteenth century they were in the same class as cogs. The two types were in fact merged some time in the closing years of the fourteenth century (Unger 1980, 168–171; Heinsius 1956, 213–225), yet the hulk did not lose its basic form nor its advantage of being able to ride well on a tide.

There was one last general type that came out of northern European shipyards, little bits of beach or riverfront temporarily set aside for ship construction. This was the punt (Fig. 10d), a river boat with a flat bottom and squared sides. Such boats could never be used at sea but they were effective bulk carriers along the many navigable rivers of northern Europe. The punt was also probably a Celtic design and well-suited to carry another Celtic invention, the barrel. Noah never built a punt in a medieval illustration of the construction of the ark, perhaps because it was such a simple and even primitive type that no one, artist or viewer, would believe that the patriarch would use that design for a vessel of such importance.

Work on the Shipbuilding Wharf

No matter the form of the hull or the origin of the design, in northern Europe the shipbuilder's work was very different from that of his Mediterranean counterpart, where building techniques placed different requirements on the shipwrights. The giving up of shell construction and going over to skeleton building may have been due to the rising cost of labor. Romans built their pieces of fine woodwork with slaves, craftsmen in the Roman Empire being typically slaves and shipbuilders being no exception. To use classical techniques the shipbuilder had to be highly skilled. Cutting all the mortises and tenons to fit, bending the planks exactly, and fitting the dowels to hold everything together required not only painstaking labor but also knowledge and experience. The fact that shipbuilders were

slaves does not show that they were not valued. In fact the opposite was the case. As slaves the ship carpenters would have had an overseer. He too might be a slave or a freedman, again the typical pattern in Roman industry.

In the late Roman Empire slave owners met with serious problems in acquiring slaves, since these usually came from conquered peoples and when the Empire stopped expanding the supply was choked off. In general the late Empire for various reasons seems to have suffered from population decline. With fewer people it became more difficult to find skilled workers, and it made less economic sense to devote great effort to training men to do complex tasks. Moreover, the general contraction of the economy meant that large ships were no longer in demand. To meet the pressures of declining demand and a shortage of skilled labor the solution was to simplify shipbuilding. The new skeleton construction did that.

In northern Europe, even after the breakthrough in the South, shipwrights still built the hulls of boats first. All shipbuilders got their hands dirty working with the wood and fitting it in place. Where the strength of the vessel came from the hull the shipwright had to fit each plank precisely to the one below. If it was not quite right the carpenter had to go back and rebend or reshape the plank so that it would conform (Christensen 1973, 142–143; Greenhill 1976, 73). There was some division of labor in the shipbuilding yard, especially in the construction of a great ship for a monarch. Decoration was always done by a specialist and some shipwrights had certain parts of the ship such as the stem or the keel assigned to them (Brøgger and Shetelig 1971, 76). But such division of labor was rare and only applied in special circumstances. In all cases in the North ribs could only be made and set up after the hull was in place. The ribs had to be cut to fit as well, and if the fit was not right then the carpenter had to take the rib out and shave it just enough to give a tight fit. Shipbuilding yards were typically much smaller in the North and that also militated against division of labor. The character of work, no matter whether it was building a keel, a cog, a hulk, or any of the many smaller types, meant that the shipwright had to be involved directly in the job of working the wood.

The revolution in Mediterranean shipbuilding changed the character of work on the wharf. For skeleton construction builders had to have a clear idea of the final form of the ship before construction began, since the design of the ship or boat was dictated by the form of the principal ribs. Builders first laid down the keel, followed by the stem and sternposts. After that came the principal ribs, usually three or five. Then they stretched a plank from

post to post along the ribs to show the basic outline of the final product. The builders at that point had fixed the essential character of the hull. The next step was to set up the remaining ribs and finally to cut hull planks and tack them to the ribs. It was not a simple process but once the main ribs were in place it was much simpler than shell building. Workmen did not need to be as skilled for skeleton building as they did for shell building. With planks fitted edge to edge in the new method there was always a danger that there might be some gaps in the hull where the planks were not carefully fitted one by one to the planks just below them. Caulking the seams saw to that problem in part and once in the water the wood swelled, which minimized possible gaps from inaccurate work. Thus the chance of a leaking hull was hardly greater than with the old building method. The caulkers who now did the final work on the hull were even less skilled than the ship carpenters, among whom there had also been a loss of skill. All but one worker on the wharf was less skilled than the craftsmen of the Roman period: the overseer.

The overseer increased rather than decreased his skills in the early Middle Ages. He changed from being an organizer of work, a foreman, to being a designer. He chose the outline of the ship and, by directing the proper cutting and fitting of the ribs, guaranteed that all the efforts of the carpenters would result in a seaworthy vessel. As ships grew in size over time and as skeleton building was completely adopted, the distinction between the designer of the ship on the one hand and the ship carpenters and caulkers—the workers—on the other became greater. The skills demanded of the workers as opposed to those of the boss were far fewer. The changeover to skeleton building did solve the problem of a shortage of skilled labor in the late Empire but the change also created a new worker on the wharf, a man with new responsibilities. The designer, the director of shipbuilding operations had already appeared in Italy by the eleventh century and would be a common figure in the Mediterranean throughout the Middle Ages. It was not until the fifteenth century, however, that northern Europeans began to build their ships in the new style, and only then did the shipbuilder-designer appear there as the central authority in the shipbuilding process.

The Transmission of Technology

Up to the fifteenth century the form of hull construction divided Europe between the North and the Mediterranean. There was nevertheless

some contact between the two shipbuilding traditions: northern European ships visited the Mediterranean, such as when carrying Crusaders to Palestine in the twelfth century (Asaert 1974, 25, 33–34). Those ships, of Viking and of cog type, appear to have had little influence on Mediterranean shipbuilding. And though a number of northern shipwrights must have travelled to the Mediterranean and made it back to their homes, neither is there any sign of southern influence on northern shipbuilding.

In the early fourteenth century the sharp division began to erode as certain northern types gained recognition in southern waters. Cogs, perhaps brought into the Mediterranean by Basque pirates, were taken over by southern shipwrights, who kept the essential features of the design but changed the method of building the hull. With some modifications in the rig the new *coca* proved to be a highly successful bulk carrier, easily defended because of its size and height above the level of the water. Experiments made with the rig of these new bigger ships in the fourteenth century resulted in the development, probably in the years before 1400 and possibly in Portugal, of the full-rigged ship.

The new type had a hull form similar to that of the modified cog and was entirely skeleton built. It carried three masts, each with a single sail. The mainmast was by far and away the largest and carried the major driving sail, which was square. At the stern was a small mast with a lateen or triangular sail. At the bow was another small mast, which carried a square sail, there to balance the mast at the stern and to help in manoeuvering (Fig. 11). Square sails were easier to handle than lateen sails. They could be easily extended or taken in and served to drive the ship when the wind was blowing in the direction the captain wanted to go. Lateen sails made it possible to sail closer to the wind. The combination of the two types of sails in the full-rigged ship gave the type greater flexibility than any of its predecessors (Friel 1983). Skeleton construction added all its advantages, and the outline of the hull, borrowed from northern Europe, guaranteed that the new type could sail on the open ocean. Over the next four centuries builders refined and improved the full-rigged ship. From the fifteenth through the eighteenth century—that is until the age of clipper ships and of steam propulsion—the essential features of large ocean going ships remained the same. Because of its many advantages northern Europeans in the fifteenth century took a strong interest in the new type. Vessels from the Mediterranean had been making regular commercial trips to England and the Low Countries since around 1300. When southern Europeans appeared with ships that were clearly superior even in the home waters of sailors in the North, curiosity turned to imitation.

It took some time for shipcarpenters along the shores of the North and Baltic Seas to learn how to build in the Mediterranean style. For example, the Duke of Burgundy had to bring in Portuguese shipwrights and set them to work near Brussels in 1439 in order to get skeleton built ships. Shipwrights in Brittany seem to have been the first in the North to learn the novel methods. They then transmitted the technology in person further to the north and east. In about 1460 a Breton went to the Netherlands coastal province of Zeeland, to the town of Zierikzee, to build the first smooth hulled boat there (Unger 1978, 32–33, n. 16). Soon after that examples of the full-rigged ship made their way to the eastern Baltic, which led to efforts there to recreate skeleton building.

The old method of building the exterior hull first never completely disappeared from the North (Unger 1980, 222–224); and clinker building remained in common use for many types of fishing vessels and other small boats even into the twentieth century. Shipwrights were often reluctant to give up well-established and successful methods. Learning the new technique well could prove difficult, and there was always the concomitant risk of costly failure. Some shipbuilders were fortunate in having Italian shipwrights brought in to demonstrate skeleton building to them, such as the men constructing warships for King Henry VIII of England. This convenience was the exception, however. Most northern shipcarpenters had to learn from inspecting ships made by using the new technology and from their own experiments. The combination of dissemination of knowledge by individual technologists and by experiment proved, in a surprisingly short time, highly successful.

The Final Results

By the sixteenth century, despite all the difficulties of adaptation, skeleton building was typical in northern Europe for large trading and fishing vessels. Northern Europeans adopted the method that had revolutionized Mediterranean practice in the early Middle Ages rather quickly because it came in the form of the clearly superior full-rigged ship. By the late sixteenth century in England, for example, frames were designed, carved, and positioned in advance, before the hull planking went on. This was true skeleton building (Basch 1972, 39). It became possible to write about how to build a ship expecting an audience to understand what was written, and to be able to put the guidance into practice. The change in shipbuilding methods came at the same time as Europeans first began to write about and publish handbooks on specific technologies such as mining and metal-

lurgy, handbooks with abundant and accurate illustration. The first printed works on shipbuilding and contemporary manuscript works confirm the presence of true skeleton building (Hasslöf 1972, 61–62). By 1600 European shipbuilding thus had a common method, a common approach to hull construction and to rigging, no matter where it was practiced in northern Europe, in the Mediterranean, and for that matter anywhere in the world.

The results for the organization and operation of shipbuilding wharfs in northern Europe were presumably the same in the fifteenth and sixteenth centuries as they had been along the shores of the Mediterranean a millennium before. An increasing distinction did appear between the builder who was the designer and the men who worked on the wharf, shaping and fitting wood. The pattern was more obvious in the seventeenth century and certainly dramatic by the eighteenth.

Rembrandt, for example, in his portrait of a shipbuilder from 1633, now in the Buckingham Palace collection, paints the man at work drawing sketches of the ribs of ships (Fig. 12). The designer hands the product of his work to his wife, who seems about to leave the room, about to take the sketch off to someone else. For the seventeenth-century artist doing a portrait of a shipbuilder, choosing presumably the most representative and important job of his trade, the decision, most likely taken in concert with the subject, was to show the builder designing the central frame for a vessel. By the eighteenth century in the Netherlands shipbuilders showed signs of entering the aristocracy, possessing coaches and sending their sons off to schools. Work on the wharf was handled by a foreman, so that the shipbuilder could be free to design ships or to see to his investments in land, the wood trade, and any other related field (Unger 1978, 95–97). The social distinction between ship carpenter, the worker on the wharf, and shipbuilder, the designer, investor, and entrepreneur, began in the sixteenth century with the adoption of skeleton building from the Mediterranean. The large amount of repair work and the continued construction of small vessels in the old style did militate to some degree against the trend toward a social distinction between worker and employer, but by 1700 the craftsman had a very different status from that of the businessman.

With the domination of shipbuilding by skeleton building the designer performed a distinct and critical function, one which put him in a class apart from woodworkers, caulkers, and repairmen. The distinction was a direct result of technical change in the industry. This reorganization on the wharf, whether in the early Middle Ages in the Mediterranean or in the fifteenth and sixteenth centuries in northern Europe, did come to be

reflected in art. Since Noah was the most commonly depicted shipbuilder, and for some time in the Middle Ages and the Renaissance the only shipbuilder depicted, the change in work arrangements in shipbuilding showed up in illustrations of Noah building the ark.

As has been emphasized in the preceding chapter, in the eleventh century there was already a distinction between northern and southern Europe in the way artists dealt with Noah, a distinction that did reflect essential differences in shipbuilding technology. The distinction existed in, for example, the Salerno ivories on the one hand and the Bodleian Caedmon and the Aelfric Paraphrase on the other. It existed despite the Cotton Genesis tradition that they shared.

In the Roman Empire, presumably an artist showed a shipbuilder as an overseer, as a man who directed the work of skilled artisans, but artisans who were slaves. In the fifth century, when artists first started to show the ark as a ship, wharfs were still producing vessels with mortise and tenon joints, with something like typical classical shell construction, thus retaining the organization of work as it had been for centuries. Classical practice or at least late-antique practice on the wharfs probably served as the source for those artists' treatment of Noah; they thus depicted Noah as a director or overseer rather than a worker, as in the case of the Cotton Genesis.

English manuscript illustrators of the eleventh century chose to change Noah into the wielder of an ax. They drew the builder of a clinkered boat working as they saw shipbuilders around them working in their own day. Once contemporary techniques were established as a source for the artist, those techniques could and did dominate established artistic tradition.

There was a tendency over time in the Middle Ages, for philosophical among other reasons, to make depictions of all things including Noah more realistic. During the Renaissance the trend created serious problems both for scholars explaining the story of Noah and for artists illustrating it. Artists logically turned to known shipbuilding practice to gain realism and to guide them in introducing novelties, in determining the ways in which they would deviate from what had been done before. The path of least resistance was always to follow what previous artists had done, a choice that assured acceptance, at least before the Renaissance, and minimized effort. When there was pressure for novelty, and such pressure mounted through the later Middle ages and especially in the Renaissance, artists often minimized their effort by turning to contemporary technology for inspiration. The drive toward realism took away any doubt in the artists' minds that they had made the right choice. It was, however, long before the Renais-

sance and even well before the Renaissance of the twelfth century that artists came to rely on contemporary technology as a source for depictions of Noah.

From the late Roman Empire on and throughout the Middle Ages the state of shipbuilding technology was at any time a critical influence and source of inspiration for Noah illustrators. That was certainly the case in eleventh-century England where artists broke sharply with tradition. This pattern continued. With exceptions—and they were few—the pictures of Noah follow closely the development in the design and construction of European ships and the changes in social relations in the industry that grew out of developments in ship design.

5

Northern Europe in the High Middle Ages

Illustrations of Noah building the ark were most common in the twelfth, thirteenth, and fourteenth centuries. The illustration of books and specifically of the Bible was firmly established by 1100 and once established the tradition was imitated, sometimes very precisely. The images were to aid those who had trouble reading; in the twelfth century there was a rise in the use of illustration to tell the Bible story, to supply a narrative. Artists took the words literally and the pictures served to replace words more than to illustrate what might have happened or to enhance or to embellish the text. This tendency first appeared in tenth-century Britain, where manuscript illustration proved to be somewhat revolutionary. The use of pictorial narrative became part of the general pattern in the development of Romanesque art throughout Europe. "The artist's interest was evidently more riveted on the portrayal of words than on visualizing the actual situation" (Pächt 1962, 57). The tendency toward pictorial narrative helps to explain why artists continued to draw the ark as a ship and why they came to rely on contemporary shipbuilding as they knew it as a source for the way they dealt with Noah.

The Cotton Genesis tradition, usually transmitted through the eleventh-century English series of Old Testament manuscript illustrations in the Bodleian Caedmon and the Aelfric Paraphrase, had a deep effect on how artists showed Noah building his ship. Despite the importance of the artistic tradition and despite the temptation to follow not only the general form but also the specific detail of those earlier works, illustrators did not simply repeat what they saw in the two manuscripts or in other portrayals in the Cotton Genesis tradition. They did innovate, making changes in depicting Noah, in the way he worked and in the ship. The deviations and variations

from established artistic convention show ways in which the technology of shipbuilding in northern Europe changed from the eleventh through the fourteenth century. The deviations and variations also show very specifically how artistic expression changed in the period.

Among theologians there was little novelty in discussion of the meaning of the story of Noah and the Flood. In the High Middle Ages the allegorical methods of Philo of Alexandria and Augustine continued to dominate exegesis and literature, confining discussion largely to morals and theology. Thus the interpretation of the ark as a type of the Church and Noah as prefiguring Christ remained fixed, though there might have been some details to add or discuss. There were some practical questions Augustine himself and other Church Fathers had raised but not resolved: whether the ark could have carried all those animals; what was the exact shape of the ark; what kind of wood Noah used; how Noah fed the animals. Originally the answers were sought to convince pagans that the Bible was accurate, that Holy Writ was true history and thus as reliable in fact as any history (Allen 1963, 66–73). Once these questions were set aside the opportunity existed for speculation. Artists speculated just as much as scholars did, combining imagination with their knowledge of technology to create different representations of the ark. In the process they gave some hints of their views of technology.

While the portrayal of the ark and shipbuilding methods changed, the depiction of Noah himself remained rather constant. He was always old, as was consistent with the Biblical description, typically bearded, often surrounded by a nimbus, wore sandals, and had his hands covered or draped. His clothes varied not only because styles of art and dress changed but also because artists illustrated different stages of work on the ark. Noah was often slightly bent both to show him at work but also to emphasize his obedience as well as his act of penitence. The changes in the understanding of work that occurred in the thirteenth and fourteenth centuries were perhaps subtly shown by slight changes in the treatment of Noah the man, as well as Noah the shipbuilder. In northern Europe manuscript illustration was unquestionably the most common place where artists showed Noah building the ark.

Romanesque Images

A very simple illustration appears in a Genesis probably done in Millstatt and if not there certainly in some nearby Austrian center in the 1160s (Klagenfurt: Museum, Landes, VI, 19, fol. 21ro.). The Millstatt Genesis is

bound with a *Physiologus,* a medieval zoology. There are forty-seven illustrations spread throughout the Genesis text, illustrations intended to help the reader by offering a parallel pictorial narrative. The Bible is in German verse, meant for an audience not able to read Latin (Kracher 1967, 11–15, 29). It is in fact the earliest example of a German language manuscript with illustration that runs through the entire narrative.

The similarity of some aspects of the Millstatt Genesis illustration to the mosaics at St Mark's in Venice, in addition to a similarity to English manuscripts that include a pictorial narrative, has led to the work being placed in the Cotton Genesis tradition (Henderson 1962, 172–173). The connection with that artistic tradition may in fact have been through an eleventh-century English manuscript, one possibly imitated by other artists. This could help to explain the form of the Noah picture.

The artist tended to collapse the story of Noah using few pictures and not dividing the action (Voss 1962, 1, 68–73, 103–104, 109–117). God, nimbed, appears from a cloud on the right with his right hand extended in the direction of Noah. The hand of God coming out of a starry arc, the source for this God and for many others in depictions of Noah building the ark, has been traced to a convention of third century Jewish art (Weitzmann and Kessler 1986, 17, 23, 41). In the same scene Noah stands holding an ax that is much too big for him. He is working on a large piece of lumber set up on two sawhorses (Fig. 13). The scene, including the sawhorses, was one often repeated by later artists. Noah is completely alone in this sparse sketch, working away with his oversized tool.

Another twelfth-century manuscript included an image very different and seemingly unconnected with any of the previous illustrations of Noah building the ark (Dresden: Lib., Secundogeniturbibl., Miniature). Two men are shown working with long-handled axes. The man on the right is much the larger of the two and is therefore presumably Noah. He also has long hair and a beard. His ax is simpler, with a shorter blade than the one in the hands of the smaller man. The long-handled ax is a significant advance over the one shown in the Caedmon manuscript and in fact looks much like a modern ax (Moll 1930, 164–166). The two men are working not on a ship but on a triangle, which may be the result of the artist's effort to show a pyramid. Origen thought the ark was pyramidal, perhaps the source for the choice. The triangle is called "*ARCA NOE*" and is then divided into a series of what may be small rooms. Next to the object of the labor is a second inverted triangle divided into layers. The names given to the five layers indicate that these are divisions of the ark; some early writers did say the ark had five decks (Allen 1963, 71). Though the ark is not a

ship in the manuscript and though this may be a return to the pre-fifth-century vision of the ark, there is nevertheless no question that Noah is a workman doing the same job as the other workman in the illustration.

Origen's speculation on the ark as a pyramid was discredited, at least in theological circles, by no less preeminent a man than Hugh of Saint Victor. He devoted some of his considerable talent to producing two treatises on Noah's ark, the more important and extensive being *De Arce Noe morali et mystica* (PL 176. 627–629). Written about 1125, it was one of his major mystical works. Before going on to literal exegesis, Hugh discussed the geometry of the ark to show the beauty of its proportions. He contended that the ark described by Origen was unseaworthy: a window in the side would be, he claimed, impossible. The ark seemed to him to look like a house, rectangular with a pitched roof and a total of five stories, the top one just under the roof designated for Noah and his family and the birds (Allen 1963, 72). Each of the numbers in the description of the ark had a specific meaning for him.

Hugh was as much interested in the invisible ark, however, the ark as a spiritual building symbolizing the Church and the body of Christ (Hugh of Saint Victor 1962, 11, 25–30, 59–70, 73) as he was in the proportions. The symbolic value of the ark and, indeed, of the entire story of Noah, was for him much more interesting. In discussing the moral as opposed to the physical ark he followed the New Testament and Augustine. Yet Hugh's geometrical diversion obviously had an effect on illustrators since more decks did appear, and pitched roofs turned up in thirteenth- and four-teenth-century illustrations.

Hugh of Saint Victor continued in the tradition established already by the early Fathers and especially Augustine of giving explanations for how the simple Bible story could possibly be an accurate description of historical events. The allegorical meaning of Noah or of the ark presented no problem for him. He and other theologians after him in the twelfth and thirteenth centuries accepted what they learned from Jerome and Augustine and did not bother to go further, though Hugh did advance somewhat on Origen's explanation.

Noah in Psalters

By around 1200 it became popular in England to include a series of Old and New Testament scenes before the pslater text. Thirteenth-century Bible manuscripts offered an opportunity to depict Noah, so that, beginning in England, the pattern spread to the Continent and especially to

French manuscript illumination (Morgan 1982, 61). Similarities in scenes suggest not only common ancestry but direct borrowing. A Bible from early in the thirteenth century (Manchester: John Rylands Library, fr. 5. Bible, fol. 13vo.) has a scene much like that in the Millstatt Genesis (Fig. 14). God is on the right, cross-nimbed, holding a book in his left hand. With his right he points to a piece of wood sitting on a pair of sawhorses. Noah, on the left, holds the piece of wood with his left hand and swings a large polless broadax with his right. The blade of the ax is curved and has a relatively short handle. The difference in length may explain why Noah can wield the ax with only one hand. The drawing suggests an improvement in the tool over the previous one hundred years. Though the ax is raised as if he were about to bring it down on the wood, his attention is fixed on God. Although Noah is almost the same size as God there is a clear difference in stature.

The increasing popularity of psalters for individual devotion was a small part of the general trend in Christianity in the twelfth century. One result of that popularity was a comparatively large number of pictures of Noah in action, working on timbers for his ark. A psalter illustrated for Geoffrey Plantagenet, a bastard of King Henry II who was Archbishop of York from 1191 to 1212, is just one example. Its illustration presumably comes from the same Cotton Genesis tradition (Leiden: Lib., Bibl. der Universiteit, B.P.L. 76 A., fol. 10vo.). King Louis IX of France is supposed to have used the book when he was a boy and thus is referred to as the Saint Louis Psalter. There are twenty-three pages of miniatures with fourteen Old Testament and thirty-two New Testament scenes. "Iconographically, the Old Testament pictures . . . are unusual, but the New Testament cycle fits with those of other contemporary Psalters" (Alexander and Kauffman 1973, 68–69).

The work is coarse and undistinguished, famous because of its former owner rather than for its artistic merits (Boase 1953, 280–281). The style has been described as transitional from Romanesque to Gothic: solemn and monumental figures predominate and faces are modelled in the Byzantine manner. At the same time, however, there are signs of the more naturalistic style typical of Gothic illustration, which became the dominant tendency in thirteenth-century illustration (Alexander and Kauffmann 1973, 67). By the third quarter of the one-hundred-year period there was a clear "trend towards a greater degree of naturalism both in the treatment of the human figure and in the representation of the visible world" (Alexander and Kauffmann 1973, 67). The interest in nature and natural phenomena as well as in the mechanical arts that turned up among theo-

logians in the twelfth century came to have an effect, even if very slowly, in the years after 1200 on depictions of the technology of shipbuilding in the form of pictures of Noah building the ark.

In the Saint Louis Psalter the story is conflated, but in this case Noah appears twice in the same panel, once on the left speaking to God and again on the right at work on the ark. Cain's killing Abel is shown in a top panel of the same page. God with a nimbus emerges from a cloud and points with his left hand, giving instructions to Noah. In his right he seems to have a scroll, and Noah looks up at him in an attitude of reverence. Noah wears a loose fitting cloak held by a clamp at the shoulder when he listens to God, but discards the cloak while working. He works on the piece of wood set up on one support on the right; presumably a second support outside of the frame holds up the other end of the piece of lumber. Noah uses both hands to wield the T-shaped broadax with a short handle— by this time a standard shape (Fig. 15).

A psalter probably produced in the last decade of the twelfth century for Ingeborg, the Danish princess who married King Philip Augustus of France, is in the same tradition of insular illustrated psalter manuscripts. It has a series of miniatures in the opening folios, with juxtaposed scenes from the Old and New Testaments (Musée Condé, Chantilly, Ms 1695, fol 105r), but there is no picture of Noah. It was done between 1193 and 1195 possibly in the bishopric of Noyon, at Tournai and/or Saint Quentin. The two artists who did the illustrations drew their inspirations not only from contemporary English illustration but also from Byzantine and German art. England seems to have been, in this case as in many others, the agent for the reception of Byzantine style and the transmission of eastern forms to the Continent. In the Ingeborg Psalter the Byzantine influence was in part indirect, the mosaics of Sicily serving as an intermediate stage. There is a mosaic influence in the background of the psalter illustrations, for example. The artists were highly successful in bringing together a number of different traditions, and the work probably represents the high point of the style of Philip Augustus (Deuchler 1967, 23, 108–147, 167). The older of the two artists is also responsible for the initials in another manuscript done before the Ingeborg Psalter and so probably from the 1180s. Much of the same influence can be seen in the two works, although in the Ingeborg psalter the figures are much more in proportion and more finely depicted (Deuchler 1967, 116–90. The picture of Noah working on the ark in the earlier pslater (Pierpont Morgan Library, Ms. 338, f. 105r) is certainly not as grand as that in other psalters. The location in the initial letter A of the Twenty-seventh Psalm gives little scope for the artist. The Noah,

however, is similar to a reduced version of the Noah who appears in more lavish and larger illustrations in the opening pages of other psalters (Fig. 16). He stands with one foot on the ground and the other resting on the gunwale of the bow of a ship. Only the forward half of the vessel is completed and there is no stern, not the way shipbuilders went about their work in the twelfth century. The vessel has a sharply curved bow ending in an animal's head, all very reminiscent of Viking ships and contemporary keels. Behind Noah is a large balk resting on a sawhorse. The arrangement is exactly that which appears in English manuscripts of the previous century and in the Millstatt Genesis.

Noah himself is not dressed in quite the usual way. He has a hat or rather a cap that covers his curly hair. His tunic is short, just reaching his knees, but rather full, draping over the upper part of his body. His right hand seems to be resting on his hip, while in his left hand is the standard ax of northern European illustrations. The frequency with which that ax appears suggests that not only did shipbuilders use such tools but also that they were identified with and even recognized by such a tool. Much later, in the seventeenth century, journeymen ship carpenters in Amsterdam were called "*bijltjes*", those who used small axes, and the thirteenth-century viewer may have identified the ship carpenter with that tool as much as did the Dutchman of the Golden Age.

In the five subsequent pictures of the ark in the manuscript (f. 107v, 111r, 122r, 132r) the same vessel complete with animal's head is repeated. The regular dark spots along the line showing where the planks overlap suggest rivets to hold the planks in place. Inside the ark in each case is a round building with a door and a dome, the later having windows just under it. While the picture might not be an accurate one of how a contemporary ship was built, the illustrations fit a pattern already well-established.

A Psalter that belonged to a member of the Huntingfield family (New York, Pierpont Morgan Library Ms. 43) seems closely related to the Saint Louis Psalter. It is from a slightly later date, about 1210–1220. It begins with a calendar, which is followed by a series of forty full-page miniatures divided into two or four compartments. The scenes vary only slightly from those of other programs such as those found in certain mosaics in Sicilian churches. In fact early Gothic manuscript illustration in England, from about 1220 to 1285, borrowed from the monumental art of the fresco. Over time the page rather than the book became the object of illustration, which each scene, each work taking on a character of its own. Early Gothic illumination in England displays a vigorousness and freshness that was missing in the earlier Romanesque style, as well as a greater reliance on ordinary human life for inspiration (Turner 1979, 9, 31). The depictions

of Noah building the ark are consistent with that trend, with even greater detail over time in scenes of the shipbuilder at work. Such characteristics were obvious not just in England but also on the Continent, where English influence was strong.

In the Huntingfield manuscript the eighth scene shows Noah building the ark. The previous scene, the one above, shows God reproaching Cain and Lamech shooting Cain. The following scene, on the next page, depicts the Flood and Noah receiving the dove. The story of Noah ends in a third illustration, that of Noah's drunkenness. The artist probably developed out of the Oxford workshop, but certain features of his work derive from the workshop that produced the Leiden psalter. It has been suggested that the Huntingfield psalter came from East Anglia (Rickert 1954, 131, n. 10), the source of a number of later illustrations of Noah building the ark. "The figure compositions are animated in narrative with much use of gesture and glance to create this effect" (Morgan, 1982: 78). The style in general falls between the monumental forms of around 1200 and the energetic style of later in the thirteenth century (Morgan 1982, 77–79).

Noah is alone while working on building the ark (Fig. 17). The vessel is held in place by four forked stanchions, which serve as something like sawhorses. Though supports exactly like those are not common in medieval illustration it is more than likely that what the artist shows reflects what in fact shipbuilders used. Noah is placed far to the left holding a short-handled but very large ax with the blade in his right hand and the handle in his left. It is doubtful that any ax was used that way. He is trimming a plank on the hull. The ship is half built, the bow complete and the stern half just started. There is no indication that any vessel was ever built that way. The ship has the form of a contemporary keel: an animal head adorns the bow, one that is rather extensively decorated, even down to having some ears. The scene has an interior frame that serves to give some depth, but it is not exactly rectangular and in places becomes confused with the lines of the ship. The hull is made up of many small planks, additional planks, cut to size it seems, are lying on the ground underneath the ship. While this is understandable the structure inside the hull is not. The artist has put a building inside the ship, with the requisite door and window, and there is something that may have been intended as a dome on top of the building. A large beam or plank extends down from the building on the left, as if it were there to support that building while the shipbuilder completed the stern of the ship.

In the next picture the completed ark is riding on the sea. It is double-ended, having animal heads at both bow and stern. The hull planks are punctuated with black dots suggesting rivets or nails. The building inside

the ark is similar to, but by no means exactly like, the building in the construction scene. It has lost something of its triangular shape. Noah stands in the doorway under an arch, dressed somewhat more grandly than he was while working as a shipbuilder. In the former panel Noah wears a tunic that goes to the knee and is, compared to the garments of other figures in the psalter, close-fitting. The neck is open and the sleeves tight to the arms; his hair is long and his beard short. His gaze is intense, his concentration on the job of building the ark complete. Devotion and steadfastness join obedience and probity, as Noah's symbolic complement.

The Munich Psalter, written and illuminated in Gloucester before 1222, has the same general composition of two panels on the same page. In this case Noah building the ark is in one and the construction of the Tower of Babel is in the other. Exceptionally, the artist leaves out of his pictorial narrative the Flood and Noah's drunkenness. Despite its origins the manuscript shows Noah building the ark in a different way from other insular manuscripts of the same period. Indeed this manuscript is a major and inexplicable exception to the general pattern of the illustration of shipbuilding in northern Europe.

On the left of the picture God, cross-nimbed, commands Noah to build the ark, holding up his right hand and pointing a finger at Noah. In his left he holds a scroll that has written on it a quotation from the Vulgate, part of the command to Noah. The bearded Noah wears a simple long tunic with a cloak draped over his shoulders, held by a clasp at his neck. He has the usual beard and long hair. He is, if anything, slightly larger than God. He stands facing forward with his head turned toward God, his right hand raised in front of him, and—oddly enough—pointing with his open left hand to the ship under construction. Three men are working away building a boat. Only the forward third of the vessel is shown, but from the way the planks are brought together at the bow it appears to be a hulk. One worker stands next to the boat wielding an adze. A second is in front of the vessel with a claw hammer in his right hand that he is using to drive nails or dowels into the hull planks. The man in the lower right corner of the picture has a four-legged trestle in front of him with a piece of wood on it. He is using a one-handed polled T-shaped ax, standard except for the sharply drawn up points at either end (Fig. 18).

The composition is similar to that in the Saint Louis Psalter, with the difference that in this case the work on the right is done not by Noah but by three other men. The tools are consistent with shipbuilding equipment of the thirteenth century; and the design of the ship is consistent with that of thirteenth century vessels. If there was some influence in this illumina-

tion from southern Europe it is hard to identify: Noah is not strictly the overseer directing the work on the wharf, but neither is he a workman. It is as if the artist, in an effort to compress the story, did not bother to include Noah as a workman and only showed him receiving instructions. The exception to the general pattern of northern illustrations is surprising but the difference may be more apparent than real.

Noah appears twice in an illustration in the *Cursus Sanctae Mariae,* a book of hours produced at the Premonstratensian Monastery at Louka in Moravia in the first thirty years of the thirteenth century (Fig. 19). The book, prepared for private worship for Saint Agnes by her aunt, has a Latin text accompanied by rubrics for the illustrations in a German dialect. The illustrator may have been subject to influence from the earlier Salzburg school or, more likely, from earlier English manuscripts (Mellinkoff 1970, 67). In this case Noah looks up, his right hand raised with two fingers extended. His left hand is open with the left arm close to his body. The building next to him is much like depictions of churches in Armenian art. It is presumably meant to represent the ark. It is similar to the ark on the doors at Sainte Chapelle in Paris done some fifty years later.

The second Noah is wearing different and much closer-fitting clothes. He is working on a balk held in place by a primitive sawhorse that is, in fact, just two forked sticks somewhat like an arrangement in slightly earlier English manuscripts. Noah wields a large two-handed ax with the standard broad blade of the period. No man could have possibly worked on the piece of wood in the way the artist has drawn the picture. The tendency toward realism was only a tendency and seems to have had less effect in central Europe than in the West.

Another thirteenth-century psalter (Oxford: Bodleian Lib., Canon. Liturg. 393), probably from the Low Countries, like many of its contemporaries has a number of miniatures from the Old and New Testaments. In this case there are captions for the pictures and in French (Pächt and Alexander 1966–1973, 2:104). The form of illustration may suggest an Italian provenance, but that seems extremely unlikely. The story of Noah is conflated, as with other illustrated psalters. The hand of God extends from an arc of heaven. Noah, seated and with a nimbus, his left hand raised and an ax in his right, looks toward God. Having Noah seated is extremely rare in any illustration. He seems more interested in the job at hand than in the announcement from heaven and so the work itself, compared to earlier illustrations, has taken on a greater importance. Noah is about one-third again as large as the other figures. He has a full mustache as well as a beard. The ark is, oddly, a box with windows and so not a ship at all, which

may suggest a connection with a pre-fifth-century artistic source or a closer reading of the Biblical text. There are three other figures in the picture, two using a bow saw (Fig. 20). Noah appears comfortable sitting on his decorated bench, but even though he is seated he is still without question a workman.

Another psalter, this one from the northeastern corner of France and dated to about 1235, shows Noah at work on building the ark (Vienna, Österreichische Nationalbibliothek, cod. ser. n. 2611, f. 6v.). Though the psalter is illustrated for the most part in the new Gothic style, the initials are not done in the up-to-date way of contemporary Paris (Branner 1977, 101–102). The psalter has a calendar preceded by fourteen illustrated pages, each with six medallions arranged in two columns. The circles have scenes from the Old and New Testament (Thoss 1978, 72–74). An entire page is devoted to the story of the Flood, beginning in the upper left with a scene that again shortens the story by depicting God speaking to Noah while the latter is working on a piece of wood (Fig. 21). God appears with a nimbus on the right, pointing with his left hand at a piece of wood that sits on supports or even a table. Noah is looking at God with an expression of concern on his face. At the same time he wields the typical heavy two-handed ax, dressing the plank. The gown he wears is close-fitting and far from elaborate. Noah is a workman. The boat that he builds appears in the next medallion with four people, one of them certainly being his wife. The vessel is an open boat in the style of a hulk and is without chambers or windows.

Psalters done in Paris in the time of King Louis IX typically had cycles of Old and New Testament pictures. A number, including one done not long after 1253 (Los Angeles, J. Paul Getty Museum, L VIII 4; ex-Dyson Perrins 32), included illustrations of Noah building the ark. The king of Hungary, Wenscelas III (1301–1305) may well have been an early owner. It is possible that it was two manuscripts that were combined, one having fourteen pages filled with a Genesis cycle (Branner 1977, 228). On folio nine verso there are five scenes from the life of Noah, beginning with an image with the caption "Ci fet noel larche." The series continues on folio ten recto with four more scenes ending with the curse of Noah. Each page has a total of eight scenes, with quarter circles at the four corners, two half circles at the side and two full circles in a central column. The psalter is both in style and format connected to the Saint Louis Psalter and the Ingeborg Psalter (von Euw and Plotzek 1979–1985, 1:322–329).

In this case as in so many others Noah builds the ark alone. He is standing inside the vessel or just behind it wielding an adze. The boat is double-

ended, with both bow and stern ending in a turn similar to a scroll and one end, probably the bow, is slightly narrower and smaller than the other. The shape is roughly that of a contemporary hulk. Noah is out of proportion to the boat. He has neither long hair nor a beard, but he does wear a close-fitting tunic (Fig. 22). The completed vessel appears in the next five scenes and in its completed form there is a building with three arches sitting inside the boat. There are never more than three people shown on board, one of whom is Noah's wife, depicted in one scene contemplating the gangplank before climbing on board.

Noah Building Woven Arks

Another Paris manuscript illuminated about the same time follows the pattern typical in northern Europe (New York: Pierpont Morgan Library 638, fol. 2vo.). The miniature shows the entire story of the Flood in four separate sections, each of equal size. The arrival of the dove, the departure from the ark, and the offering of burnt sacrifices occupy the last three portions. In the first God commands Noah to build the ark, and in the same picture Noah works on the ark. God issues from the clouds with a crossed nimbus. Noah looks up at him with hands open and outstretched. He wears a flowing robe over a darker garment. The second figure of Noah has discarded the robe, exposing a short, belted tunic. He concentrates fully on his job and wields a two-handed polless T-shaped ax, working on a piece of wood set up on a trestle. He is obviously shaving down one side of the piece of wood, perhaps to fit it inside the hull, about a third of which appears on the right. On the ground lie a spoon auger with curved handles and a hatchet. The second panel, showing the ark riding on the waters of the Flood, makes clear that while the building inside the ark is constructed with lumber in the usual way the hull is made up of pieces of wood woven in a lattice (Fig. 23).

The earliest example of an ark with a woven hull is from a capital at the Church of the Madeleine at Vézelay dating from the first half of the twelfth century (Vézelay: Church Madeleine; Nave: Capital: South side, pier 3). The medium and the position of the sculpture severely confined the artist, so that the result is a far cry from the efforts at more realistic arks that turn up in manuscript illumination of the same period. On the left is a man with both hands controlling a broadax. On the right is another man, probably Noah, with his head and the upper part of his body inside what looks much like a bird cage or wicker basket. Noah seems to be weaving the ark, passing reeds in front and in back of two posts that

rise from the base of the construction. The reeds seem to be fastened to the posts, which form the corners of the box-like cage. There is a sloping roof as well. A completed ark of similar woven construction can be found in the Cathedral of Saint Lazare at Autun, done by an artist who also worked at Vézelay (Horrall 1978, 207).

Even if the Hebrew Bible did say that Noah built the ark with reeds, medieval artists and exegetes in the Latin West probably did not know it. The Vulgate was virtually their only source and the Latin Bible gave no indication whatsoever that reeds might have been used. In both pictures and literature, however, the ark was built like a medieval house: a builder first set up timbers, next wove wands or twigs to those frames, and then covered the walls inside and out to make them waterproof. The fourteenth-century English poem *Cursor Mundi* is explicit in its description of building the ark with wands wound back and forth. After this was finished Noah, so the story went, was to cover the vessel with pitch and then plaster it inside and out. The literary source may have taken its inspiration from art, the opposite of the norm in the Middle Ages (Horrall 1978, 202–203).

Apparently, as is obvious from a small surviving fragment, the ark of the Cotton Genesis was panelled. The exterior with all the small pieces of wood gave the impression of a woven surface. First perhaps in Vézelay and then in the Pierpont Morgan Library manuscript the error of interpretation of a Cotton Genesis illustration was repeated (Horrall 1978, 202–204, 206–208). Though artists who depicted woven arks were not recreating shipbuilding practice, they were recreating house building practice. From the tenth century on a number of artists showed arks as ships with a hull and some fanciful house or palace set in the middle of the vessel. Thus for the building inside the artists drew on contemporary house-building technology, just as they drew on contemporary shipbuilding technology to depict Noah's work on the hull.

Noah in Sculpture

Three English church sculptures, one from the twelfth century and two from the thirteenth, show Noah building the ark. The medium imposed strict limitations, but the results are nevertheless very similar in many ways to manuscript illustrations. They are consistent especially in their representation of the technology and of the shipbuilder's role. The frieze across the facade on the west exterior of Lincoln Cathedral, dated to the 1140s, has a Noah (Fernie 1977, 26–27; Saxl 1954, 47–49, 57) who

lectures a smaller man holding a hatchet. Noah's right arm is extended and he points his index finger at the smaller figure's head. In his left hand Noah holds a hammer, which rests on his shoulder. Noah's beard, incidentally, is rather short, as is his hair.

The two men are working on a small clinker-built ship, which sits in the background. The overlapping planking is obvious. The bow is sharply brought up and curved, reminiscent of contemporary Scandinavian vessels and their descendants, keels. While on the one hand Noah is directing the second man or boy, he is also directly involved and interested in the work. He carries a tool, making the impression clearly that of a worker (Fig. 24). The decoration and sculpture of the west side of the Cathedral was subjected to considerable influence from French art and sculpture, and specifically from Abbot Suger and the church at Saint Denis (Zarnecki 1953, 21–28), but in the case of Noah working on the ark the connection is more certainly with a number of manuscripts both from England and elsewhere, including the Munich Psalter done in Munich (Saxl 1954, 52–55).

The Noah sculpture in the tympanum of the Cathedral of St. Andrew at Wells, dated to the thirteenth century, is unequivocally connected to the insular manuscript tradition. Noah is bent over a plank that is set on two sawhorses, holding the wood with his left hand. His right arm has broken off, but the single-handed T-shaped broadax he is using is still there. A hammer and an ax are on the ground beside the sawhorses. Behind the singular figure of the working Noah is a clinker-built boat. It has a keel and posts at either end and, like the boat in the Lincoln Cathedral frieze, looks like a keel. Noah again is bearded but here he also has a thick mustache. Oddly, he wears a loose jacket and skirt, not like the standard close-fitting garments of most thirteenth-century depictions of workers.

The Noah sculpture decorating an arch spandrel along the north wall in the Chapter House of Salisbury Cathedral was begun soon after 1272. It, like so much of the rest of the decoration, has suffered from Victorian restoration (Gardner 1951, 108–109). This Noah also has a loose-fitting robe and though again the influence of manuscript illumination is obvious, the drapery especially shows the effects of the exposure to French sculpture. The influence may have come from imported images (Prior and Gardner 1912, 612–613) but it could also have come from the Salisbury artist having seen similar decorative figures in France. The scenes are like those at Wells in that they are simple, but the figures typically are in picturesque postures, quite different from the stately simplicity of those at Wells (Stone 1955, 131; Prior and Gardner 1912, 345). The depiction of Noah building the ark is the sixteenth scene of a series recording sacred history from the

Creation. The depiction conflates God commanding Noah to build the ark with Noah hard at work on it, as is the case with a number of earlier and roughly contemporaneous manuscript illustrations. God, on the left, has his hands extended toward Noah, who is looking at him in rapt attention while he hold an auger and turns it into the keel of a ship. Noah wears a cap. The vessel, which takes up almost the entire right side of the scene, is clinker-built and has an animal head at the prow. The Viking parentage of the vessel is obvious. Only the forward half of the ship is completed. The bow seems to rest on the ground, but the portion of the keel where Noah applies his auger rests on a tree that serves the purpose both practically and artistically of the sawhorses of the manuscript illuminations (Fig. 25).

The Noah sculpture at Wells Cathedral is very much like the Noah in the archivolt framing the tympanum of the portal of St. Honoré at the Cathedral of Notre Dame at Amiens done earlier than Wells, that is, in the first half of the thirteenth century. At Amiens Noah works alone with a tool in his hands. He is one of many figures on the second archivolt following Adam in a series of Old Testament figures that starts with the first man. The next archivolt has figures of the prophets, and the fourth and final one apostles and evangelists, so that as a whole the archivolts give a clearly articulated narrative of sacred history. Most of the Old Testament figures are individualized by specific action; Noah is no exception. He is shown working with an auger on a plank, an ax lying within easy reach. He leans forward to press down on the auger, as usual deeply engrossed in his work, in the posture of one perhaps atoning for his and others' sins through his labor. Scooping out round holes was typical work on a clinker-built hull, since before the invention of the brace and bit in the fifteenth century all the holes for the dowels had been made by hand, using augers. Noah in the Amiens sculpture thus shows the standard methods of operation. All of the Old Testament figures chosen for the archivolt were typologically related to the bishop's function, St. Honoré having been a bishop (Katzenellenbogen 1961, 1:280–283, 286). In Noah's case it was his preaching function.

Another French Noah sculpture, this one from the second half of the thirteenth century, is unique because it has Noah using a very different tool. At Sainte Chapelle, commissioned by King Louis IX, Saint Louis, to house the sacred crown of thorns that he bought from the Latin Emperor of Constantinople, Noah appears in a quatrefoil in the door (Babelon 1968, 4:56–61; Liberani 1967, 9:1034), holding a long-handled brush, which he uses to swab the clinker-built hull of a ship (Fig. 26). Presumably he is covering the ark with pitch, as ordered by God (Genesis 6:14). The Hebrew word for pitch does not occur anywhere else in the Bible, but it does

correspond to the word used in the Gilgamesh epic. The writers of the Bible regard the function of the pitch as being to keep water from getting into the vessel (Cassuto 1961, 2:61–62), and it had the same function for shell-built hulls. They were typically covered with pitch and even caulked, though the planks were fitted tightly together. Such caulking was more extensive with shell-built hulls of the Roman type than with hulls having overlapping planks like those built in northern Europe. The ark on the Sainte Chapelle door looks much like a seventh-century Armenian church set inside a northern European ship. While the church inside appears out of place, the ship design is perfectly consistent with contemporary northern French building technique. It is doubtful that the workman who did the Sainte Chapelle Noah was from southern Europe, though the suggestion has been made (Lessing 1968, 111–112).

Thirteenth-Century Manuscript Illustrations and Their Descendants

Two early thirteenth-century Spanish depictions of Noah building the ark belong stylistically and technologically to the collection of northern European works. The so-called Pamplona Bibles from around 1200 are picture Bibles apparently produced in northern Spain, though their origin is uncertain (Bucher 1970, 1:38–40). On the back of the eighth folio two panels show Noah, identified by name, first listening to God's commands and then working on a vessel. God, with a nimbus, appears in the upper left corner in both panels. In the lower panel there is not even a cloud surrounding him. In the lower panel Noah is on the right, holding a rather modern-looking ax in both hands. His loose fitting and flowing garment is not designed for work. The outline of a completed vessel appears clearly in the center of the picture. It is a rounded ship, and while it is not a precise reproduction of the design of the northern European hulk, it bears more resemblance to that type of ship than to any thirteenth-century Mediterranean vessel (Fig. 27). Basque shipbuilding in the High Middle Ages borrowed heavily from northern European practice. The barques used in forays down the Iberian coast in the thirteenth century and to Morocco and the Atlantic Islands in the fourteenth were much like keels common in northern Europe (Soto 1975, 23–56). It would thus not have been surprising to find a hulk being built along the northern coast of Spain in 1200, nor to find an artist depicting one.

The Noah building the ark in a fresco in the Chapter House of the Sigena monastery in Aragon, unquestionably in the Mediterranean basin, is definitely a workman and not an unoccupied director of other men. The

series of Old Testament scenes starting with the Creation that decorate the arch spandrels were done in the first years of the thirteenth century. The fresco was destroyed during the Spanish Civil War, but the remains were collected and taken to Barcelona where they were pieced together for exhibition. The tenth scene in the series shows Noah at work on the ark, wearing a short-sleeved tunic over more closely fitting shirt and hose. He is putting planks in place in a ship that is certainly northern in design, looking much like the keels Noah builds in the Salisbury Chapter House and Lincoln Cathedral sculptures. He wields a small hammer with a claw foot, holding it easily in one hand. His left hand is placed on the planking of the ark. He appears to be putting planks into place, scarfing them one to the next with straight joints (Fig. 28).

Some characteristics of the faces suggest influence from Byzantium, possibly through Sicily. On stylistic grounds art historians have argued that in fact the artist was from Winchester and probably had worked on the Winchester Bible (Oakeshott 1972, 104–105). A number of Anglicisms are evident in the painting style, the Byzantine influence being limited to the figures (Pächt 1961, 166, 170–171). The technological evidence clearly bears out the conviction that the artist who planned and at least in part executed the Sigena fresco apprenticed in England. The method of building and the ship itself suggest a northern European origin for the artist. He may have inserted southern figures, but in every other respect he adhered to the style and composition he had learned earlier in Winchester. The wall paintings at Sigena provide another example of the role of English artists not only in importing Byzantine style but also in moving beyond the work of their Byzantine masters.

The thirteenth and even more so the fourteenth century experienced a wave of manuscript illustration of Noah building the ark. Many of the manuscripts are originally from England, are related, and can be firmly placed in the tradition of the Cotton Genesis. Despite this debt to earlier works innovations in shipbuilding could and did appear in the depictions of Noah. Undoubtedly the best example is a thirteenth-century psalter that has Noah wearing a cap and working on a small boat (Cambridge: Library, St. John's College K. 26, fol. 7vo.). The vessel has a keel, and at either end there are posts that end in animal heads. The form is similar to that of the contemporary town seal of Bergen, Norway (Fig. 29). The vessel sits on two trees that have been cut and trimmed to act as sawhorses.

Noah has completed more than half of the hull planking, just as in the Salisbury Chapter House sculpture. Again he is using an auger, but this one shows an innovation. The auger has a small pad on the top against

which Noah leans, so that the entire weight of his body presses the auger forward, leaving his hands free to turn it. This breast auger was a significant improvement over its predecessors, since it gave the workman more force behind his tool (Moll 1930, 167, 171). It could also be used easily in tight places, a great advantage when working on ships. The breast auger was probably first introduced around 1000; although there is one in the Bayeux Tapestry the illustration in the Saint John's Psalter is the first good illustration of the new piece of equipment (Goodman 1964, 171–172, Moll 1930, 171). Noah, as always, is intense and concentrating on his work; he works alone (Fig. 30).

The much later Velislav Bible picture, dated to about 1340 and owned by Queen Elisabeth Rejcka, offers another form of conflation of the Noah story (Prague: University Library XXIII C. 24, Lob 412, fol. 9vo.). It also may depend on an English model, and thus perhaps be related to the Millstatt Genesis and ultimately then to the Cotton Genesis. The artist was a minor official in the chancellory of Emperor Charles IV (Réau 1946, 152) and his style is Gothic, possessing a softness not found in earlier works on the same topic (Weitzmann and Kessler 1986, 25–26). In the upper panel a group of people on the left watch as Noah both builds the ark and brings the animals into the ark. The vessel resembles a two-story house; the man working with an ax above is certainly the same as the man showing animals up the gangway below (Fig. 31). While two Noahs often appear in English manuscripts, they are always depicted as receiving God's command and working on the ship. Despite this difference there is clear evidence of English influence in this work, as well as that of Bohemian mural paintings, this latter an influence apparent quite generally in the work of the two or more artists who did the nearly seven hundred and fifty illustrations in the Velislav Bible. Several pictures show the realities of everyday life (Kvet 1959, 7, 17–18), presumably the one of Noah among them. The upper of the two Noahs is certainly a worker, climbing as he does up on the ark.

A slightly earlier psalter from East Anglia begun for the Saint Omer family in 1325 shows Noah building his ark in clinker style (London: BM, Add Ms. 39810, fol. 7). The Beatus page is elaborately decorated along the border with medallions containing scenes from the Old Testament. The seventh in the series depicts the building of the ark (Millar 1928, 56 and Pl. 1). Within the medallion the long-haired but unbearded man working inside the completed hull with a hammer presumably represents Noah. This Noah has men working with him, one of whom is climbing a ladder set against the ark. Over his shoulder the assistant carries a piece of a rib.

The ark is at the stage where the overlapping exterior planking is in place and the frames have to be shaped and inserted. Four other men work away down on the ground in front of the ship. The two at either end of the ship are putting rivets in place. One of the others is dressing a plank with an adze, his two feet astride the piece of wood. The last man is using an ax on a piece of wood that is set up on a trestle. This last attitude is reminiscent of other Noah scenes, but this man has his foot on the plank, an uncomfortable but apparently not uncommon position, since it appears in other depictions of shipbuilding. Outside of the medallion eight other workers do various jobs associated with the construction of a ship. Two use axes to cut down a tree, another carries a rib slung over his shoulder up a ladder, the fourth man holds the ladder for the third, another man uses a breast auger and a sixth uses a hatchet on the end of a plank, while the last two pull on a rope attached to the prow of the ark as if they were starting its launch (Fig. 32). The vessel appears to be a cog with some upperworks at the bow, already called a forecastle in the thirteenth century. The cog became in the fourteenth century the dominant cargo carrier for long-distance transport of bulk goods in northern Europe. Since cogs were larger than any contemporary vessels in the North, the artist, in choosing to show a cog, reflected a change in shipbuilding practice. And since building one of the new bigger cogs was a more ambitious undertaking, it is not surprising that the Noah of the Saint Omer Psalter does not work alone. Yet he does work, the presence of assistants not deterring him from putting his hand to the job.

Noah in Fourteenth-Century Manuscripts

Two early fourteenth-century Paris manuscripts on the other hand have Noah as the solitary shipwright. An undistinguished antiphony shows Noah building the ark in a miniature in this case inside the initial Q against a decorated background (Paris: Collection, Marquet de Vasselot, Antiphony, fol. 4). He is raising an ax. There are two figures in the border but they are grotesque and clearly have no connection with building the ark. One is wielding a mace while the other is an archer going after a bird.

The second manuscript, dated to 1317 (Paris: Bibl. de l'Arsenal, 5059, Jean de Papeleu, Bible, fol. 12vo.), may have been done by Maitre Honoré, whose work greatly influenced the well-known Life of Saint Denis manuscript of the same year (Bib. Nat., Ms fr. 2090–2092; Egbert 1974, 3, 11–17). The work is certainly in the style of Paris manuscript illumination of the reign of Philip the Fair (Réau 1946, 137–138). God with a nimbus

appears in the upper right in a cloud. He looks down at Noah, who has his eyes raised toward him. Noah is bearded, but in this instance bald. Noah has both hands on an ax with which he is chopping at the gunwale of a clinker-built boat (Fig. 33). Behind him a second more modern ax rests on the ground and on the post of the ark. Obviously then the broadax, descended from the battle-ax, existed side by side with the modern ax. The vessel appears to be a hulk with a keel. It is not possible to date with accuracy when northern builders first tried to improve the hulk in the same way that they had earlier improved the cog, making it more seaworthy. It may be that this is the earliest illustration of the improved hulk.

There are four fourteenth-century English manuscripts that show Noah building the ark. They continued the tradition already well established in the eleventh century. The Queen Isabella Psalter, executed for the wife of King Edward II around 1303–1308 is the least impressive of the group (Munich: Staatsbibl., gall. 16, fol. 21vo.). The command to build occurs within an initial letter D, Noah being addressed by a half figure of God, who is much larger than Noah. Below, where he is identified by name, Noah is swinging a large-bladed polless broad T-ax. On the right the ship is filled and on the water (Fig. 34).

The Queen Mary Psalter, also from the early fourteenth century, is certainly a more famous manuscript and one that had some influence on later Bible illustrations (London. BM, Roy. 2B. VII, fol. 6ro.). Though from the East Anglian school (Millar 1928, 17–18) it was probably made in London. Among manuscripts from that school it most closely approaches French style (Rickert 1954, 139, 142–143), being more modelled and showing an interest in the representation of space and in naturalistic depiction that became commonplace in subsequent years (Alexander and Kauffmann 1973, 90). Such stylistic innovation signalled a move beyond the style typical of Gothic illustration to an even greater interest in nature. The focus on nature itself was part of the interest in technology, in power over nature, that became obvious in many sources in the course of the fourteenth century. In the case of this manuscript the images were to explain a legend told in Anglo-Norman verse that deviates significantly from the usual story of Noah and the ark. The devil, so the story goes, wanted to stop the secret building of the ark. Noah's wife agreed to help the devil, since the angel who told Noah to build the ark appeared in human form and that made her jealous. Accordingly, Noah's wife gave him a potion in order to find out what he was going to do. The first blow that Noah then struck in building the ark was heard around the world, the noise signaling to God that the secret was out. In other versions of the story at this point all of

Noah's work on the ark was destroyed and he had to start over. God then forgave Noah and sent an angel with ready-cut building material to speed up the already delayed project. Nevertheless, somehow the devil snuck onto the ark, but when the dove returned Noah blessed it and the devil was driven straight through the bottom of the ship. The serpent then had to fill the hole created by the devil's departure with his tail (Horrall 1978, 204–205, n. 19; Réau 1946, 145–146; 1956, 106; Warner 1912, 13–15, 56–57). The connection of Noah's wife with the devil may well be derived from the fourth-century *Book of Norea* that circulated among Gnostics and is mentioned in apocryphal literature (Kolve 1984, 201–203; Tonsing 1978, 132).

In the Queen Mary Psalter the angel appears to Noah on the left side of a lower panel. On the right he is building the boat and the connection with earlier manuscript illustration and sculpture in England is obvious. The boat sits on sawhorses that are also trees; the two are confused. The vessel is probably a cog. Noah in the foreground works on a piece of wood also set on sawhorses. His left foot is on the piece of wood and he swings his pol-less ax with both hands. This is the same ax he had on his left shoulder while listening to the angel (Fig. 35). On the next page the top panel tells the story of the devil's appearance and of Noah drinking the potion. In the lower panel the angel returns with the needed material. It turns out that the pre-cut supplies are reeds, thus a portion of the ark, the upper part of the ship's hull, is woven. Inside the ship is a palace which shows no sign of weaving (Figs. 36 and 37).

The Holkham Picture Bible, begun about 1326, was probably influenced by the Queen Mary Psalter, though there are similarities with the Velislav Bible as well (London: BM, Add. Mss. 47680, fol. 7 vo.–7ro.). Both this picture Bible and the Pamplona Bibles show the degree to which the influence of the Cotton Genesis tradition, transmitted directly or through various intermediaries, had become pervasive by the fourteenth century. It shows as well the degree to which artists could and did vary and embellish that tradition (Weitzmann and Kessler 1986, 28, n. 147). The Holkham Bible, a picture book with a short explanatory French text, may have been produced in London. The style is broad and vigorous rather than fine or meticulous, but little is left to doubt in the extensive illustration (Mellinkoff, 1981:66). Although the legend of Noah's wife is shortened it is the same story (Horrall 1978, 205; Rickert 1954, 150). The characterization of Noah's wife as devil's advocate and flouter of God's intentions makes her story curiously parallel to that of Eve, since if Noah was a new beginning then she must have been the mother of all men. She is described as such at

times in earlier Christian literature (Stichel 1979, 92). Her reputation was to deteriorate even further in the drama of fifteenth-century England, and it seems that the plays did ultimately influence illustration.

The Holkham Picture Bible has forty-two leaves with a total of two hundred and thirty-one pictures, all by the same artists. The story of Noah appears on folios seven verso to nine (Hassall 1954, 1–11, 25, 29, 35, 41). Noah is once again given reeds to finish his job, which is running late: the final product has a lower hull, the first four stakes, in something of the shape of a scow made of planks and an upper hull made of woven reeds. Noah is shown twice building the ship. In the first case he works with an ax on the planks of the hull, which is set on the ground. He has his right foot on the planking and he wields the ax with his two hands (Fig. 38). In the second Noah is weaving the reeds in and out along the posts, which are already set up in a frame (Fig. 39). Both an ax and a single-handed adze are shown, but here when Noah is talking to God they are at rest, hanging from the frame.

In both cases Noah acts alone as the builder of the ship, whether working with planks or wattles. In both cases Noah is bearded. He wears a loose-fitting garment and for the first time in medieval illustration, a *Judenhut* or Jew's hat. The Jew's hat appears rarely on the head of Noah the shipbuilder, though other Old Testament figures are often depicted wearing them in the twelfth century and more so in the thirteenth, after church councils made it obligatory for Jews to wear distinguishing clothes such as a pointed hat. The hat was certainly a sign of opprobrium: in the manuscript from Louka in Moravia the scene of Cain slaying Abel appears before the scene of Noah building the ark, and in it Cain wears a pointed hat but Abel does not (Mellinkoff 1970, 128–129). The fact that Noah escaped almost completely from being shown with a Judenhut certainly indicates that he was not classed with the enemies of the church, with infidels and heretics. His place as a type of Christ far outweighed any connection with Judaism.

The last of the fourteenth-century English manuscripts is more problematical (London: BM, Egerton MS 1894, fol. 2vo). Done in the third quarter of the century, possibly at Durham, there is strong evidence of Italian influence in the decoration, so much so that originally it was not thought to be English. There are twenty leaves, all devoted to a continuous illustration of the book of Genesis. By this time pictures no longer served only to highlight the salient points of the story, as was the case in the high Middle Ages, but rather to give a continuous narrative. Each page is divided into four compartments and each compartment has a single scene. The Egerton manuscript definitely belongs to the Cotton Genesis tradition, with many similarities to the Bodleian Caedmon and Aelfric Para-

phrase manuscripts of the eleventh century. The artist may have based his work on some Anglo-Saxon intermediary or on a last antique original, an archetype of the Cotton Genesis (Weitzmann and Kessler 1986, 17, 25). It is possible that the English artist was in Italy when he completed the illustration, which would explain the elements of the Italian style and also the connection with the late antique format, since it was well-known in Trecento Italy (Pächt 1943, 57–69; Henderson 1962, 177–178, 187–189, 196–197). The artist did execute at least two other psalters, which like this one show the expressionistic trend of English illumination in the second half of the fourteenth century (Alexander and Kauffmann 1973, 90–91, 100).

The third item in the continuous narrative of the Egerton Genesis is Noah being ordered to build the ark. God stands on the left. Noah stands in the middle flanked by his wife, who is given the name Phurpara. He is bald, has a short beard, and holds an ax on his left shoulder. In the right foreground a beam sits on a pair of sawhorses that are no longer confused with trees. It appears that by this time shipbuilders used purpose-built sawhorses rather than relying on stumps. In the lower right quadrant Noah is at work building the ark. The vessel is a cog with a flat bottom and posts at a sharp angle to the bottom. Overlapping planking of eight strakes is already in place. Inside the boat is a framework, obviously for a house, the next step being to weave the wattles for that part of the ark. Noah is behind the vessel working on a plank that sits on two more sawhorses. He uses an ax or an adze. A young man carries a basket of pegs on his head that he is bringing to Noah (Fig. 40), though despite the assistance it is obvious that Noah is doing the building work.

Noah in Church Windows

Three French stained glass windows embodied the same northern European tradition that appeared repeatedly in sculpture and in manuscript illustration. The window in Chartres Cathedral displays the best workmanship and is the best-known example of the three. Done in the thirteenth century, the window in bay forty-four was supplied by the guild of woodworkers, carpenters, and barrelmakers (Réau 1956, 105). Since Noah was the first to practice viticulture the barrelmakers were pleased to be included, and some of the jobs of their trade appear in inserts in the window. The guild could and did use the window to advertise the symbolic connection with the Old Testament patriarch and thus to lend status to their labor and their trade. The window testifies to the emergence and en-

hanced status of professional groups in the twelfth and thirteenth centuries. Their search for dignity and recognition of their contribution, as well as assurance that what they were doing would not lead to eternal damnation, manifested itself in such depictions as this (Legoff 1980, 112–115).

The window tells the story of Noah in various scenes. One in the middle of the window shows him building the ark. Bearded and laboring intensely, Noah has a small two-handed T-ax with which he works on a plank that sits inside a finished hull. It appears that Noah is cutting a frame to fit inside the hull of what must be a keel, with its overlapping planking and curved form. Behind Noah is a man who carries a piece of wood on his back to the boat (Fig. 41). At the bottom of the same window are two men with small two-handed T-axes just like Noah's working on a plank set on sawhorses. Their relation to the building scene in the middle of the window is not clear. Because the window had to be split into so many panes the artist was forced to tell his story on a reduced scale and with episodes not always clearly linked to one another (Delaporte 1926, 409–411).

The thirteenth-century stained glass window at Niederhasslach in Alsace, presumably in the abbey church, is very similar in composition to the later work at nearby Strasbourg. There are two figures, the one on the left using an ax or possibly an adze to dress a plank that sits on two sawhorses and the one on the right, probably Noah, wearing a cowl rather indistinctly portrayed (Moll 1929, Hc 204). The work itself is in no way distinguished and the connection with Noah is only apparent through his use of one of the tools and the sawhorses that are connected with him in contemporary manuscript illustration.

The Strasbourg Cathedral window dates from about 1315. At the bottom of a window in the narthex the story of Noah appears in a series of sections of the window devoted to Genesis. God commands Noah to build the ark in one section (Reinhardt 1972, 179–185) and he appears in the next with another workman. He still has a beard and a green tunic, but he has shed the long pants he wore while taking his orders from God. Both Noah and the other worker are using axes on a piece of wood or possibly the boat itself, set on sawhorses. Noah is presumably the figure on the left using the T-ax. The ax is polless and short-handled, but Noah still uses both hands. The other man has a smaller two-handed ax of more modern design. Noah has a beard and wears a cap. In this case as in the others, the medium compels a simplicity of illustration, though the essential manner of depicting Noah remains unchanged. It is not certain if the continued presence of smaller vessels similar to the keel in French illustrations of the

fourteenth century was dictated by the medium or, in fact, by the slower adoption of the cog in France. The latter is not only possible but likely.

The different representations from northern Europe of Noah in the act of building the ark that date from between 1100 and 1400 in stained glass, in sculpture, and in manuscript illumination, chronicle a vision of the patriarch shared by many artists and much of their audience. There can be no question that northern Europeans of those 300 years understood Noah to be a workman, an artisan who used tools, who worked with his hands. Even with the notable exception to the pattern in the Munich Psalter done in Gloucester around 1220, artists and their patrons to a greater or lesser degree took Noah to be the sole builder of the ark or the builder with some amount of help. Where another worker or workers appear, Noah is still seen picking up and using the tools of the shipbuilding trade. The iconography of Noah certainly fell within the theological prescriptions of the time. The addition of the legend of the devil and Noah's wife in early fourteenth-century England did not eliminate or supersede the critical theological features of the Noah story as identified by the Church Fathers. Noah building the ark always and above all symbolized the founding of the Church. The images of Noah not only adhered to theological prescriptions but also remained consistent with what is known about contemporary shipbuilding technology from archaeology, from other visual representation, and from written documents on the building of ships. Thus Noah is shown building vessels with overlapping planking for their hulls, the strength of which vessels clearly comes from the shell since the hulls are finished first. Frames are added later, most obviously in the Saint Omer Psalter. Noah is often shown boring holes for the treenails that held the clinkered planks in place. The images of Noah show in various ways what work was like on a northern Europe shipbuilding wharf in the high Middle Ages. Artistic representation was consistent with the technology of the day and drew on it for inspiration.

6
Southern Europe in the High Middle Ages

Southern Europe produced far fewer images of Noah building the ark in Romanesque and in Gothic style than did the North. Even in Italy, the most common place for such images, the number of cycles with Noah as a shipbuilder is quite small. The variety of vehicles for Bible illustration did not exist in southern Europe on the scale that it did in the North. Moreover, the greater relative prosperity of southern Europe made possible the creation and retention of artistic works on a grander scale than in the North. The ties in southern Europe with the classical past not only in art but also in language, literature, and politics were always relatively stronger. At least in art, these ties did not prove confining; the opposite was in fact the case.

Italian art moved rather quickly in the Middle Ages to new forms of expression, in part under the impetus of knowledge of late antique art. Already in the fourteenth century Noah appeared in early Renaissance style, a style that owed much to knowledge of late antique art through works like the frescoes in Saint Paul's Outside the Walls. With few exceptions Italian artists drew their inspiration from the fifth century, either directly from works of the period or indirectly through intermediaries. Presumably the decoration, the iconographical program of first Old Saint Peter's, then Saint Paul's Outside the Walls, and after that the abbey church at Monte Cassino inspired most images of Noah building the ark. The fact that the large majority of these images appear on church walls in the years up to 1400 and even after supports the conclusion that Roman church decoration was the primary inspiration.

The cycle of scenes with major figures from the Old Testament usually created the opportunity to show Noah, and since the cycles decorated

churches it was only logical that Noah should be shown building the ark, the type of the Church. Artists did also show the Flood, sometimes at the expense of a scene of shipbuilding, but the tradition from the fifth century made the choice of showing Noah as a shipwright the typical one. Most of the images of Noah are related not only because the topic was the same and the plan of the cycles was the same but also because many specific features such as composition, dress, tools, and so on are very similar or exactly the same. With few exceptions the depictions of Noah building the ark in Italy and in southern Europe in general in the twelfth, thirteenth, and fourteenth centuries belong to the same artistic tradition. That tradition may very well, like English manuscript illustration, have borrowed heavily from the Cotton Genesis.

Images of Noah on Church Walls

The cycle of frescoes now in very poor condition at the abbey church at Ferentillo, north of Rome in the direction of Assisi, shows clear stylistic similarities to the frescoes at Saint Paul's Outside the Walls (Wilpert 1916, 2:588–589). There is a significant difference of opinion over whether they are in Romanesque (Grabar and Nordenfolk 1958, 51; Vitzthum and Volbach-Berlin 1924, 58) or pre-Romanesque style (Wilpert 1916, 2:592), and there is a difference in dating, some opting for the last quarter of the twelfth century (Grabar and Nordenfolk 1958, 51) and others for the eleventh (Vitzthum and Volbach-Berlin 1924, 58). The rendering of Noah building the ark has the familiar composition of a seated Noah directing three men, presumably his sons. He is larger than the workers. The frescoes have not been the object of extensive study, presumably because of their condition, an unfortunate state of affairs since they form a link between the eleventh- and thirteenth-century cycles of Old Testament scenes and fit firmly within an established tradition.

A twelfth-century sculpture on the ninth capital on the west side of the cloister of the Gerona Cathedral is much more problematic. There are two scenes. In the first a bearded man, presumably Noah, is felling a tree with an ax. In the next the same man works with a short-handled polless T-ax, dressing a plank that is set on sawhorses. To the right of Noah is an angel. To the left is another man with a similar ax doing exactly the same type of work (Fig. 42). The capital looks very much like contemporary English manuscript illustrations; the ax, the trestle, and the single assistant all turn up in eleventh-, twelfth-, and thirteenth-century manuscript illustration in northern Europe.

The Gerona capital seems to belong to the northern European sphere of depiction of Noah rather than to the Mediterranean one. Yet there is no evidence to suggest that the sculptor at Gerona was from the North, or for that matter that the area experienced extensive influence from northern Europe in the Romanesque period. In fact, because Gerona lay on the pilgrimage route from Lombardy to Compostella, the greatest artistic influence in Catalonia was Lombard (Porter 1923, 1:186–187; Durliat 1963, 103). If there was any alternate source for the way of showing Noah it would have been from Toulouse, from the south of France (Guidol 1937, 26). The Gerona capital is an oddity that, though certainly geographically southern and in fact even found virtually on the shores of the Mediterranean Sea, still depicts a Noah consistent with the shipbuilder of northern Europe.

The Noah in the mosaic of the Capella Palatina in Palermo on the other hand is Mediterranean both artistically and technologically. The Norman King of Sicily, Roger II, had the chapel built. It was consecrated in 1140 and the mosaics are from a slightly later date, probably finished around 1160 in the reign of King William I. The nave is the place, as usual, for the series of Old Testament scenes. The mosaics were probably done by Greek artists and their western pupils (Anthony 1935, 181–182; Dalton 1911, 406–409). The upper register of the north wall retells the story of Genesis in a series of scenes punctuated by windows. The Fall of Man, complete with serpent and tree, is followed by the judgment of Adam and Eve. Cain and Abel next make sacrifices, and in the subsequent scene Cain kills Abel. Then Lamech tells his wives of the slaying of Cain and next, after a window, is the assumption of Enoch. The next set of images is a detailed retelling of the story of Noah. In the first scene Noah is shown with his wife and his three sons with "*Sem. Cham et Iaphet*" written above the sons. Noah is tall, with muscular arms, long hair, and a long beard. He wears a long robe draped over his torso and left arm. He leans on the back of a chair where his wife sits, looking despondent. The three sons are of differing ages and sizes, the youngest being shown as an infant old enough to walk. A window separates the family group portrait from the mosaic showing the building of the ark. The latter seems to have some connection in composition with manuscript illustration in the tradition of the Cotton Genesis. The connection may be indirect, depending on some English manuscript intermediary, but despite the telltale signs of English influence not everyone is convinced (Dalton 1911, 401; Weitzmann and Kessler 1986, 28). The command to build the ark and the construction are shown together in the same scene (Fig. 43). Noah on the left looks up to a God

who is offstage surrounded by a cloud. Written above the scene is "*FAC TIBI ARCA in DE LIGNIS LEVIGATIS.*" Noah has his two hands open in front of him. The tree on the right recurs in later depictions of the construction.

In the middle of the mosaic is the ark itself, a ship built in the style of the Mediterraean with planks fitted edge to edge. There is a wale or bumper running the length of the ship just below the gunwale. Ships needed wales for protection when riding at a quay, something they did often in the Mediterranean but did rarely in contemporary northern Europe. The vessel is double-ended, the ends turn sharply up and in. This looks more like the design of a galley than of a typical cargo carrier, a round ship. Inside the vessel, which seems to sit on a trestle or sawhorses, is a house or palace. There are three workmen but they are definitely not Noah's sons; no one of them looks anything like the three boys in the previous scene. One of the workmen stands on the ground in front of the ship using a small hatchet, much smaller than the axes typical of northern European depictions of Noah. The fact that hull planking on southern skeleton-built ships was thinner than hull planking on north European vessels could explain the use of a less powerful tool. A second man, to the left, is making a hole in the top strake with an auger. It is a simple device. Such holes were needed to take the treenails that kept the planks attached to the frame. The third worker sits astride the roof of the ark and drives a nail or spike into the roof with a two-headed hammer. Noah is much larger than any of the workmen.

The mosaics continue the story of Noah on the south wall of the nave. There Noah is shown leaving the completed ark, which has a building inside with four windows, at each one of which is a member of Noah's family. The sons look much older than they do in the first scene on the north wall. Noah himself, complete with long white hair and beard, is at the bow helping animals exit from the ark down a ladder. The next scenes on another spandrel on the south wall shows the harvesting of grapes, Noah's drunkenness, and his being covered by his sons.

The series of Biblical scenes and especially scenes from the story of Noah is rather full and extensive and goes beyond many other similar series to which it might be related. In the depiction of Noah building the ark the connection with the Salerno ivory seems clear. Though the number of workmen is different the composition is certainly similar. The connection of the Palermo Noah with a later mosaic at nearby Monreale is even more obvious.

King William II of Sicily had the cathedral of Santa Maria la Nuova at Monreale built rather quickly between 1174 and 1182, very much in the style and tradition of the Capella Palatina. Monreale was to be, like the Palermo chapel, a dynastic monument, as is clear not only from the mosaics but also from documents produced in connection with the construction (Kitzinger 1960, 117). The mosaics do form an organic whole, but attention to detail was limited, perhaps because of the speed with which the building was built. In any case the style is not as good as at the Palermo Palace Chapel. The Monreale mosaics may have also been done by Greek masters, or by them in combination with local pupils (Dalton 1911, 410–411), since they too include many scenes from Genesis and are even more detailed than those at Palermo. They start on the south wall with a number of Creation scenes, followed by two of Adam in Paradise. The series then shifts to the west wall where God creates Eve and Eve is presented to Adam. Turning the corner the Fall and expulsion of Adam and Eve are on the north wall. After the scenes of the sacrifice of Cain and Abel, the killing of Abel and Lamech's slaying Cain, Noah appears dressed in a long robe with an outer garment wrapped around him and draped over his left shoulder. He has a full beard but it is not long, his hair only going to his shoulder. He looks up to the hand of God with his own hands raised and opened.

The mosaic of Noah building the ark appears on the south wall above the triumphal arch of the nave (Fig. 44). The figure of Noah resembles those of earlier mosaics. He is much larger than any of the five workmen, and his name is inscribed above him. He has his left hand extended in the direction of the workmen, as if he were directing them or pointing out to the viewer what is being done. Three of the workmen may be Noah's sons, since they resemble somewhat the men who appear on the ark in later scenes. In the foreground of the scene two men are working in front of the ship, the one on the left dressing a small piece of wood with a little hatchet and the other sitting astride a plank and working on trimming it with a small single-handed T-shaped ax with a blade much more curved than the northern European type. In this case as well the tools are lighter than those shown in images from northern Europe. The ship is set up on two sawhorses. It is much like the ship in the Capella Palatina but is even more dramatically curved, the ends turning in over the vessel.

Inside the ship is a two-part building, each part with a window, which doubles the Biblical number of windows. On the roof a man sits using a bow saw, a tool virtually unknown in northern European depictions of

shipbuilding. The frame of the saw has a rope stretching from one end to the other and a stick inserted in the rope. By rotating the stick the tautness of the rope could be changed and in turn the tension on the blade. The stick stays in place because it sits against the central bar of the saw. The man on the roof of the ark has finished about two thirds of the sawing of the plank, which he holds with his left hand. The saw is in his right. In the upper right corner of the mosaic two men use a frame pit saw. The large balk is propped up by a pair of stakes. The man above has his right foot firmly planted on the large piece of wood, while the second man crouches and is perhaps in a pit. It appears that two cuts have already been made in the big piece of wood and the men are about half way through the third. The saw has large teeth, obviously designed for heavy work.

After the depiction of shipbuilding there are two scenes above an arch, with Noah and another man who is presumably a son helping animals up ladders into the ark. The ark itself has a building inside with three windows; two people look out of each window. Four of the six people appear to be women. In the next scene the ark is on the water and Noah, with even longer hair, is receiving the dove. Two scenes follow showing animals being helped from the ark and Noah making an offering with the rainbow in the background. The next two scenes depict, predictably, Noah's drunkenness with his sons covering him, and the building of the Tower of Babel.

The shipbuilding scene is clearly connected to the Palermo mosiac and ultimately to the Salerno ivory. Also clear is that Noah is not a workman. He is dressed differently, is distinguished in physical stature from the workmen, and shows no sign of lifting a hand to do work. While a number of English manuscript illuminators did borrow from the general style of these Sicilian mosaics in developing their pictorial narratives of the Bible for psalters, none of them borrowed the relationship shown between Noah and the men on the wharf, which further confirms the critical role of contemporary technology in the choices of these artists.

Mosaics from Northern Italy

A third and later mosaic is very similar, and firmly establishes a connection with the Cotton Genesis manuscript tradition. The mosaic at Saint Mark's in Venice of Noah building the ark was probably done in the early thirteenth century, though the dating of the scenes in the series is very difficult. Work began between 1071 and 1112 but was not finished until the 1280s (Bettini 1944(b), 18–19, 25–26). The Noah story appears in the atrium in the second bay on the vault on the left side. It covers the full

gamut of the story from God speaking to Noah through the construction of the ark, the lading of the ark with a variety of animals, the arrival of the dove with olive branch, Noah's cultivation of vines, his drunkenness and nakedness, and finally his death.

The scene of building the ark has unfortunately suffered from extensive and largely incompetent restoration but the work is accurate in the arrangement and in the attitudes of the figures (Demus 1984, 2, 80, 247, n. 20). First a bearded Noah stands with his two hands raised and looks up at a hand extended from an arc of heaven (Fig. 45). In the second scene just to the right the same bearded Noah is speaking to a man, explaining to him what to do. The man he addresses is one of ten workmen busy with various chores. The carpenters are presented strip-like and were probably in two rows in the original manuscript. The first man instructed by Noah holds a straight-edge and appears to be a foreman in charge of the rest of the crew. The remaining nine workmen are divided into three groups of three each. In the first set two men stand facing each other and work on a beam set on two sawhorses. A third man sits in front of them with his left hand raised. He seems to be using a tool but the rendering is not clear. These figures could be analogous to the ones that appear on top of the ark in the Salerno ivory. The second trio has two men using a frame pit saw. One sits on the ground while the other stands above, and in this case his left foot is on the large balk being sawed. The third man is in the background and seems only to be speaking to one of the sawyers. In the third group the top two men bore a hole in a large timber with an auger, oddly representing two men using what was usually a one-man tool. Below them in the foreground is a seated man dressing a plank with a large two-handed broad T-ax. The job would normally have been done by a standing worker, but the mosaicist was so interested in squeezing as many men into the strip as possible that he put that man below the others in an unaccustomed attitude (Weitzmann 1984, 119).

Many scholars have seen Byzantine influence in the mosaics of Saint Mark's. This influence is certainly apparent; the work may very well have been done under the direction of Greeks (Dalton 1911, 399–401). But the style of nearby Ravenna, which boasted impressive mosaics composed in the late antique manner, also comes through in the Saint Mark's mosaics. So too are Romanesque elements present in the decoration of Saint Mark's, as well as signs of influence from the Salisbury school of painting. The mosaics had varied and different iconographic inspirations (Bettini 1944(b), 7–8, 12–13); nevertheless, there can be little doubt that the ultimate source dates from the fifth century and that it can in fact be

identified as either the Cotton Bible or some closely related manuscript (Tikkanen 1889, 99, 152). It is now widely accepted that the style and composition of the Saint Mark's mosaics owe much to the Cotton Genesis (Weitzmann 1984, 119; Morey 1953, 74), and that their design was probably copied directly from that manuscript (Weitzmann and Kessler 1986, 17–20).

Indeed the Saint Mark's mosaics are a principal source for knowledge of the since-destroyed Cotton Genesis. Using miniatures as models for mosaics or other monumental art started in the classical era and continued through the Middle Ages. There were in all such cases of transmission certain common and constant principles applied. Artists, for example, were always selective; they condensed, omitted, added, conflated. All such principles can be identified as having been employed in the case of the depiction of Noah building the ark (Weitzmann 1984, 105–108, 141–142).

Comparing the Saint Mark's version with that in other works related to the Cotton Genesis makes clear the changes introduced by the Venice artist. Above all he expanded the personnel of the wharf to a total of ten, a far greater number than that shown in any other depiction of the job. Moreover, he only shows the ark in its finished form. The men are shown working in wood but they are not seen working on the ship itself. It may well be that the mosaicist wanted to include as many trades, as many types of artisans, as possible in the illustration to satisfy the knowledgeable audience he certainly had in what was then the largest port in Latin Christendom. It seems certain that while the Saint Mark's mosaic fits the Cotton Genesis tradition, there were other and perhaps even more immediate inspirations behind the composition of the work. There is absolutely no question about Noah's relationship to the job of building the ark. He is not only removed from the task of shaping wood but he is also distanced a step further from labor, now having an intermediary to transmit his instructions to the men handling tools.

Since Venice had such a large shipbuilding industry it is likely that Venice also enjoyed a high degree of specialization in the assignment of jobs on the shipbuilding wharves. It could be that the Saint Mark's artist was only reflecting a trend in Venetian shipbuilding. The ship designer there was perhaps becoming even further removed from the actual construction of the ship, paving the way for men like the seventeenth-century Dutch shipbuilder of the Rembrandt painting.

The Noah in the Florentine Baptistry ends the list of twelfth- and thirteenth-century Italian mosaics showing the building of the ark. Though the Baptistry was already an old building in the ninth century the mosaics date from the late thirteenth century. They have been attributed to many

artists, among others Andrea Tafi, who was born in 1213. He is said to have brought a Greek mosaic worker over from Venice to advise him; the mosaics make clear Greek influence. The lower portion, which includes the Genesis scenes, was done by another artist, perhaps Gaddo Gaddi. Whoever was responsible, the errors and stylistic lapses can perhaps be blamed on inexperienced Tuscan artists (Anthony 1927, 11, 17; Dalton 1911, 412; Wilkins 1927, 1, n. 2).

Noah appears in the octagonal dome in the lower zone, among other Genesis scenes that run from Creation to the Flood. The mosaics were extensively restored at the turn of this century, the restoration of the mosaic of Noah building the ark being completed in 1906. It is difficult to say how much the depiction owes to the thirteenth-century artist and how much to the modern restorer, though there has certainly been some change from the original (Anthony 1935, 201–204; De Witt 1954, 1:2–4). Noah appears first in the eleventh scene, commanded to build the ark by a hand issuing from an arc of heaven. Noah is depicted with a nimbus, and on the right stand his three sons. In the twelfth scene Noah stands on the left with his hands outstretched, facing his three sons who are hard at work on building the ark (Fig. 46). Noah wears a full-length robe with complex drapery, while his sons wear short simple tunics. The differences in footgear also suggest a distinction between the director of work and the workmen. The two sons in the foreground are using a frame pit saw to cut a large piece of lumber. Not much can be made of the ship other than that the planks are fitted edge to edge. The third worker is inside the vessel, reaching out with a hammer in his right hand and what appears to be a caulking iron in his left. Oakum was usually forced into the seams of skeleton-built boats to insure that they were watertight. Caulking was another of the tasks typical of thirteenth-century Mediterranean shipbuilding. Its presence in the depiction further suggests that the creator of the Florentine mosaic found inspiration for at least the technical details of the construction of the ark in contemporary shipbuilding practice.

A Manuscript from the Holy Land

The universal history became a popular type of work in France and Italy in the second half of the thirteenth century; one written in Acre between 1223 and 1230 on both French and Byzantine models may be a product of some confused and menged artistic traditions. The surviving manuscript, dating from about 1285 (London: BM, Add. Mss. 15268, fol. 7vo.), was probably a royal dedicatory copy presented to the last king of

Jerusalem at his coronation in 1286 (Buchthal 1957, 84–87, 99, 150–151). Whether it should be understood as a northern European work or one from the Mediterranean is difficult to say. In the depiction of Noah building the ark it shows contributions from both traditions. The illustrations taken as a whole are reminiscent of the Arsenal Bible, which suggests a stronger influence from northern France than from the eastern Mediterranean (Buchthal 1957, 68–80).

The building of the ark forms the upper panel on a page, Noah bringing the animals into the ark in the lower panel (Fig. 47). As was typical in southern Europe, construction is being done by a number of workers, in this case seven. The ark is of the Byzantine type, with a hull and inside the hull a palace. The building has three stories, the top two with four windows each and the lowest with four and one half windows. The lower panel shows that each was intended to have four windows, the number per story being uniform there. Two workers occupy the foreground, one of them nailing spikes into the hull with a claw-footed hammer. The man to the left is on his knees and seems to be rubbing something, perhaps a rough stone, over a piece of sawn wood. Three of the four and a half windows on the first level have in them a man each: one uses a hammer, but the other two are without tools or apparent task. The two men outside the building, on the other hand, have specific jobs. The one to the right is using a bow saw, while the one on the left is making a hole with an auger. All of the workers wear tunics and have short hair.

Noah also appears on the left and pushes into the border of the picture. He is very much different from the workers. He wears a long flowing robe that almost engulfs him and has long hair, a long mustache, and long beard. He is much larger than any of the other men in the picture. Noah resembles the patriarch of the Italian mosaics except in one critical respect: he holds a raised polless modified T-ax in his left hand and in his right he has a piece of wood. It is not clear whether Noah is supposed to be working on the piece of wood he holds. It would in fact be difficult for him to do anything, since the wood rests on nothing and if he tried to deliver a blow with his ax his arm would hit the end of the ark, which comes just under his chin. Painting in the Crusader states was necessarily unique because of the unique political and social circumstances, the result of what was to be a short period of Latin rule established by an imported dominant military caste largely from northwest Europe. It seems very possible that the artist included Noah as a shipbuilder, as a man doing work, because of some northern French model. Noah's isolation from the rest of the picture,

his elaborate clothing and exceptional general appearance suggest that some alternative influence—perhaps Mediterranean in origin—provided inspiration for the depiction of Noah, an influence that counteracted the depiction of Noah as worker, laboring beside the men working on the vessel. Such speculation offers a satisfactory if not certain solution to the seemingly contradictory evidence in the illustration.

Images in Churches from the Fourteenth Century

Only a few years after the completion of the Acre manuscript, between 1292 and 1304, the frescoes of the Upper Church of Saint Francis of Assisi were finished. The cycle of Old Testament scenes, done in the late 1280s, is closely related to those in the abbey church at Ferentillo and more importantly to those at Saint Paul's Outside the Walls (Wilpert, 1916: 588–589, 592). The inclusion of illustrations modelled so clearly on those in Saint Paul's can be taken as evidence of a Roman party at Assisi (Belting 1977, 93; Tintori and Meiss 1967, 10–11). The dating of the Assisi frescoes is made more certain by the fact that Cavallini's restoration of the Old Testament scenes at Saint Paul's did not get underway in earnest until the 1280s. He presumably brought back what he had learned to Assisi to renowned artists such as the youthful Giotto and Cimabue, who worked on the frescoes in the Upper Church. The picture of building the ark was done, however, by another painter, one who followed the predominant Roman style. It may have been Jacopo Torriti, but it was more likely another Roman painter who came from a group that worked around him (Belting 1977, 225; Smart 1971, 3–9, 117–121). The striking similarity to the scene of Noah building the ark in Saint Paul's guarantees that there was a close connection between the two, so close that the Assisi painting has even been attributed to Cavallini (Wilpert 1916, 602).

As in Rome, in Assisi Noah appears twice, first being commanded by God to build the ark and then seated on a throne directing construction, but in Assisi the two scenes are put into one. Noah looks up to heaven to a hand that appears from an arc. He has his own hands raised and open as if in prayer. Noah has long flowing hair, a long beard, and wears a flowing robe. His appearance is similar when seated, but while the standing Noah resembles more closely the standard type of apostle of the day, the seated Noah shows greater similarities to early Christian depictions. Seated, Noah's left hand rests but his right is extended and he points with his index finger as if directing the three workmen who are on the right of the

scene. His seat or throne lacks a back but is accompanied by a footstool. There is a simplicity and even austerity to the representations (Formaggio 1958, 20–21).

One of the workmen kneels and is dressing a plank with a one-handed ax or adze. The other two workmen are using a frame saw to cut a large piece of squared timber into planks. To do this they have set the balk up on a small stand created by tying two poles together. The men have already made two cuts in the piece of lumber and are making their third and presumably final one, as in the scene depicted at Monreale. Although the man on the ground crouches slightly he is certainly not in a pit, nor does he have to sit on the ground. The man working above the balk has climbed part way up the incline created by the positioning of the timber and has both feet planted on it. Incidentally, the latter worker is shown to be very dark (Fig. 48). In the Bible Noah was said to have cursed one of his sons, Ham, for making fun of his drunkenness and nakedness. The son and his descendants were to be the slaves of the descendants of the other two sons (Genesis 9:21–27). The story was used as an explanation and an excuse for black slavery throughout the Renaissance and down into the nineteenth century, black Africans being taken to be the descendants of Ham.

This work possesses many features of early Renaissance style, even if in composition it obviously owed a great deal to the past. It is not a slavish following of the late-antique model; the artist shows a good deal of freedom in dealing with the scene (Belting 1977, 225). Even so, the depiction of Noah is unequivocal. He is in charge of the wharf and directs work, seated in such a way that he cannot lift any tools. In this posture he lost his value as a symbol of penitence or atonement, although he may have retained the role of a symbol of patience and probity. In southern Europe Noah typically was not represented as a worker, so that he himself could never be the vehicle for showing a change in attitudes toward work, though the context in which he appears is a scene of physical activity. A more positive attitude toward work would only be communicated by depicting work being undertaken by the patriarch himself. What Noah did do in southern Europe—oversee others—was always depicted positively.

The Church at Decani in Serbia has a series of frescoes with scenes from the Old Testament. The church, the largest medieval church in Serbia, was built between 1327 and 1334. Although the building was designed by a Roman Catholic friar the style is very much removed from that of contemporary Italy. The friar came to Serbia as part of a royal policy of opening the kingdom to western Catholicism, but since this policy had already failed when it came time to decorate the interior of the church, the

frescoes are Byzantine in inspiration. With more than twenty cycles, they are extensive, with Genesis being the subject of forty-six paintings (Stewart 1959, 36–38).

In the scene devoted to the building of the ark Noah stands in the middle of a large ship (Fig. 49). The vessel appears to be a round ship similar to the typical Mediterranean cargo carrier. There are four other figures in the picture. One uses an auger at the bow, while a second climbs a ladder to enter through a port—perhaps the window mentioned in the Bible—but there is a man there to speak to him. Behind Noah on the deck of the ship is a man who is erecting a large scaffold. The two posts and cross piece serve to frame the bearded Noah, who appears with a nimbus and uses his two hands to hold a large and slightly curved piece of wood. The most striking feature about the patriarch is his size. He dominates the entire scene, and though not strictly overseeing work he is not himself engaged in it either. The picture of Noah is certainly outside of the Italian or Latin or western European tradition, yet the technology it depicts is not alien to what appears in western scenes of Noah building the ark.

At Pistoia in Tuscany, there is a silver altarpiece in the Saint James Chapel of the Cathedral dedicated to Saint Zeno. The work, attributed to Pietro di Firenze, probably took its place around 1364 (Franklin 1958, 263; Lessing 1968, 18–19). One part of the silver is devoted to showing Noah building the ark. The scene is very reminiscent of the Salerno ivory and the Sicilian mosaics. A large Noah stands in the center with his right arm raised, behind which another Noah kneels to hear the command of God. On the right is the ark, box-like but with a peaked roof. In the foreground are two men, each working on a piece of wood, one with what may be an ax and the other with an auger or saw. Another figure appears in the window in the center of the ark. On the roof are two men who look like they are nailing shingles into place. Workers on the roof of the ark are a recurrent part of the composition in Italian mosaics and manuscript illustration.

Manuscript Illustration in the Fourteenth Century

Fourteenth-century manuscripts are largely consistent with earlier works, but do show some invention in the presentation of technology. According to one scholar, a Haggadah manuscript produced in Catalonia shortly after 1350 and now in the National Museum in Sarajevo, Bosnia, "is certainly the most famous of Hebrew illuminated manuscripts: it is among the most beautiful: it is perhaps the most important." (Roth 1963, 7). The Haggadah was the ritual for the domestic service recited on the

Eve of Passover. Since the service was carried out in the home and since all participants, including women and children, had copies, many manuscripts have survived. In Spanish versions the illumination was separate and the text came later, in a separate part of the book; the illustration was often only incidentally associated with Passover. In the case of the Sarajevo Haggadah there are thirty-four leaves of illustration with a total of sixty-nine illustrations, usually in two panels, one above the other, on the same page. The illustrations cover the entire story of the Pentateuch from the Creation to the death of Moses.

Page four shows a familiar scene (Sarajevo: Museum, Haggadah, fol. 4ro.). The top panel of the page is of Cain killing Abel. The lower panel has Noah on the extreme right with a beard and mustache wearing a hooded robe (Fig. 50). He holds an unidentifiable object in his left hand. His right is raised and he points with his index finger, directing three men. One of them kneels with a tool in his right hand and his left clenched, grasping the ark, which looks like a very small box. It has much of the same form of arks in Italian illustrations, going back as far as the Salerno ivories. The other two men in the miniature are using a frame saw, one man standing on the large squared timber and the other on the ground behind the ark. These workmen clearly establish a connection with an established artistic tradition. The Biblical scenes are consistent with the oldest Jewish miniatures but also show influence from contemporary art (Landsberger 1961, 382–383).

Gothic style obviously had the greatest effect on choices for the setting, the background, and the border of the miniatures, all of which are similar to those of French miniatures from earlier in the century (Müller and Schlosser 1898, 24, 34–35). The long garments, youthful faces, and elongated figures all are consistent with and imitative of Gothic style (Roth 1963, 8–17, 18, 26–29). This rare instance of a representation of Noah building the ark in Jewish art suggests that the sources for inspiration were similar for all artists and included, among other things, contemporary shipbuilding practice.

Four fourteenth-century Italian manuscript illuminations of Noah and the construction of the ark present difficulties, each in its own way. They demonstrate the continued originality of artists even within established traditions and existing technology. An antiphonary probably of Paduan origin is by no means as clear as, for example, the Sarajevo Haggadah illustration in establishing Noah's role as the overseer (Padua: Bibl. Capitolare, Antiphonary II, fol 73ro.). In the Italian case Noah appears along with four

workers in an initial letter D decorated with foliate ornament (Fig. 51). In the middle at the top of the miniature God appears, with a nimbus and with hands outstretched. Rays extend from his mouth, suggesting that he is speaking to Noah, who looks up attentively.

Strangely for southern Europe Noah holds a polless T-ax in his right hand and is using it to shape the piece of wood that he holds with his left. His long hair and beard unmistakably identify him as Noah. Two workmen carry planks, a third uses a plane, and a fourth has a short-handled adze. The ark is box-like, with planks at each level a little smaller than the ones below. The nails that hold the planks together are clearly depicted. It is obvious from this illustration that not all artists in southern Europe insisted on showing Noah as the supervisor. Some ship designers might well have turned their hands, on exceptional occasions, to the repair of boats, which could be the source for the artist's impression that even shipbuilders sometimes used axes. Certainly for ship designers to be so employed was rare, judging from all the other pictorial evidence.

The four miniaturists who illustrated a Bible completed in Naples around 1360 worked very much in the French tradition (Vienna: Nat. Bib., Lat. Ms. 1191). The Bible was probably prepared for the court of the Angevin ruler of the Kingdom of Naples or for someone connected to the court (Bise and Irblich 1979, 7–13, 119). On one side there are two Noahs in a landscape (Fig. 52). Both are nimbed as is God, who speaks to the first Noah. God enters from outside the miniature, his right hand extended and his index finger pointing. Noah kneels before him, holding his heavy cloak over himself with both hands. The second Noah has his back to the first. His right hand is extended and he holds a rod or wand, which he uses to direct five workmen. They are busily building the ark, but it is not the typical ark of earlier depictions. It is just a frame, something that appears to be more of a house than a ship. Two of the workmen use hammers while another carries a heavy piece of wood. The timbers are decorated. It is apparent that the finished building would have a peaked roof, though the top of the structure reaches beyond the miniature.

This ark was a deviation from the pattern standard since the ninth century of having a building inside the hull of a ship. The question of the ability of the ark to sail appears to have been put aside by this late fourteenth-century artist. The style may have owed a good deal to the influence of contemporary French manuscript illustration, although subsequent influence may have gone in the opposite direction, since depicting the ark as a house was repeated in later French works. On the other hand, the

depiction of Noah as the overseer is consistent with the predominant Italian style. So too is having two Noahs, one listening to God and the second showing his obedience to God by directing the construction of the ark.

Another fourteenth century Bible from the court of the Count of Anjou at Naples shows the same pattern. The Hamilton Bible offers a summary of Genesis in sixteen miniatures set out in a matrix four by four (Berlin: Kupperstich Kabinett, ms. 78 E 3, fol. 4). The ninth in the series shows Noah seemingly on top of the ark listening to orders from God, who appears in the upper left corner of the square (Fig. 53). The ship is a house with a least four men working on it (Salmi, 1957: 35–38). The depiction is very similar not only to the other Neapolitan Bible but also to a slightly earlier work from Tuscany.

The late fourteenth-century Rovigo picture bible, probably illustrated in Padua, has many of the same features (Rovigo, Bibl., Accademia dei Concordi, 212, fol. 4vo.). The more than three hundred miniatures appear to have been a reworking of Giusto de'Menabuoi's fresco in the Baptistry there, though the Bible illustrations are by another artist (Bettini 1944(a), 141–142; Folena and Mellini 1962, ix–x, xxxii, li; Salmi 1957, 40–41). The pages are divided into four panels, typical of Paduan miniatures of the years around 1400 (Fig. 54). The depiction of Noah building the ark is strikingly like that of the Cotton Genesis, and though the Rovigo Bible was not a direct descendant of that now heavily damaged manuscript the ultimate source must have been the same for the two works (Weitzmann and Kessler 1986, 17, 26).

The Noah story begins with a bearded, long-haired patriarch supported by a staff, standing in front of his three sons and looking up toward heaven. Noah is twice the size of the other figures. In the upper right corner is God with a nimbus, surrounded by an arc and rays. God has his left hand raised (Folena and Mellini 1962, liii). The entire scene is in a landscape of trees and grass, which is largely obscured in the second panel on the same page showing the construction of the ark. Noah, on the left, holds his staff in his left hand and has his right hand open in the direction of the work. Noah oversees five men. One is on the ground in front using a bow saw with M-teeth, while a second is in back using a large short-handled polless T-ax that is very much out of proportion. Each of the other three has a tool but it is difficult to make out exactly what anyone of them is doing, though one may be using a plane and another a rule. All of them are beside the ark and are all working on planks. In the next scene the finished ark appears, resembling a large box with a window in the roof that looks more like a door. There are four men in front of Noah, two kneeling on the ground,

apparently putting the finishing touches to the ark. Noah again as in the previous panel is clearly the director, the boss of the project.

Frescoes from the Fourteenth Century

Three frescoes complete the collection of fourteenth-century depictions of Noah the shipbuilder in southern Europe. The first, the model for the Rovigo Picture Bible, is from the Baptistry in Padua. The work was finished before the death of the artist, Giusto de'Menabuoi, in 1393. The story of Noah, in the sixth section of the drum of the Baptistry, is merely another of the Old Testament scenes (Fig. 55). The section devoted to Noah, as in all the other drums, is divided into two parts (Bettini 1944(a), 77–85). In the upper part a large bearded Noah in a mountainous landscape leans forward, half kneeling with his hands open and his right arm outstretched. He is looking up to a cross-nimbed God in an arc of heaven. In the lower portion a number of men are busy working with wood.

As in the mosaics at Saint Mark's in Venice there is no ark, but the artist shows many different wood-working trades. Although the fresco makes it difficult to identify all of the tools, a two-man frame saw and a pick or peavey can be identified. Noah himself holds a one-handed polless T-ax in his right hand, standing at the upper left of the lower section holding a plank with his left hand and the ax raised about to strike. The problem is the same as with the Padua Antiphonary. Why Munabuoi chose to show Noah as a builder is not clear, though his source could have been some manuscript or artist from northern Europe.

The fresco attributed to Piero di Puccio that serves as wall decoration at the cemetery Camposanto in Pisa was completed in 1390 and falls in the tradition established at Assisi. It has been extensively restored at least twice. The painting is divided into three parts. In the first, the angel of God speaks to Noah in the upper left and construction begins (Fig. 56). In the second, the ark stands on Mount Ararat while in the third, Noah, surrounded by some members of his family and some animals, makes a sacrifice. Noah has a long beard and like the other figures in the paintings is heavily outlined, which gives an effect of swollen roundness. Piero di Puccio also used shadows carefully, rendering certain figures and especially Noah more complete, more full, and more impressive.

The construction scene is carefully balanced and busy, a sharp contrast to the deserted landscape in the second part (Bucci and Bertolini 1960, 87–89). In the construction scene Noah looks up at the angel with his left hand extended (Ramalli 1960, 108–109). Just behind him is the same

Noah, now facing the workmen, who are busy with tools creating an ark. The vessel is outlined in the background. It has at least six completed stories, with a window in the top one. Though the roof is peaked and the roof planks are already in place, only a small portion of the walls is up. In the foreground two men operate a framed M-tooth pit saw, one standing on the squared timber. The balk they are cutting is set on a purpose-built frame, something much more permanent than that which appears in earlier works. Two others seem to be measuring a plank, another planing, while another sits astride a workbench and does something to a board with tools taken from a basket. The poor condition of the fresco makes it difficult to identify all the tools. Nevertheless, it is clear that by the fourteenth century Italian shipcarpenters had added the plane to their tool kits, along with some more varied measuring devices. The second Noah overlooks all this work with an attitude of concern, holding his cloak in his left hand with his right hand open. The serious-looking figure standing next to Noah with arms crossed appears to be a foreman, an intermediary between the shipbuilder and the workmen. There can be no question that the Camposanto fresco was done in the style of the Renaissance. Behind that artistic style lay a new sensibility and new ideas about language and exegetical method, all of which would, in the long term, have a weighty effect on how Noah the shipbuilder might be depicted. Yet the composition of this late fourteenth-century work fits firmly in the tradition that can be traced back through the Sicilian mosaics and the Salerno ivory to the basilican churches of Rome. The painter thus drew on established artistic practice, existing technology, and the social relations created by that technology, just as his predecessors had done.

The Sienese artist Bartolo di Fredi who painted a fresco for the collegiate church of Saint Augustine at San Gimignano in 1367 (Meiss 1972, 23) may have been influenced by the work of Taddeo Gaddi. Bartolo included twenty-four Old Testament scenes in the fresco cycle (Schubring, 1908: 558–559), including one devoted to the building of the ark. In it Noah is an old man in the lower left, holding a staff longer than he is. He points with his right index finger, directing at least eight workmen, who are busy using a variety of tools. The ark itself is a house with a dormer on the upper left that has a door, presumably for Noah to look out of at the end of the Flood (Fig. 57). The fresco shows nothing out of the ordinary. It is perfectly consistent with other contemporary depictions; its importance lay in the significant influence it would have in the next century in Paris.

The pictures from southern Europe are unquestionably better technically than those from northern Europe in the twelfth, thirteenth, and

fourteenth centuries. The skill of artists, their ability to execute works in different media and styles to show what they wanted to show, and to show detail was greater than that of their counterparts in the North. This greater skill should give the southern products greater documentary value for the study of technology, but despite their greater skill the southern artists drew ships that were neither especially interesting or accurate. In the fourteenth century a number of artists rendered the ark as a house, abandoning any attempt to depict a ship—a reversion to early Christian interpretation. It seems that they simply did not bother to show the hull of the ark, which held the house or palace that was to serve as shelter for Noah, his family, and the animals. What the artists did show about shipbuilding is consistent with Italian technology of the time. One of the rare pictures of shipbuilding that is not from the Noah group comes from Italy, perhaps from Venice, and dates from the first half of the fourteenth century. It shows workers doing the types of things that turn up in contemporary pictures of building the ark (Fig. 58). The standard equipment—auger, hammer, hatchet—are all in use. The vessel has its ribs in place and the workers have started to pin on the hull planks. It could easily be a picture of the building of the ark, except that it lacks a house or palace inside the ship and a Noah as overseer. Consistency of technology and most importantly the consistency of work in shipbuilding reinforced artistic tradition.

The traditional way of depicting Noah the shipbuilder was dominant in southern Europe, most obviously in Italy. Since artists saw on the docks of high medieval Italy much the same thing as artists saw in late antique Italy there was no special reason to change the way they showed Noah. With no obvious experience from everyday life to contradict the artistic tradition of having Noah as the director of operations, artists, with a few notable exceptions, retained past practice.

In the fifteenth and sixteenth centuries there was a significant change in artists' approaches to Noah, to the story of building the ark, and that of the Flood. The Renaissance changed the form, composition, and topics of works of art. The new views about human knowledge that were an essential part of the Renaissance created a drive toward greater realism in both art and thought. Theologians came to deviate from the framework of understanding set out by the Church Fathers on almost all subjects, including the story of Noah. Scholars, thinkers, and writers presented Noah in a different way, as did popular culture. Obviously some new features had crept into the Noah story since the time of Augustine, but the novelities in literature and theology only became clear in the closing years of the Middle Ages. The new views of Noah had a direct effect on how artists

dealt with showing him. The changes of the fifteenth, sixteenth, and seventeenth centuries in the approaches to Noah and then his final disappearance from art can be explained in part by the new ways of understanding him and the building of the ark. But the innovations in approach can also be explained by significant changes in shipbuilding techniques in the same period.

7

The Renaissance,
the Reformation, and Noah

Interest in Noah declined in the later Middle Ages because of changes in Christian thought and devotion. This decline was part of the general and well-established turn away from the Old Testament to concentration on Mary and the cult of Mary, to concentration on the sacrifice of Christ and his body, on his human form, and also on a new type of religious devotion. The *devotio moderna* that became popular in the late fourteenth and fifteenth centuries especially in the Low Countries is only the best example of this change in piety. More mystical, it called for an increasingly personal, subjectivist, private religion, removed somewhat from the learned approach of scholars. While this movement and others like it produced works on prayer, morality, and the good Christian life, it did not generally produce works of Biblical commentary.

The increase in the production of Books of Hours, intended for private devotion and for widespread diffusion, was a striking indication of the change in religious practice and religious sensibility. The books had prayers in the vernacular, another sign of the rise in "individual lay piety" (Meiss 1972, 7). While the new type of book might provide more chance to illustrate Noah building the ark, the new kind of devotion—with a principal goal being communion with God—led to an inevitable decline in interest in the Old Testament, in Old Testament patriarchs, and in depicting Old Testament scenes.

The scholars themselves showed even less of a concern for Noah and the building of the ark. Like Hugh of Saint Victor before them they accepted the allegorical meaning outlined by the Church Fathers. From the fourteenth century on there was, however, a growing concern among them for the practicality of the Noah's ark; how it could have been built,

how it could have sailed, and how all those animals could have fit into it—questions reminiscent of Augustine's late antique discussions.

Nicholas of Lyra (c. 1270–1349), a French Franciscan exegete, professor at the Sorbonne for much of his life and "the greatest biblical commentator of the later Middle Ages" (Hailperin 1963, 3), turned the matter even more to the practical. He could read Hebrew and was familiar with the most important medieval Jewish commentators on the Bible, as well as with Latin Christian exegesis, especially that of the great scholastic doctors of the thirteenth century. Nicholas did not reject the typological method of biblical interpretation, but sought and found moral, typological, and allegorical meaning in the Bible. He insisted that the Bible was not only allegorical but also historical, as Augustine himself had argued (Augustine 1950, 517).

While Nicholas was not an extreme literalist he did nevertheless claim that the literal sense of Scripture, the story itself, was the most important and decisive meaning of the text. The literal sense thus had to be fully understood, since it served as the basis for all other interpretations. Nicholas understood passages to have both an inner mystical and spiritual meaning and an outward or literal and historical meaning, the latter being more exposed and more immediate. It was this literal meaning that Nicholas decided to treat first and at great length. He did not hesitate to use diagrams to help to explain the literal sense of a passage (Hailperin 1963, 137–141, 252–253, 256–258, 283 n. 13). Nicholas, for obvious reasons, became known as the plain and useful doctor. His insistence on the centrality of literal meaning of the Bible explains both his influence on and his popularity with many Renaissance scholars and Protestant reformers. His *Postillae Perpetuae sive Brevia Commentaria in Universa Biblica* was the first Biblical commentary ever printed (Rome, 1471–1472).

Nicholas tended to gather together all past questions and commentaries on Biblical passages, report them, and then try to deal with objections to the stories. For example, Nicholas introduced a number of windows into the ark, since he thought they would have been necessary for all the animals (Allen, 1963: 75–76). Editions of Nicholas' *Postillae* published in 1481 and in 1485 carried woodcut illustrations of what the ark might have looked like, with two possibilities offered in each case. The later version was nothing more than barges with buildings inside (Schramm 1922–1940, 8: 1; 15: 1, 3–4). Just as artists and printers were beginning to try to show technology for a new market they were also trying, as did the author, to figure out how it was possible for the ark to function.

The insistence on the importance of the literal meaning of the Bible, picked up by many followers of Nicholas in the fifteenth and sixteenth centuries, made more pressing a number of questions about the ark and the Flood. The size of the ark, its exact design, and the number and types of animals that went in the ark were all exposed to careful scrutiny. It was the same problem faced for so many years of making the Bible appear reasonable, of making it consonant with what human rationality would understand to be possible. The increasing emphasis on human reason in the Renaissance put ever greater strain on the Noah story. The questions raised seemed almost unanswerable. That is not to say that no one tried but most scholars, at some point, abandoned dealing effectively with all the questions and over time artists followed them. The eventual result was to make the entire story of the Flood itself less important and less worthy of consideration.

The greatest Protestant reformer, Martin Luther, was one who abandoned giving a full explanation. Though he rejected the typological approach, he did follow Nicholas of Lyra closely in his lectures on the Old Testament, often quoting him. Luther too concentrated on the literal meaning of Scripture, rejecting allegorical interpretations but using allegory himself in explaining or elucidating the text. Although Luther's comments on Genesis come from notes taken by students during lectures that were extensively emended and revised by an editor, it is nevertheless likely that the published comments on the story of Noah building the ark do accurately reflect Luther's thoughts.

Luther praised Noah because his was a faith by which he lived his life and because he did exactly as God told him (Luther 1911, 42:317). Since Noah was commonly represented in medieval art and thought as a symbol of righteousness and obedience Luther's observation was not novel. In fact in general Luther had little new to say on the construction of the ark. Even though he thought the passages from Genesis important—he anticipated the imminent destruction of the world as in Noah's day—he merely dealt with the typical questions that had so preoccupied his predecessors when it came to discussing the construction of the ark. He spoke about the type of wood used, whether the gopher wood of the Hebrew meant pine, cedar, or fir. He worried about the use of pitch to keep the vessel watertight, since in his day ships were caulked with oakum and pitch that was highly flammable.

Luther did not get involved in a discussion of the dimensions of the ark, saying merely that it was a nice problem that had excited geometricians.

But he did advance his conviction that the ark did not have a peaked roof because in Palestine houses had flat roofs, something he learned from a passage in the Gospels. He even took up the problems of where the different animals went and where the manure was stored. He did mention that Augustine, following Philo, wrote that the ark had the same proportions as the human body, and that the ark prefigured the Church and the window in the ark the wound in the side of Christ. Luther thought these allegories not scholarly but innocuous; they could be used for ornament but definitely not in disputations.

After mentioning the questions raised by the story, Luther in frustration offered a simple allocation of space for certain animals and considered this sufficient. He put aside all the incidentals (*accidenta*), professing satisfaction with a simple, if incomplete, explanation for how the ark could have functioned as a ship (Luther 1911, 306–311). Luther's decision out of frustration to give up trying to explain how Noah could have built an ark to house all the animals was one increasingly made by theologians in the sixteenth and seventeenth centuries.

The other principal thinker of the Protestant Reformation, John Calvin, had even less to say about the Biblical story of Noah. For Calvin as for Luther the obedient Noah did what God directed immediately and without questioning His command, thus functioning as a good example of diligence and devoted service to God. Calvin compared Noah and his family to the few who would be saved from among the mass of the sinful (Calvin, 1863–1900, 27:418, 29:366; 33:27; 55:267). With questions about Noah and the ark, as with many issues, Calvin repeated the ideas of the early Church Fathers. He, like others, apparently did not think it worth bothering with details about the ark, its size or shape or how it was built.

Some geometricians still tried to create a shape that would fit all the requirements set in Genesis. They accepted, like Nicholas of Lyra, Luther, and many others, that the Bible was historically accurate; thus they thought that knowledge from science and mathematics could be used to help to explain and to understand the Bible. Johannes Buteo (1492–1572), a French geometrician and the author of the oldest treatises on algebra written in France, attacked the problem of the shape of the ark as the first of fifteen topics in his *Opera geometrica* published in 1554. The book is a mixed collection of essays on various geometrical questions. Buteo, having learned Greek and thereby the elements of Euclid, put his knowledge to work first of all to explain the shape and form of Noah's ark (Cantor 1892, 517–519; Pillet [n. d.], 250) but his explanation proved no more workable than any other.

In the course of the fifteenth but especially the sixteenth century there seems to have been a gradual erosion in confidence as very learned scholars, one after the other, had trouble with the story of Noah. These difficulties were made even more acute by advances in technology and advances in the ability to present technology in illustrated books. The success of shipbuilders in producing vessels that performed unheard of feats such as sailing around the world made it seem only logical that modern shipbuilders or mathematicians or theologians could now describe how Noah built the ark. God had, after all, given rather specific instructions on how the job was to be done. It was not that sixteenth-century writers asked new questions about the building of the ark; in fact they sought answers to many of the same questions that the Church Fathers had posed. But the sixteenth-century scholars placed an even greater emphasis on the literal approach to the Bible, insisting on the importance of the historical interpretation, which made even more pressing the need to find answers to practical questions. That shift in emphasis when combined with unprecedented advances in technology made the problem more acute. The illustrations of Noah building the ark showed some signs of the problems writers were facing and of changes in shipbuilding technology, though typically artists only slowly abandoned older traditions.

Noah in Late Medieval Plays

The popular image of Noah was shaped by the ideas of churchmen, but more often than not these ideas were transmitted to a larger public through illustrations and through drama. Plays did not adhere strictly to the Biblical text, since playwrights interwove legend with scripture and made changes for dramatic effect. There is evidence from as early as the end of the ninth century that certain Biblical scenes were acted out, enhancing the liturgical texts. The scenes were typically short but could be extremely down-to-earth, thus enjoying widespread appeal. Most of these liturgical plays were developed between the tenth and thirteenth centuries and by the twelfth century were being performed on church porches. Since the plays were often naturalistic in the extreme, the greater importance and seeming official recognition of drama was another sign of the move toward naturalism that turned up in visual art as well in the period (White 1978, 34–35). The liturgical plays promoted the increase in pictorial narrative in the twelfth century (Mellinkoff 1970, 35), but it could well be that both the recognition of drama and the richness of illustration have a common origin in contemporary thought.

It was not really until after the twelfth century that the plays took some firm shape. England offers the best examples because of the abundance of surviving evidence surrounding the plays. Pope Urban IV started the feast of Corpus Christi by decree in 1264, saying that the Church needed a chance to celebrate the Last Supper. With the impending disaster of Good Friday, the proper joy could not be attached to the celebration of the Eucharist in Holy Week. To overcome the emotional conflict the new feast was set about eight weeks after Easter, so that it fell very near midsummer day, when the weather was generally good and the day long. The bishop or one of the priests carried the Host from one church to another or from a church out through the town and back to the church. Churchmen followed and guildsmen soon became part of the procession. In the course of the fourteenth and early fifteenth centuries the procession changed from simply walking through the streets dressed in costumes of characters from the Bible to the giving of short plays from wagons. The wagons acted as stages and were pulled around the town, stopping at different stations along the way where guildsmen put on the plays. The plays were arranged in cycles, something like the frescoes of late antique church walls. They began with the fall of Lucifer or with Creation and continued on to the Last Judgment. Though city authorities probably assigned the different episodes to specific guilds and maintained overall control, the plays themselves were entirely in the hands of the guildsmen (Nelson 1974, 5, 11–13; Purvis 1962, 9).

The performances had a number of purposes, not the least of which was to show how bad behavior was punished. The stories of the Fall, of Cain and Abel, and of Noah were extremely helpful in showing the perils of breaking the law (Squires 1982, 274–275). For example, Cain in one play became a comic character while Abel was always right. Cain suffered from trembling of the limbs as a mark of his stigmatization, a trembling that had no Biblical precedent but that was suggested by certain early Christian writers. For the playwright the trembling was a source of entertainment and a way of generating social satire or even, in the extreme, social protest (Mellinkoff 1981, 81, 86, 100–101). The treatment of Noah and the building of the ark was similar in the license taken by the dramatists. The surviving texts vary greatly in the amount of information in them about the plays (Mellinkoff 1970, 28–32), typically representing how the plays were given from the mid-fifteenth century on—that is, after they had been tested and refined. Old Testament cycle plays became more common in France in the fifteenth century and continued to be performed in the sixteenth. The Deluge was typically included, but it never enjoyed

anything like the popularity of other parts of such plays (Petit deJulleville 1880, 2:352–6, 362, 369) and nothing like the popularity in different English towns. Not surprisingly, the most elaborate story of the building of the ark was developed for performance when it was the guild of shipwrights that got the job of giving that part of the cycle.

The York mystery cycle is the best example of the symbolic emphases chosen in the dramatization of the Noah story. The eighth play, Noah building the ark, takes the form of a dialogue between God and Noah. God tells Noah what he must do and Noah protests that he has no skill as a shipwright. The guild definitely wanted to make it clear that not just anyone could build a ship. Noah protests again and God explains that he will guide Noah in the job. God then launches into a careful description of how the ship is to be built, with squared timbers and then wands interwoven between them—like the arks shown in the earlier Queen Mary Psalter and the Holkham Picture Bible. God gives further instructions and Noah responds by explaining what he will do, including sewing the seams of the ship and nailing the boards fast (Purvis 1962, 45–48).

At Newcastle the shipwrights produced the play, and there too Noah says that although he is not a shipwright he will be able to do the job with the supplies and the instructions that God will provide. This time an angel appears to Noah and tells him what to do; Noah, in response, describes some of the work he plans on carrying out. In both York and Newcastle there are additions to the story of Noah that have no Biblical precedent. The Newcastle play involved the lengthy tale of Noah's wife and how she was visited by the devil, the same story as the one that appears in East Anglian psalters with woven arks (Horrall 1978, 205, n. 17; Warner 1912, 14) and is illustrated in the Ramsey Psalter done near Peterborough in the first or second decade of the fourteenth century. In the Newcastle play the devil convinces Noah's wife that Noah is doing something that will not be to her profit or that of her children. The devil gives her the potion, which she in turn gives Noah when he comes home tired from his great labor. He tells her that building the ark is God's will and then, realizing the secret is out, asks God if he will still be able to do the job. The angel appears again and assures him that there is nothing to worry about (Davis 1970, 19–25). In most of the other plays Noah's wife poses a less formidable threat to God's will by being merely reluctant to enter the ark.

At York, following the shipwrights, the fishermen and mariners performed the episode of entering the ark, in which despite requests from Noah and from her sons Noah's wife refuses to come on board. Noah tells her that there will be a flood and she retorts, "Thou are right mad." Two

sons finally force her on board the ark, where she is consoled by the wives of the sons (Purvis 1962, 50–53). She is stubborn in the plays at Chester and Wakefield as well (Kolve 1984, 205). For example, in the Chester play of Noah's Flood, the third in that cycle, she insists she wants to stay and chat with her friends, telling Noah to go off wherever he likes and find himself a new wife. She gossips with members of the audience until, after Noah's entreaties fail, two sons take her away from the friends with whom she has just shared a drink. The first thing she does on entering the ark is to hit Noah (Hopper and Lahey 1962, 97–102; Twycross 1983, 8–10).

The tradition of the reluctant wife may have been an old one in England. It is possible that one of the illustrations in the early eleventh-century Caedmon manuscript in the Bodleian Library, on the page after the one showing Noah building the ark (see Fig. 5), depicts Noah's wife being reluctant to enter the ark and being urged to mount a ladder by one of her sons (Garvin 1934, 88–90). The story thus may not be unique to the plays but indeed have much earlier beginnings. A number of efforts to attribute the difficult wife to various motifs that appear in literature, art, and folklore have proven largely unsuccessful, however. Despite the similarities, it still seems unlikely that the playwrights were attempting to reproduce exactly the folktale about her which had currency on the Continent as well as in England, but rather were more interested in dramatic effect.

The difficult and gossipy wife is a stock character of the plays. Her actions in the Noah plays offer some comic relief to what must have been a long and very serious series. The actions at the same time also contributed to a recurrent theme of misogyny in the plays (Axton 1974, 186–187). It may be that the dramatists used Noah's wife to depict the sinners of Noah's day who refused to mend their errant ways: after some convincing this sinner accepts the right and clear path, which is to ride upon the symbolic waters of baptism in the ark, a symbol of the Church. It was a lesson for contemporaries. Unlike the story involving the poison, here Noah's wife in effect dissolves her symbolic connection with Eve; by going on board she changes from being the daughter of the rebellious Eve to being the progenitor of Mary and, indeed, the mother of the new humanity (DiMarco 1980, 21–37). There is also a certain humility in her actions, a pondering why when all others are to die she should survive, why she is judged better somehow than her friends (Kolve 1984, 209).

The story of Noah's wife being reluctant to enter the ark must have enjoyed some currency: Chaucer, for example, used it in "The Miller's Tale" of his *Canterbury Tales*. There one of the speakers talks about the problem of getting her on board as if it were common knowledge (Chaucer

1957, "The Miller's Tale," lines 3518, 3538–3543, 3818). In fact there are many similarities between the wife of Noah in the plays and the Wife of Bath as drawn by Chaucer (Storm 1987, 303–315). Both certainly experienced marital discord and it was this difficulty between husband and wife that was the typical explanation put forward in the plays for all of the difficulty with Noah's wife. Since only in the case of the Newcastle play did the devil take a hand in the conflict, that form of the story can not have been very popular (Kolve 1984, 203). A difficult Noah's wife turns up in many different places as diverse as late medieval Swedish wall paintings and recently retold folktales from the Ural Mountains (Kolve 1984, 201–202).

The tradition of the reluctant wife did not alone inform the treatment of Noah's wife, however. She appears in fourteenth-century manuscripts and plays as a helpful wife participating in the task of building the ark and loading the animals on board (Kolve 1984, 201). In the Cornish *Ordinalia*, a mystery cycle from the southwest of England, she shows no reluctance and is completely the willing helpmate, even fetching Noah his ax, auger, and hammers when he asks for them (Harris, 1969: 28–29). Her depiction in the N-cycle that was probably written in Lincoln is similar (Thomas 1966, 39–48; Nelson 1974, 100). Even where she is difficult in the beginning eventually she goes on board, acquiescing and accepting her fate, consistent with the established theological view of her place (Storm 1987, 318).

When it came to describing the design of the ark most playwrights relied on the Vulgate. There is the usual mention of small rooms, of the dimensions and the need for a small door (e.g. Harris 1969, 27, 250–251, n. 7). In the Chester play the ark is to be made of "trees dry and light," and little chambers are to be built. In addition the ark gets pitch for binding, a window one cubit by one cubit, a door for entry and exit, three eating places, one or two cabins perhaps on the top of the vessel, a mast tied with cables, and a yard and sail. There is a topcastle on the mast and a bowsprit is also mentioned. The detail is extensive and the wagon for the play was fitted with bows at both ends to make it look like an ark. Often associated with spring rites, wagons made in the form of ships were part of processions in Europe even before the rise of Christianity (Schnier 1951, 58–59). Though the pagan practice may have died by the fifteenth century, it could have served as a precedent for the ark of Noah in the plays. In the Chester play the sons even mention the tools they will use, saying that they are ready to go to work with ax, hatchet, and hammer (Hopper and Lahey 1962, 93–94, 95–97; Twycross 1983, 4–6).

The English dramatists had to wrestle with the same problems that had bothered theologians and artists since the second century. How to depict and describe a vessel that could carry all the animals continued to be a

problem, and was solved in different ways in different towns. The authors of the plays, clerics or not, had the same sources and faced the same difficulties as their predecessors. They tried to make the building of the ark understandable, comprehensible for their lay audience, which was why they included references to familiar technology such as certain features of construction and, more importantly, certain specific and well-known tools. The plays incorporated not only what was in the Bible but often part of the popular conception of Noah, the legends that had grown up around the Noah story.

In the fifteenth and sixteenth centuries, the period of the surviving texts of the English mystery plays, both art and drama shared the attempt of thinkers to show how, in practice, Noah was able to build the ark and save all the animals and his family. The effort failed. The dramatists, however, always persisted in depicting Noah as a practicing shipbuilder, a man who did the work on the ship and handled tools himself. He was so much the working craftsman that he even complained about how tired and sore he was from the work (Harris 1969, 28; Davis 1970, 23). In that way the dramatists were consistent with the approach of artists in northern Europe and consistent with northern European technology.

New Technology in Images of Noah

In the course of the fifteenth century northern European shipwrights slowly began to use skeleton construction. At the outset shipwrights in northwestern Europe simply had to find out how to build ships in the new way, but by around 1500 the new technique was being rapidly adopted for a wide range of vessels. By 1600 shell-built ships were the exception, especially for larger oceangoing vessels. So for the fifteenth and early sixteenth centuries, at least in northern Europe, a mixture of building techniques with shell building went on beside the new imported skeleton method. Art reflected the temporary confusion and diversity of technology: in northern European illustrations of Noah the shipbuilder show him both as a worker and as a director of work, while in southern Europe he remained an overseer but took on more attributes with the rise of Renaissance style. Ultimately, however, the most significant change was probably the decrease in depictions of Noah building the ark.

In southern Europe in the fifteenth century artists rarely turned their skills to illustrating shipbuilding in any form. Dello Delli painted the typical scene of Noah at work as part of a fresco series for the Chiostro Verde of Santa Maria Novella in Florence, probably in 1446 to 1447. Delli lived in Florence, Siena, and Venice and spent a good deal of time in Spain. His

work shows a number of influences including Spanish, Italian of various types, and Burgundian (Pudelko 1935, 71–76). The composition of the Noah scene is familiar and presumably depended on the pattern in earlier series of Biblical scenes in church decoration. An angel with a nimbus speaks to a large, bearded, and kneeling Noah, who looks up to the sky with his right hand outstretched pointing toward a yard where three men are busy working in wood. One of the three has a right angle and is doing some measuring while another seems to be doing much the same thing. The third may be sanding or planing a large piece of wood shaped like a trough, which stands on feet. The story again conflates in the same scene the command to Noah with the building of the ark. Despite the conflation it is clear that Noah is, as in similar scenes from the previous century, separated from the physical labor of building the ark.

The most famous southern European illustration of Noah building the ark is a painting on the ceiling of the Vatican Loggia done in 1518 or 1519. Originally commissioned by Pope Julius II the design for the Loggia and the decoration was done by Raphael of Urbino (1483–1520). The group of artisans and craftsmen that Raphael had gathered around him executed the design (Cartwright 1895, 63–64). There were thirteen bays in the Loggia and each received four small frescos, scenes from the Old Testament in all but the last bay. The third bay starts with the building of the ark and includes three other scenes from the story of the Deluge. The work was probably executed by Giulio Romano (1499–1546), though another prominent member of Raphael's workshop, Giovan Francesco Penni (1496–c1528), could have painted it (Dussler 1971, 88–91; Marabottini 1969, 256–264, 298–299; Sparrow 1905–1907, 55, 207). It is an excellent example of high Renaissance style, simple and direct. Noah stands on one side covered in drapery (Fig. 59). He is bearded and seems pensive but has his right extended toward the workmen, acting as a director. On the left three men are working with saw, ax, and adze respectively. The men have made progress: behind them are the ribs of a ship that certainly does look like it will be seaworthy. The men serve the artistic function of filling the upper part of the picture and bringing the background and foreground together.

It has been suggested that the artist was trying to contrast the contemplative life in the solitary draped figure of the patriarch with the active life of the workmen, their muscular bodies exposed to show their effort. The distinction is traced to Neoplatonic thinking of the Renaissance (Omer 1975, 697). Whether this was the goal or not Noah is undoubtedly represented as the presiding architect who gives guidance rather than taking part in the job. He is also something of a creator, perhaps in the same

sense that the artist, Raphael, was a creator or even in the same sense that God was a Creator, so that the human being in the person of Noah, imitates through technology that act of creation. The idea of the poet or painter as a creative genius who could perform godlike feats with his imagination did in fact appear often in the musings about art in the sixteenth century (Panofsky 1962, 171–174). Since viewing the shipbuilder as an overseer set apart from the physical labor of construction was common in southern European throughout the Middle Ages and a common feature of ship-building practice in Italy, Neoplatonic thought was not a prerequisite for Raphael to make a distinction between workers and overseer.

Incidentally, Michelangelo in the Sistine Chapel included the story of Noah in three scenes, but left out the building of the ark. This seems strange given the long tradition of including the construction in series of Old Testament scenes, even more so since it was a topic of contemporary discussion. Savonarola, for example, dedicated forty-two sermons to the issue. Michelangelo instead painted three balanced scenes, the Deluge flanked by the drunkenness of Noah and the sacrifice of Noah. The last shows peace, redemption, and unity of the family, while Noah's drunkenness implies the opposite, implies in fact the chaos that is the theme of the Deluge in the middle. The scenes are phases of one coherent argument into which building the ark did not fit as part of the progression (Wind 1950, 414–418). Since there were many illustrations throughout the Middle Ages of Genesis, of the story of Noah, and of the Ark where the act of building the vessel was passed over by an artist, Michelangelo's decision, though perhaps strange given contemporary thought, was by no means unique.

From northern Europe there is an altar painting, finished in 1383 and originally intended for Saint Peter's Church in Hamburg, that has a rather confusing scene of Noah building the ark. Because the altar was later moved to the nearby village of Grabov it has come to be called the Grabov altar. It is a massive work, measuring 1.80 meters high and 7.20 meters across with the wings open. The artist was Master Bertram of Minden. As with Gothic painting his figures are not flat and shadow-like but rather solid, thickset, and highly plastic. They are represented in the round, and look astonishingly realistic. The ultimate source was the Italy of Giotto but there may have been a Bohemian intermediary; Master Bertram himself may have worked in Prague. The realistic path of Gothic art did turn up in pictures of men working. In fact in the fourteenth and more so in the fifteenth century the theme of work took on greater importance, mostly in secular works (Husa, 1967: 18), but the altar piece of Master Bertram shows that the trend could be found in religious art as well.

There are twenty-four painted panels in all in the altar piece, done in two rows of twelve pictures each and placed one above the other. The six panels on the lower left show the Old Testament scenes with incidents from the lives of patriarchs, while the lower right treats the birth of Christ ending with the Flight to Egypt. The Old Testament scenes are a "somewhat rudimentary transition" (Portmann 1961, 6) from the Creation across the top and the Nativity series on the lower right. The smooth curves of the human features, the earthiness, and the immediate highly individual emotion all contribute to the very personal nature of the work, indicating an extremely personal mode of interpreting religious events. The work is subjective (Portmann 1961, 1–8), consistent with the contemporary *devotio moderna*.

The panel given over to the story of Noah (Fig. 60) depicts the patriarch looking up to an angel, receiving instructions to build the ark. Words flow from the angel's mouth: "*Fac tibiarcam de lignis lenigatis.*" He hears the order, as is demonstrated by the inclusion in the depiction of the ark nearing completion. The scene is balanced in its composition. Master Bertram paints Noah as an older man, balding but with a short beard, wearing a close fitting tunic. Most of his body is covered by two other figures at work on building a small boat. One of the workers has a large hammer raised above his head at its highest point, about to bring it down. The second workman in the background has an ax, which he uses to dress a plank. A third man just off to the right pours what appears to be some wine into a drinking bowl. Only a small portion of the ship is visible. The bow on the left is topped by the head of an animal, half dragon and half dog, while the stern on the right shows a sternpost with a rudder hanging from it and a sharp angle between that post and the bottom of the boat. The design features suggest a small and simple cog. Though Noah may not be working he does carry an ax just like the one used by the second workman. Noah is the same size as the other figures and is dressed in the same way, so that only his age, his expression, and his contact with the angel set him apart from the others on the wharf. In this as in all of Master Bertram's work the human figures dominate; there is little room for considering the ark itself or how it was built (Portmann 1963, 5–12, 109–110).

The Noah of Christian Education

The contemporary *Biblia pauperum* and *Speculum humanae salvationis* also served as a guide for the format and the form of expression in Master Bertram's Grabov altar. The anonymously created *Biblia pauperum*

was not a Bible but rather a work designed for meditation and teaching. The earliest of such books date from the mid thirteenth century and possibly even from the late twelfth. More than eighty different examples are known, their very limited texts being in either the original Latin or in German. Most of them date from the fourteenth century. In its original version the *Biblia pauperum* had thirty-four main scenes, each one flanked by two lesser scenes associated with the main one. The *Speculum humanae salvationis* was derived from the *Biblia pauperum,* but rather than having a limited or nonexistent text the *Speculum* had an extensive explanation attached to each miniature. The work appeared in a number of translations and survived the shift from manuscript to blockbook and finally to incunabula in the late Middle Ages. Illustrated with woodcuts, the book probably gained acceptance among lay buyers as well (Mellinkoff 1970, 71–73). The last printed edition dates from 1769; it is from the name of that edition that all the rest take the name *Biblia Pauperum.* "[I]t is unique in portraying more fully and dramatically than any other book of the period, the medieval concept of typology, or the thesis that all the events of the New Testament were prefigured by the events recounted in the Old" (Wilson and Wilson 1984, 10).

Each page has a central scene, typically from the New Testament, flanked on either side by scenes from the Old Testament that prefigure or foreshadow the principal scene. For example, Christ is mocked in one of the main scenes, on either side of which is a smaller scene, one of Eliseus being mocked and the other of the nakedness of Noah receiving the same treatment (Henry 1986, 3–4, 7). Since the books were each copied from another the same scenes always recur. Noah's only appearance is sleeping naked after his becoming drunk (Wind 1950, 412). The ark did appear in some versions in a small panel at the top of the page (Henry 1986, 3–7; Musper 1961, 3:23; Wilson and Wilson 1984, 9–10, 146), again equated with the Church, a common type since before the time of Augustine.

In only one version of the *Speculum* is there a scene of Noah building the ark. That is in a manuscript produced at the monastery of Saint Bertin in Saint Omer in the second half of the fifteenth century (Fig. 61). The text is in Latin, though the explanations for the miniatures are in French verse (Lutz and Perdrizet 1907, 1:105, 166). The scene of Noah at work using two hands to wield a broad-bladed ax appears in the upper left panel of the page. The other three panels continue the story of the Flood and end with the arrival of the dove. The ark itself had a door and a curved roof, giving it something of the appearance of a barrel. Noah is bearded and

wears a short tunic while he is at work. He is working at the job and is the only worker in the illustration. The connection with earlier northern European illustrations is obvious.

Two French miniatures of the early fifteenth century show Noah in a different way but both relied directly on Italian precursors. The Bedford Hours was done in 1423 for the wife of the Duke of Bedford (Thomas 1979, 85). Seven years later she presented the work to her young nephew, King Henry VI of England. Additions were made at the time to impress the new king with his responsibilities as the king of France as well as England (Meiss 1974, 1:364; Spencer 1965, 496–497). Among those additions was a scene of Noah building the ark (London: British Museum, Add. 18850, 15vo.). The scene resembles closely the ones in the late fourteenth-century Neapolitan miniatures.

In the Bedford Hours the illumination covers a full page and is rich in detail. There are a dozen workmen doing various jobs, employing a wide variety of tools. The addition of the new equipment not seen before in Noah illustrations is, in fact, a report of changes in what was happening on shipbuilding wharves. Four men work on the ground in front of the ark, one with a plane, the second with a two-handed short-handled ax very different from earlier forms, the third with an auger, and the fourth with a long handsaw, the first time such a tool turns up in pictures of the construction of the ark. The remainder of the extensive crew is busy with the ark itself. One on the right uses an auger. Two men carry planks up to the top, where three men are busy nailing the roof in place on the already completed frame (Fig. 62). Behind the ark is a peaceful landscape with ships sailing on the water and a shepherd watching over his flock (Brion and Heimann 1956, 207). The God in the top middle of the picture is rather small, and though he certainly is commanding Noah to build the ark the action seems to have nothing to do with what is going on below.

The center of attention for the picture is undoubtedly Noah. Bearded and with a long cloak he looks up with his right arm raised, pointing at one of the workmen. It is obvious that he is the director of operations, unusual for a work in northern Europe. The influence from Italy, perhaps from the Neapolitan school, which grew up around the Angevin court is obvious in composition, in actions, and above all in the design of the very distinctive ark. There is also a more direct and more easily traced connection with Italian depictions of Noah building the ark. The San Gimignano fresco of Bartolo di Fredi was a direct source for the second French illustration, this one done at the Cité des Dames Workshop in Paris about 1412 (Paris: Bib.

nationale, fr. 9, fol. 13). It was probably based on drawings of the fresco. The French work shows four men working on building a house with a bearded Noah giving them direction (Fig. 63).

The artists of the Bedford Workshop certainly relied on the Cité des Dames illustration, which was repeated twice later, in about 1417 and again in about 1420 (Meiss 1972, 23–24, Figs. 54–58; 1974, 12). The culmination of the series was the 1430 additions to the Bedford Hours. There the ark is not, as in the other cases, a ship or a vessel with a palace in it; it is instead a house, complete with three stories and an attic. The finished product that appears in the following miniature had a large door two stories high, four rectangular windows, and two round windows showing in the third story. There is a small dormer in the roof with a window. It is far removed in kind from the Biblical ark or the ark of the Church Fathers, as is it from contemporary shipbuilding practice since the artist, under the influence of earlier Italian works, chose not to depict the ark as a ship, even though he did depict a variety of woodworking tools.

A rather sketchy wall painting done around 1420 at the church at Mollwiss in Silesia near Wrocław shows the construction of the ark. The work is impressive neither artistically nor for the technology that it shows (Moll 1929, Kb #17). There are two men in the foreground working with rather modern-looking long-handled axes. They seem to be shaping a piece of wood that is supported by some type of trestle. In the background is a large object, scored into squares, with one corner of its rounded shape left open to reveal four figures. One of them passes an oar over the side. It is impossible to say which of the figures is Noah, but since there is no man supervising the work Noah is, if not a workman, at the most a passive observer. A stained-glass window from the same region, from Frankfurt on the Oder from about 1500, is clearer and more consistent with traditional depictions (Moll 1929, Hd #199). Noah stands behind a boat with overlapping planks. He has long hair, a beard, and a mustache. In his left hand is a long-handled ax, which he grips firmly; his right arm is not shown. He is a solitary figure, the only one working on the ark.

In a book of hours done probably at Bourges in the late 1480s by Jean Coulombe and his workshop there is a miniature of an Old Testament scene for each of the hours. Often in such books the scenes were taken from the New Testament, but not in this case. For the Vespers of the Holy Spirit there is an illustration of Noah building the ark (Baltimore, Walters Art Gallery, Ms W445, fol. 67v). The conflation of the story that appeared in eleventh-century English manuscripts and recurs throughout the Middle Ages was carried on in this work. Noah is looking up to the sky, standing

off to the left of the shipbuilding dock but still on the raised platform that surrounds the vessel. He is different in stature, clothing and attitude from the six workmen, who are busy laboring on the vessel (Fig. 64). Noah has a short beard and long hair and wears a full-length robe with elaborate folds. He looks up at the heavens, his hands open and his right arm extended away from his body. One of the workers wields an ax, while two others have hammers with large and small heads respectively. Lying on the platform are a long-handled broadax and two large augers; an additional two lie on the ground along with another large long-handled ax and a caulking wedge. At the stern there is a large pole or cylinder with grooves like a large screw. It does not seem to have any real function and its purpose is certainly not clear. The ship itself borrows from Mediterranean technology: the frames are in place, rising above the the unfinished sides of the ship, and the planking is only partially completed (Wieck 1988, 197). The representation of Noah borrows, it seems from Mediterranean artistic style as well as from Mediterranean shipbuilding technology.

Illustrations in Germany at the End of the Middle Ages

Manuscript illustration in Germany presents more problems. The development of woodcut techniques together with printing increased the potential for producing illustrated works of all types, but especially illustrated Bibles. This in turn increased the opportunities to depict Noah building the ark, though the opportunities were rarely seized. Nevertheless, over time the illustration of Noah did change.

In the Gotha Bible done in 1460 (Basch 1972, 28; Moll 1929, #G1, c13) Noah is on the right (Fig. 65) behind two men working with axes to dress a plank that sits on a trestle. Behind them is the ark. The hull planks are complete and two workmen are inside the vessel fitting the frames to the finished hull. There can be no question that the illustration shows shell building technique, nor that Noah is the supervisor of the work. While the artist did show the established building method—one that would disappear but that at the time undoubtedly predominated in Germany—he also put Noah in a position quite different from the usual one of being a worker. The illustration shows no other signs of influence from southern Europe. It may well be that already by the 1460s when skeleton techniques were only just taking hold in northern Europe, shipwrights there began to assume more the role of the director. Noah is definitely a director in the Gotha Bible: he is dressed differently from the others and is larger than the others, his right hand raised and his left pointing. This looks like it was the model

for the much larger and more impressive woodcut of Noah building the ark done thirty-three years later that appeared in the *Liber Cronicarum.*

Hartmann Schedel wrote his *Liber Cronicarum* between 1490 and 1493. He was the Nuremberg town physician and a devoted Renaissance scholar, an avocation he picked up in Italy while studying medicine. Using his knowledge of the classics, some Greek, and a little Hebrew, he put together a history of the world since Creation based principally on printed works by Italian humanists contained in his extensive and impressive personal library. He was far from original; it is even possible to recognize words or phrases that he lifted verbatim from the sources. The chronicles and the author reflected the new humanism. Sebald Schreyer, the patron of the publication, was a humanist as well. Schreyer contracted to have the illustrations done in the workshop of Michael Wolgemut and his stepson, Wilhem Pleydenwurff. Albrecht Dürer had been Wolgemut's godson and apprentice but he left the workshop just as work began on the Nuremberg Chronicles. The printer for the work was Anton Koberger, who ran the largest printing and publishing house in the world at the time. He was known for large woodcuts and for his long press-runs, producing at least two thousand copies of each of the two editions of the Chronicles. The first Latin edition appeared in July, 1493, and it was followed in December of the same year by a German edition, translated by another humanist, Georg Alt (Schedel 1493).

There was a plan to do a third edition, to be edited by Conrad Celtis, but an Augsburg printer, Johann Schönesperger, captured the market with a modified shorter and much cheaper version of the Chronicles. The illustrations were reduced and redrawn. They are inferior, but the German edition of the Augsburg Chronicles obviously did very well. The 1496 edition was followed by a Latin one in 1497 and then another German one in 1500 (Duniway 1941, 18–33; Kunze 1975, 1:368–369, 379–380; Zahn 1973, 2–27). The book had a wide circulation, being marketed in a number of major European cities (Kapp 1886, 292–293).

Apparently the artists drew up exemplars, samples to show how the page would be laid out, so that both printers and artists knew how much space they had. The exemplar page for Noah's ark has survived because it was used as an end paper for a Bible produced by the same printer (Nuremberg: Stadtbibliothek, Cent.II, 98). In the final edition the woodcut turned out to be much larger than planned. On the same page, below the depiction of the building, there was a rainbow put in a small insert in the text. It symbolized, so Schedel said in the text, God's contract with man that there would never again be a Flood (Wilson 1975(a), 115–116, 128–129; Wilson 1975(b), 112). A colored author's copy of the Chronicles

from Schedel's library has survived (Munich: Bayerische Staatsbibliothek Latin Printed MS). A number of other standard uncolored versions still exist, attesting to the popularity of the work.

Noah building the ark appears near the top of folio 11 ro. (Fig. 66). Noah is on the right, directing two workmen in front of him who are dressing a squared timber. The timber sits on a trestle, the workers using short-handled axes. Noah's beard, his hat, and his clothing all set him apart from the workmen. He holds a wand in his right hand and seems to be using it to direct the workers. The ark itself is a carrack, a type of full-rigged large cargo ship built in both northern and southern Europe in the late fifteenth century. The skeleton construction is all but obvious. The artists had an eye for ships, perhaps gained in part from copying works done for Breydenbach's description of his voyage in the Mediterranean, *Peregrinatis in Terram Sanctam,* published at Mainz in 1486. Certain city views with ships before them were adapted from the work for use in the Nuremberg Chronicles (Duniway 1941, 28). It is true that woodcuts often did accurately show types of ships and construction methods in the period (e.g. Pianzola 1961, 18–19; Nance 1955, 281–288), and the ark in the Nuremburg Chronicles is no exception.

There is a good deal of action in the work, almost reaching the point of frenzy among those in the yard. The ship is already launched and workmen stand or sit on a raft by it, while others on board do various jobs. Inside the ship there is a structure, complete with a window and a door in which a woman is standing. The different parts of the structure are labelled (Schmidt 1962, 55, 61). In anticipation of the end of the story the dove appears at the top right with an olive branch in its beak. As in southern Europe so in the Nuremburg Chronicles Noah is shown as the overseer of work on a skeleton built ship.

In the Augsburg Chronicles or *Buch der Chroniken,* as the German edition was titled, Noah appears with only one other worker (Fig. 67). Instead of covering the top of the page the picture is a small square in one of the two columns (Dresden: Landesbibliothek, Signatur Inkunabel 20116). The text is the same as in the Nuremburg Chronicles. In this instance Noah is on the left with the long wand in his right hand resting on his shoulder. He wears a pointed hat. On the right the workman wields an ax, dressing a squared timber that rests on a trestle. The dove, complete with olive branch, is over Noah's head (Kunze 1975, 2:228, fig. 105). The ark is still a ship with a building in it but it is much less clearly defined and not a good representation of contemporary shipbuilding practice. In general the work of the unknown artist is much poorer than that done for the Nuremberg Chronicles. It may be that the artist tried to imitate the

Nuremberg work by making a sketch and then transferring that sketch to a woodcut. The fact that woodcuts print in reverse would explain why Noah appears on the other side of the picture. Whether or not this is what happened by the end of the fifteenth century, at least in southern Germany, Noah the shipbuilder was, like his Mediterranean predecessors, Noah the supervisor.

Arks of various types continued to appear in works of art, whether associated with building or not. A Low German Bible printed at Lübeck in 1494 shows a ship with a sternpost but no stempost and a hexagonal building inside it (Leipzig: Universitätsbibliothek, Signatur Biblia 204). There are three tiers, the lowest with windows containing animals looking out, the second with columns and people looking out, and on top a cupola with the birds (Kunze 1975, 2:228). There was a revival in the depiction of the ark as a box, thanks in large part to Luther's insistence on the original meaning of the Hebrew word. The Luther Old Testament published at Strasbourg in 1524 shows the ark as a box or chest, square with a top, riding very low in the water. It is clearly marked "*Der Kasta Noe.*" The same type of ark appeared in later derivative Bibles such as the Old Testament published at Lyons in 1538 and illustrated by Holbein (Dodgson 1929, 176–177).

Ships were a common motif for popular devotion. The ark or the ship was often shown as the Church trying to avoid danger. A *Speculum Humanae Salvationis* produced at Utrecht in the 1470s, for example, showed the ark as a ship and inside it a church with a vaulted nave (Kloss 1925, 9). It was a popular image, copied by many artists, among them the first printer in Lübeck for a chronicle in 1475 (Stillwell 1942, 20). Protestant reformers adopted the ship image for propaganda purposes (Scribner 1981, 106–115), which at the least kept artists busy imagining the correct shape of the ark.

The traditional images of the ark continued to exist side by side with new and different ones. But pictures of the ark were already on the decline by the beginning of the sixteenth century, a decline even sharper for pictures of Noah the shipbuilder. The Nuremberg Chronicles woodcut showed Noah in a different way from that which was typical in northern Europe before 1500. Noah was now in the North, or at least as far north as Nuremberg, like the Noah in the South. Changes in technology had unified European shipbuilding. The approach common to construction everywhere was followed by an artistic treatment of Noah the shipbuilder common throughout Europe.

8
The Decline and Disappearance of Noah

After the middle of the sixteenth century the tendency to have a representation of Noah building the ark common everywhere in Europe was even stronger. The movement toward showing Noah as the boss of the shipbuilding yard, already established in the North by 1500, continued with the rarest of exceptions through the sixteenth and seventeenth centuries. Artists tried harder than ever to make the scenes look realistic, to make Noah look like a real shipbuilder overseeing a real, meaning contemporary, shipbuilding yard. The decline in illustration of the cycle of Old Testament scenes continued as before. Total artistic production rose rapidly because of the addition of printed works to already existing outlets, making the decrease in pictures of Noah and the ark, relatively, even more marked.

Sixteenth- and Seventeenth-Century Depictions

In southern Europe Jacopo Bassano or Jacopo da Ponte Bassano (1510–1592) produced a set of four paintings, oil on canvas, of the story of Noah, a cycle that is a good example of the high quality of sixteenth-century Venetian painting. The series includes the building of the ark, the entrance of the animals, the Deluge, and the sacrifice by Noah. A naturalism typical of Renaissance painting is here even more pronounced, especially noticeable in the careful and accurate depiction of the animals (Zampetti 1970, II, 23–27). The works were executed about 1574, and since they were done in the workshop of Bassano it is difficult to say how much of the work was done by his brother, Francesco (1549–1572), and how much by others (Arslan 1960, 1:146–147; 2:198–201, 203; Berenson 1957, 1:15). There is a surviving oil of the sacrifice of Noah definitely attributed to

Francesco that shows many of the same features and the same style as the Noah cycle (Sparrow 1905–1907, 55, 201; Torselli 1969, 80, #120). The naturalism of the work forced the elimination of many of the traditional elements in depictions of the construction of the ark. Work is certainly being done in the foreground: one man is planing, another sawing, and both are using trestles of some sort. There are also four women in the picture watching, carrying wood, or doing other chores. The foreground is filled in with a large number of animals. A shadowy figure in the background, upper right, holding a long staff appears to be Noah. He is removed from any of the action. Since it is difficult to say where the ark might be or how far work has progressed, it is also difficult to determine exactly what Noah is doing. In the painting of the sacrifice in the same series Noah is also shown in the background, almost unseen, at an altar making his burnt offering, while work goes on in the foreground and the animals stand around. Noah, whether he acts as overseer or not, is certainly distant from the work of building the ark.

Guido Reni (1575–1642) turned his hand to the subject of the Flood in the first decade of the seventeenth century (Baccheschi 1971, 116–117; Daniel 1971, 106; Levinson-Lessing 1965, 6). He produced an oil on canvas that shows a man in the foreground working with a hatchet and speaking to a woman who seems to be carrying something (Fig. 68). At least two more figures are at work in the background. It is not clear which if any of the men is Noah, nor in fact if there was any intention to show Noah at all. The principle figure in the foreground is not a likely candidate, since he lacks the long hair and beard and certainly does not appear to be over the requisite 500 years of age. If he is one of the sons then Reni succeeded in departing entirely from tradition by producing a painting of the construction of the ark without Noah, thinking of and depicting the event without the principal character.

Raphael's fresco from the Vatican Loggia was a popular source for printmakers. Cesare Fantetti, for example, produced the scenes of the story of Noah some time in the mid seventeenth century. Fantetti, who called himself Caes. Fantectus, clearly stated his source under the print. The representation is an accurate one, with only minor and almost imperceptible differences in proportion (Mussini, 1979: #9–12). Presumably the reproduction was done not only because it was a well-known work attributed to a famous artist but also because it did not look especially strange either artistically or technically to a mid seventeenth-century audience in southern Europe. Raphael's work also became known through etchings made by Giovanni Lanfranco and Orazio Borgiani (Strauss 1982,

#310; 1983, #368). The former reversed the scene while the latter is con-
sistent with the original. The etchings are certainly meant to be copies of
the Raphael painting; they are true to almost every detail down to the
angle of Noah's head. They also formed parts of series on the Flood, bor-
rowed directly from Raphael. Borgiani's cycle ran to fifty-two scenes, all
taken from the Loggia paintings. He began with God separating light and
dark and continued down to the Last Supper, taking most of the scenes
from the Old Testament. Noah himself appears in four of the etchings: the
building of the ark, the Deluge, leaving the ark after the Deluge, and offer-
ing a sacrifice. The Biblical series was one of his last works. It is dated
clearly as 1615; it comes complete with an HB monogram (Fig. 69), and
Borgiani died in January, 1616.

Lanfranco worked later, dying in Rome as well but not until 1647. He is
better known than Borgiani, having painted works for churches in his na-
tive Parma, in Naples where he spent about a dozen years, and even
frescoes in Vatican churches. His altar pieces often included scenes of re-
ligious history, so it is not surprising that he should have chosen to do
etchings of Raphael's Loggia paintings. The series probably dates from his
time in Rome before the departure for Naples in 1633 or 1634. His series,
called Biblical Scenes, has only twenty-eight parts, starting with God
creating the Sun and Moon and ending with the baptism of Christ. Noah
appears only in two of them, building the ark and making a sacrifice of
thanks to God. Presumably the prints of Borgiani and Lanfranco gained
some currency, so that through the seventeenth century Raphael's image
of Noah the creator, Noah the master, Noah the director was a not uncom-
mon vision of the patriarch.

In the North in the second half of the sixteenth century Renaissance
realism and technological change in the adoption of skeleton building
along with the merging of artistic styles all led to an ever greater simi-
larity in approaches to Noah. The story of Noah appeared in two great
tapestry series made in Brussels, one manufactured by Willem de Kem-
peneer and Pieter van Aelst the Younger in about 1550 and the other
by Willem de Pannemaker in 1563–1566. The first tapestry, done on a
commission from King Sigismund Augustus of Poland, hangs in Wawel
Castle, Cracow. It was done after a cartoon by Michiel Coxcie, some-
times called the Raphael of the North, and his Noah building the ark
does certainly look like the figure in the Vatican Loggia. The cartoons
were used a number of times in subsequent years as models for other
series (Crick-Kitzinger 1930, 170; 1947, 25; Szablowski 1975, 11–12,
389, pl. 9; Misiag-Bochenska 1972, 75–82, 154–157, 179–185), so the

Wawel work is virtually the same in every detail as the second tapestry.

Philip II of Spain, then the sovereign of the Low Countries, commissioned that work. The tapestry maker Pannemaker had already done work for Philip's father, Charles V, such as tapestries depicting the Conquest of Tunis completed in 1554 (D'Hulst 1967, 199–202; Göbel 1924, 64, #271, #273). The ships before Tunis looked like real vessels, nothing like the ship that Noah built in the Philip II tapestry. The ark in the background is very much like a house (Fig. 70). Members of Noah's family, both men and women, are busy around him, using a great variety of tools. Noah himself stands in the center of the scene directing the action; the form and line of his body are central to the impression of the work. This tapestry, unlike that in Wawel Castle, is distinguished by an elaborately decorated border filled with animals (Junquera de Vega 1973, 162–167), their function and purpose open to question. The style is definitely consistent with the works of Italian artists of the period, just as is the type of ark Noah is having built.

Maerten van Heemskerck, a Dutch artist who studied in both Haarlem and in Rome, produced in 1558 a pen and ink drawing on paper of God commanding Noah to build the ark (Copenhagen: Kupferstichkabinet #31). It is one of six drawings of the Deluge and the survival of Noah and his family. Copper engravings of the scenes were published in Antwerp by Cornelis Cort (1533–1578), a student of Hieronymus Cock. The building of the ark was the first of the six published pages (Hollstein 1949, 5:40; 8:241; Preibisz 1911, 3–7). Cales Janszoon Vischer also produced copper engravings based on van Heemskerck's drawing (Garff 1971, 50, #50). This work, like many of van Heemskerck's, shows the deep influence of his time in Italy (Bergot 1974, 7–10). God appears in the upper left, Noah in the lower right (Fig. 71). God's beard is longer than Noah's and he is surrounded by cloud. He has a globe in his right hand and his left hand is extended toward Noah, who kneels in an attitude of prayer. Behind them work proceeds on a highly imaginative vessel. The shape bears some similarity to the outline of the ribs in the picture in the Vatican Loggia. There is a keel. A building is going up inside the vessel but there are also extensions—something like bulging balconies—on the two sides of the ark. The vessel is extensively decorated with animal heads, shells, and carving along the exterior of the principal frames. There is an army of workers, one of whom is caulking the seams of the planks, which are placed edge to edge. Noah's second appearance in this conflated version of the story is in the lower left corner. He is talking to a workman who holds a long-handled ax and appears to be a foreman, taking his orders from Noah. The patriarch is certainly far removed from any physical labor.

The Bible of Feyerabend, printed in Frankfurt in 1583 and reprinted in 1589, shows Noah designing the vessel in the same picture as the animals entering the ark. A Zurich master, Jost Amman, made some of the woodcuts but did not finish the job, so Feyerabend took them over and used them to illustrate his Bible (Schmidt 1962, 263, 268). The ark itself has a baroque stern and a long gangway with the animals, two by two, slowing climbing it (Fig. 72). Noah is on the far right with his head turned toward heaven. Rays from the upper right corner suggest that Noah is receiving instructions from above. In front of Noah is a low table and on it is a plan or schematic design for the ship, next to which is a compass and leaning against it a straightedge. Noah had presumably made up the design, drawing the form of the ship before the work began. The artist has brought the whole story together in one scene, from God's command through design and construction to the loading of the ark. The artist, in a crucial distinction, chose to show Noah not with the tools of the shipcarpenter but rather with those of the designer, the man far distant from the building of the ship.

A similar illustration of some of the same events appears in an engraving by the Augsburg artist Melchior Küsel (1626–1683). A member of a family of artists, he was and is best known for his book illustrations. In 1679 he published his *Icones Biblicae Veteris et Novi Testamenti*. Picture Bibles like this one first appeared in 1560 and artists continued to produce them through 1702. Küsel's was a set of two hundred and fifty-one engravings, with a scene at the top of each page and below it six lines of text in Latin followed by six lines in German, the texts written by J. B. Croph (Hollstein 1977, 20:63, 117; Küsel 1679, #8). The eighth page bears the title "*Noachus Arcam AEdificat.*" The source is identified as Genesis, 6:14. The ark is not yet complete (Fig. 73). For his Bible illustrations Küsel often copied from other works, in many cases from those by prominent artists like Rembrandt, Raphael, and Rubens, but the engraving of Noah building the ark appears to have been original with him. The style harks back to the work of earlier Netherlandish artists like Maerten van Heemskerck and even to Lucas van Leyden (Tietze-Courat 1908, 41–47). The ark looks like a contemporary ship: the keel, posts, and frames have been set up first, before the hull planking goes on. The stern of the ship is rounded like the arks of Amman and Raphael, and for that matter like some seventeenth-century ships. Again an army of workmen is busy completing the job of construction, including work on a building that sits in the ship. The workers are carrying out many different tasks with a profusion of different tools. Noah is in the lower right facing forward but looking back over his left shoulder toward the sky. Rays descend out of clouds

from above; it appears that he is receiving God's command. In the center foreground lies what is unmistakably a plan for the ship. The keel and ribs are obvious, and the basic outline conforms to that of the vessel under construction. Just as Rembrandt earlier in the century in his portrait of the shipbuilder showed him drawing an outline of the main frame of a ship (Fig. 12) so Küsel, when it was time to depict Noah's building of the ark, showed him with a design for the ship.

By no means does this short list exhaust depictions of Noah building the ark. Nor are all pictures consistent with the general tendency. The most apparently jarring example of deviation is a drawing by a Low Countries artist completed before 1646 (Allen 1963, 167, #11). DeVos, one of the many seventeenth-century Flemish artists to bear that name, showed the building of what had by that time become the standard ark (Fig. 74), complete with skeleton construction, a rounded stern, and a building inside with a sloped roof. There is a pitch pot on the left and a supply of logs handy. Four men are working on the ark, presumably Noah and his three sons, the man on the right in the foreground with the hat and long beard being most probably the patriarch. He is using his hands, hard at work joining another man in using a saw to cut a log. Though the influence of Renaissance style is unmistakable in the background, which includes a castle, the well-established trend of showing Noah as the supervisor is absent.

This break with more than a millennium of artistic tradition in southern Europe and a century of artistic tradition in northern Europe can be explained by the fact that the design was not originally a depiction of Noah. DeVos copied directly, and with only minor changes, a print done by the Flemish Protestant refugee, Theodore DeBry, to illustrate Jeremy Benzon's *History of the New World*, a book that DeBry himself published in 1594 from his Frankfurt workshop as part of a series that would eventually reach fourteen volumes. Usually just called *Pars quarta*, it was said to be written by "Hieronymo Benzono" and further described as *Omnia elegantibus figuris in æs incisis expressa a Theodoro de Bry Leondiense*. DeBry was the first European artist to lend to the illustration of travel literature about the New World both elegance and accuracy (DeBry 1976, 7–11). Plate nineteen of the total of twenty-four plates that appear separately at the end of the text of the *Pars quarta* bears the title *Olandus caravellam, & cases ædificare curat XIX* (Benzon 1594). The picture was originally meant to depict some of the members of the Diego di Niquesa expedition to Panama in 1509. After running aground their commander, Olando, had a vessel built with the timber of their wrecked ships (Fig. 75). It is possible

that the details for the work on the vessel came from some Flemish shipyard (Chatterton 1967, 44–53, pl. 10). DeVos' borrowing of another illustration was not odd in the seventeenth century, and though he was acting counter to established artistic tradition in his depiction of Noah, saving himself time and money seem to have weighed more heavily on his mind.

While manuscripts with advice for would-be ship designers existed even from the fifteenth century, in the sixteenth they became more common and spread from Italy to northern Europe (Timmerman 1963, 9–15). The shipwright to Queen Elizabeth I of England, Mathew Baker, turned his hand to writing a short manuscript on shipbulding (Baker 1585). In it there was a picture of the ark. He saw the vessel as a great box-like scow with right angles everywhere and one door in the side (Fig. 76). It was, all in all, an improbable craft. The practice of including some discussion of the most important Biblical ship, however, did become common as the number and variety of books on shipbuilding increased in the following years. By the second half of the seventeenth century publishers had brought out the first massive studies on shipbuilding; the most extensive and best of such works came from the Dutch Republic, the home of Europe's largest and most advanced shipbuilding industry (Unger 1978).

When Nicolaes Witsen, sometime mayor of Amsterdam, came to publish a book on shipbuilding in 1671 he felt obliged, in the established form of Renaissance scholarship, to include the history of classical and pre-classical shipbuilding. Thus on page one he discussed Noah and the construction of the ark. Witsen did not know who built the first ship, but as Noah was the first shipwright mentioned in the Bible it was only reasonable to start with the ark. He quoted a number of learned men, including Hugh of Saint Victor, Buteo, and Nicholas of Lyra on the question of the size of a cubit. Witsen's own response to the suggested measurements for the ark was that most were too large. They would, he said, give the vessel too much capacity. He also took exception to the idea that the vessel had a flat bottom and no keel, since those features would have made it sail badly, problems that certainly did not bother Mathew Baker almost a century before. Witsen was also worried about how leaky the ship would be, apparently because he presumed that at least part of the hull was to be woven. Since the description of the ark seemed to Witsen so inconsistent with what he knew about shipbuilding he concluded that arks—or, more literally, chests—must have had a very different form in the first centuries after Creation (Witsen 1690, 1–3). He did not mention an experiment carried out at the Dutch town of Hoorn in 1604, when a wealthy merchant, Peter Janszoon, had a vessel built with the proportions of the ark. He had

reduced the scale and concluded that while the vessel was not good for long voyages and required a large crew to handle it, it could carry a great deal of cargo (Mangenot 1912, 1:1, col. 923). Peter Janszoon's experiment seems to have been the ultimate effort in trying to give technical validity to the Bible story. The experiment must have made little impression if Witsen did not even find it worthy of comment some sixty-seven years later.

While Witsen gained his knowledge from talking to shipbuilders, the next Dutch author who followed in his tradition, Cornelis van Yk, was for many years a practicing shipcarpenter. Van Yk brought a greater technical accuracy to his work, but this did not stop him from travelling the same path as Witsen. Van Yk began with the first shipbuilders and conceded that Noah, though he did not build the first ship, did build the biggest and best known one. Van Yk reviewed the technical suggestions of a number of scholars and drew the ark that each had described (Fig. 77). The first is Origen's, the second Hugh of Saint Victor's, the third Cajetan's, the fourth Nicholas of Lyra's, the sixth Wilhelm Goree's. Goree was an obscure Netherlander, while Cajetan or Tommaso de Vio (1469–1534) was the chief of the Dominican order, a prominent theologian and the author of a work on the Pentateuch (1530–1531). He had made himself unpopular with his fellow Dominicans by insisting that the Vulgate was not sufficient for making serious studies of the Bible. The fifth example van Yk claimed represented how artists in his own time chose to show the ark; not surprisingly, it was the ark he preferred, though his choice was presented as being based purely on technical grounds. He maintained that this version would have ridden best in the water and provided more rest for the animals inside. Van Yk did offer a seventh and final alternative. Since Noah was not trying to sail anywhere the ark could have been shaped underneath like a modern scow or punt, then slightly rounded and with a building set inside the vessel. Van Yk also took up some issues not considered at length before, raising questions such as where Noah found the funds for the wages and material. He surmised that it must have taken many men and a great deal of wood to build the ark, and being a practical businessman first he concerned himself with very practical matters. He thus pondered how Noah had learned to build a ship, how he got it done before the Flood started even with all that time, and how he knew to start so long beforehand. Van Yk's solution to these problems was not forthcoming: he gave up any hope of answering the questions, turning them over to the theologians, philosophers, and scientists (van Yk 1697, 2–5).

Despair also marked the discussions of those thinkers about answering such questions. In fact the importance of the questions seemed to dimin-

ish, even among dramatists, perhaps because it seemed they could not be answered. Another seventeenth-century Dutch writer, the greatest of all Dutch authors, Joost van Vondel (1587–1679), took up the story of Noah in his last play, *Noah of Ondergang der Eerste Weerelt,* a *"treurspel"* in five acts finished in 1667. A solemn and religious account of the Flood ending with a choral song, it wanders far from the Biblical account (Allen 1963, 151–152), although Vondel himself insisted that he had consulted a number of commentators. He assured his patron that Moses had written the true story of the Flood and that he was presenting that story. On the question of building the ark the foreman or master builder reported Noah to have been hardworking, trustworthy, and brave, a good director of operations who never made anyone feel badly about making a mistake. Sometimes Noah even picked up a tool himself, but the foreman certainly deemed that to be unusual. The foreman and his assistants worked, so the foreman said, from a drawing or plan made by Noah, a plan in which no one could find fault. The discussion of Noah as a shipbuilder ends, as does each act, with a chorus of angels (Vondel 1867, 11:23–26, 35–46). The play made Noah into a shipbuilder of Vondel's day, but it also suggested by its topic, by the questions treated, that the Bible story was more about morality than about technology.

Noah's Flood, an "opera" by Edward Ecclestone published in London in 1679, just a dozen years after Vondel finished his play, took this dramatic trend even further. Lucifer, Satan, Beelzebub, and others like them are the principal characters; Noah's family does not appear. The dialogue dwells on abstract ideas of sin, death, and redemption, to be made dramatic through effective use of lighting and sound, the details being sketched in the stage directions. While Ecclestone's play does deal in Act Five with the planting of vines and Noah's drunkenness there is no mention anywhere of the building of the ark. The play nevertheless makes abundantly clear that pride leads to man's doom, since Ecclestone, like the poet John Dryden on whom he relied heavily, considered abstract rather than practical considerations to dominate completely any and all discussion of the Noah story. Incidentally, though the play was reprinted in 1685 under a slightly different title, it appears that it was never performed.

The Search for Accurate Answers

After 1700 writers of technical treatises on shipbuilding rarely if ever bothered with the question of Noah's ark. Witsen and van Yk in the seventeenth century had followed a practice dating back to the early Church

Fathers of looking for a reasonable explanation for what the Bible said. Their knowledge of shipbuilding, which earlier thinkers such as Hugh of Saint Victor or Nicholas of Lyra lacked, showed them that they would not and could not find the answers to basic questions about the nature, form, and structure of the ark. Their own technical knowledge was simply too much at odds with the Genesis story. Writers on shipbuilding were not the only ones who questioned the Bible in the seventeenth century. Spinoza's critical attack on the inspiration of the Pentateuch and the resulting scholarly dispute brought directly into question the historical reliability of the Old Testament. His views were not accepted immediately or by everyone, but the denial of the accuracy of the story of Noah and of the description of the building of the ark changed the character of discussion and made illustrating the construction unnecessary if not impossible. The path to Spinoza's conclusion about the historical accuracy of the Bible had been established not only by the tradition of philological studies begun in the Italian Renaissance but even before that in the continuing and continually falling efforts to answer technical questions raised by the text. Noah's building of the ark was one of the problems that many scholars addressed. The failure of each in turn to make the description in Genesis fit with personal experience and knowledge of ships, shipbuilding, and mathematics, eroded confidence in the text as an historical work (Allen, 1963:60–66). The result was that by the beginning of the eighteenth century artists abandoned efforts to draw pictures or plans of the ark.

From the earliest Christian art in the catacombs to the end of the seventeenth century many western European artists attempted to show what the ark was like and how Noah built it. Those images show the interplay of ideas, technology, and art. The depictions of Noah the shipbuilder are manifestations of thinkers, writers, and artists wrestling with technical questions and with external forces—intellectual, economic, and technical. The most pressing concern evident in the work of the artists and for that matter of writers, theologians, and dramatists was the desire to be realistic. All were convinced about the historical validity of the Bible and so were certain that there was some simple explanation for how Noah built the ark, how it was able to survive forty days in a storm and then some days later to come to rest on a mountain, all while carrying an indeterminate number of animals of many different types. This desire to prove the accuracy of the Biblical story appeared by the fifth century, was in evidence throughout the Middle Ages, and became a passion in the fifteenth and sixteenth centuries. All previous discussion was brought together in long works repeating the same questions as before and offering the same answers. Nicholas of Lyra and Alfonso Tostado, two literal commentators

of the fourteenth and fifteenth centuries, set the pattern for Renaissance exegetes (Allen 1963, 74–91; 142–154). By the seventeenth century the failure to produce a reasonable explanation for the story of Noah and the trend of philological study finally led to skepticism.

Since writers and artists were trying to explain how the story in Genesis could be true they described the events and the construction of the ark on the basis of their own knowledge of shipbuilding techniques. Thus Noah the shipbuilder was understood in terms of contemporary shipbuilders and the ark was generally, at least from the fifth century on and with the rarest exceptions, a contemporary ship. The prevailing contemporary technology was central to artists' attempts to conceptualize concretely the building of the ark, and thus influenced strongly artists' depictions. Similarly the technology was important to the popular conception of Noah and the story of the Deluge. The popular ideas about the Bible were formed by art and drama and by their own knowledge of how things were done around them. All forces combined to make Noah the shipbuilder into a contemporary craftsman with all the talents, skills, and limitations of a shipwright of the time. Since changes in shipbuilding practice were reflected in popular conception and in the work of artists, the iconography of Noah always depended heavily on the shipbuilding technology of the day.

Noah in the North and the South

Noah as a workman was unique to northern Europe. He was shown to be intense, concentrating on his work whether acting alone or joined by others. There is no consistency in the number of workers. Usually Noah was shown alone, but in some cases he was supported by one or more younger men. The number of assistants was not central to the story of Noah. Extra workmen were not Biblical nor were they necessarily Noah's sons, though that is what a number of artists and a few English dramatists had in mind.

Northern European artists were heavily influenced by the Cotton Genesis or a manuscript directly descended from it, the same or virtually the same source that was available to their counterparts in the South. Yet when faced with the late antique source northern European artists, and most notably English artists, handled it very differently than did painters and mosaicists in Italy: they made Noah a carpenter, putting in his hands the simple tools typical of the shipcarpenter. The standard piece of equipment for Noah was a T-ax, a tool for shaping wood rather than for cutting it. The size and the shape of the T-ax varied from illustration to illustration

but the differences were not great. If there was any change it was that over time Noah came to be shown using different and more complex tools. In all cases he did the day-to-day work of a shipcarpenter, and often the lowest of tasks in the trade. The shaping of planks with a T-ax was a final step, nearly *the* final step, in the process of putting together a clinker-built boat. An adze turns up rarely; as a less accurate tool it was less useful (Mercer 1960, 81–93, 179–180). T-axes themselves, though the handier tool, disappeared from the tool kits of builders by the seventeenth century—truly medieval instruments.

Northern European pictures of Noah did not show any sort of complex, large scale, or advanced equipment. It would be too much to expect slipways, drydocks, or cradles for hauling ships out of the water, all of which were not used until the sixteenth century in the North. The few cases that do depict the stocks on which Noah's ark sits show them as primitive supports. At the end of the fifteenth century the Nuremberg Chronicles illustration shows the workers sitting on a raft while doing final work on the ship, including caulking. The northern European Noah is never shown using a saw, either two-man or one-man, until the odd and plagiarized mid seventeenth-century illustration by DeVos. The Bible mentions explicitly the need to cover the ark with bitumen both inside and out and yet only on the doors at Sainte Chapelle in Paris did any medieval artist in northern Europe depict the process. The absence of saws and caulking irons in the North can best be explained by the dominant technology of northern European shipbuilding. When caulking does appear, as with the late fifteenth-century Nuremburg Chronicles, the vessel is clearly skeleton-built. By that time the southern building technique had been transferred to northern Europe.

Noah was virtually a different man in southern Europe. He did have his beard and long hair but already by the eleventh century the representations of Noah put him distinctly outside the job of building the ark—sometimes literally outside the frame of the scene. Artists showed him to be bigger than the other figures and wearing different clothes, usually a long flowing robe instead of the closer fitting work clothes of the laborers. In northern Europe in some cases Noah did appear in a robe to hear the command of God, but in the next step in the story he is depicted as having taken it off to go to work. He kept his robe in southern European pictures. In the South artists never showed Noah alone building the ark. There were always other workers present, even in the rare cases where Noah had a tool in his hand—the sentiment being, it seems, the greater the number of workers the better. Noah is depicted as the transmitter of God's com-

mands to the men building the ark, and as the director of operations he always stands erect, is seated, or is even enthroned. When southern artists represent Noah listening to God or the angel of God he is usually kneeling or bent slightly, while in northern Europe Noah only bends to use his ax. In the South the position of Noah's hands served to indicate the direction of the action. He usually points, establishing the principal line of the work, clearly manifesting by his pointing his position as overseer of laborers. Composition and the relatively large size of Noah almost always created a distance between Noah and the work site, and definitely between Noah and the workmen. The operation of building the ark was more complex in the works of southern European artists. The larger number of workers and the greater variety of tools demonstrated that complexity. T-axes and other types of axes, adzes, claw hammers, frame saws, one-man bow saws, as well as other types of saws all show up in the southern representations (Mercer 1960, 16–23, 31–33, 149–150; Moll 1930, 167).

Southern Europeans borrowed the composition for their pictures of Noah building the ark from the classical past. The paintings in the Upper Church at Assisi, which owed much to direct inspiration from the late antique model of Saint Paul's Outside the Walls in Rome, is only the most obvious and most easily documented case. The artists of the Church of Saint Francis had recently worked in Rome and the similarities between the sixth-century depiction and the one at Assisi are unmistakable. It did not take the recovery of knowledge of Saint Paul's Outside the Walls to establish late antique influence, however. It was not just that artists of the Renaissance were attempting to harken back to some classical source. The late antique composition of the scene of building the ark, and even the idea of having a progression of Old Testament scenes depicting those who prefigured Christ, survived in Italy throughout the Middle Ages. The ivories at Salerno, the fresco at Ferentillo, and the mosaic at Venice all demonstrate the survival of the late antique form. By the fourteenth and fifteenth centuries, however, artists were making a conscious effort to imitate classical style, and yet to represent reality faithfully.

Noah did not lose his symbolic value in the Renaissance. He was still thought of as being obedient as well as patient, as he had been throughout the Middle Ages. On the other hand he did not represent probity or even penitence. In northern Europe through the act of labor, of actually using his muscles to shape wood, Noah might have been seen as a righteous man and even perhaps as atoning for the sins of the world. This was never true in the South, since Noah hardly ever appeared at work. In addition to functioning as a symbol of obedience, at least by the Renaissance in

southern Europe Noah had become a representative of the creative power of God, of human beings and especially of the artist.

Shipbuilders and Economic Change

Beginning in the tenth century, Italy enjoyed a period of economic expansion that included a long-term growth in trade, commerce, and shipping. The development led to a greater division of labor and of function, and ultimately to a reconsideration of the place of different sorts of labor in the salvation of a Christian's soul. The new forms of business contracts that came into use in Italy laid the basis for extensive investment in trading and for drawing many different types of people into commerce. By the thirteenth century, for example, there were specialized carriers, men who promised to convey goods for a fee from one specified place to another within a specified period of time. They had no interest in the buying or selling of the goods. The owner, or owners if there was an effort to distribute risk, of a ship could by that time be very different from the operator of the ship, and most likely would be different from the builder of the ship (DeRoover 1942, 34–39; Lopez 1971, 56–122). God ordered Noah to build a ship. In Venice or any large Italian port in the thirteenth century such a decision would have led to placing an order with a builder. The builder would have worked under the supervision or direction of the buyer or a representative of the buyer or buyers' syndicate. This was the experience of the Crusaders when they hired transportation to the Levant. Saint Louis, the king of France, and other crusaders like him laid down certain requirements for the needed ships and the rest was left in the hands of the builders in Italian ports, who worked to fulfill the conditions of their contracts (Pryor 1984, 171). A thirteenth-century Venetian reading Genesis would have seen Noah as the buyer and future operator of the ship, to his mind having no part in the specialist work of building the ship.

Technological change and practice in the shipbuilding industry that came as a result of the economic development of the high Middle Ages was completely congruent with the late antique way of depicting Noah as a shipbuilder. Since the two were consistent there was no reason to change the way Noah appeared in art. The growth and expansion of the Mediterranean economy from the tenth century made it possible for artists to feel comfortable in showing Noah the way artists had done in the fifth and sixth centuries. It also made their public comfortable with what the artists produced.

Medieval artists showed Noah building a wide range of ship types. The changes in the ships depicted reflected the long-term evolution of not only

ship design but also ship use. The evolution of the economy directed the choices of ship types made by the shippers who bought the products of Europe's shipyards. In the North vessels like Viking longships in various forms appeared up to the high Middle Ages, giving way to cogs and by the fourteenth century even, on occasion, to a hulk. In the South Noah built both relatively long vessels like cargo galleys and relatively short vessels like round ships. From the Renaissance on everywhere in Europe Noah typically built a full-rigged ship. Artists, it seems, wanted to show the patriarch fashioning the most important large ship of the day, using the most advanced technology in building the ark. All of the arks on which Noah worked alone in northern European depictions were clinker-built. Planks were overlapping, as was common medieval practice in that part of the Continent. Since the shell construction method dominated there, so did it dominate in the pictures of Noah building the ark. One major advantage of this method was that each plank could be individually shaped to fit the one below it, the reason the T-ax appears so often in Noah's hand.

In southern Europe the ships had smooth hulls. Skeleton construction came to be known from the late Roman period on and dominated the region after the tenth century. The Octateuch picture of Noah building the ark shows an unmistakable mold already in place before the planks were added (Fig. 4); for skeleton construction frames or molds had to be set up first. The building method in the South made the shipbuilder the man who decided on the form of the ship. It was highly skilled work, much harder and more responsible than the simple task of cutting the planks to fit onto the molds. The Mediterranean shipbuilder, and by analogy Noah, rose to being more than just a craftsman. Design became a conscious act in the process of building a ship, and thus came to be depicted as a conscious act for Noah in the illustrations.

The presence of the frame pit-saw in southern pictures is not solely because of late antique influence. Planks, which were bent and pinned to the frames, were first sawn. In the North builders did not saw the planks. They needed stronger strakes for their hulls since it was those pieces of wood that were the source of the ship's strength. Shipwrights split logs to guarantee the strength of their planks and then shaped them with a T-ax or sometimes an adze. In the South builders could and did cut with saws, only doing some final and minor shaping with axes and adzes. The planks were cut to fit the molds rather than shaped to fit on to other planks. In the South Noah's assistants did on occasion appear to be caulking the seams of the ship. In that as in so many other ways the depiction of Noah followed the patterns of shipbuilding and ship owning in Europe, both north and south.

9
Ideas, Artists, and Technology

The place of the shipbuilder in the process of constructing a ship, the place of the shipbuilder on the shipbuilding wharf in medieval and Renaissance Europe, was consistent with the composition of depictions of Noah as a shipbuilder, consistent both geographically and temporally. The exceptions to the pattern, the oddities of some depictions of building the ark that do not fit the general progression of technical change, typically come from southern Europe. Yet despite those few cases a pattern did exist. The representation of Noah did reflect technical change in European shipbuilding, and thus can without doubt serve as a source of information about prevailing technology.

Artistic traditions were unquestionably critical for artists in deciding how to deal with Noah. When in doubt, when unfamiliar with certain aspects of their chosen subject matter, they followed what was done before, often influenced as well by the encouragement of their patrons to adhere to what was known. Prevailing thought laid down guidelines and constraints for artists depicting Noah the shipbuilder. The influence of ideas on iconography has long been recognized and has long been a subject of debate, both in general and in dealing with particular cases. Art historians have for many years commented on the importance of theology to medieval art and political thought as a critical factor in determining the topics, form, scope, and character of illustrations. There can be no question that strong ties do exist between the history of ideas and the history of art. There is always, however, more to be found and considered in the work of artists than reflections of Christian thought, such as the extent to which prevailing social and economic relations and conditions set the bounds for particular artists. These conditions in turn were strongly influenced and shaped by technology.

Medieval and Renaissance artists as much as theologians and dramatists wanted to explain the Bible. For artists it was a matter of explaining the texts not only to themselves but also to a wider public. The medium, the form did not matter to them so much as did composing a memorable image—whether it be a painting, a mosaic, a narrative poem, or a play—from which the Christian might learn (Kolve 1984, 198). Artists turned to contemporary science and technology to help them in the task of reaching as many souls as possible, a tendency that can be seen from the typological arguments of the Church Fathers down to the exact technical arguments of van Yk at the end of the seventeenth century. The result was a long series of pictures of Noah building the ark that were surprisingly consistent with contemporary technology, that followed the changes in shipbuilding practice in general and even in some particulars, such as the use of certain tools.

For art historians to understand what medieval artists did, at least in this case and one suspects in most cases, it is necessary for them to know about the dominant technology. To understand the iconography of Noah in medieval and Renaissance Europe, for example, it is necessary to understand shipbuilding technology. Representation of Noah did change over time because of changing views about art and its function. The concern of artists for representation of all of nature and with it the concern for representation of technology went through two major changes, the first in the twelfth-century renaissance and the second in the Renaissance. Artists were in both cases following and reflecting the new views of theologians and philosophers about nature, ideas that are extremely helpful in interpreting the trends in artistic representation of technology. For depictions of Noah as a shipbuilder, however, neither the new ideas about the mechanical arts of Hugh of Saint Victor and his contemporaries nor the new views about the function of art in Quattrocento Italy are adequate for explaining artists' choices. While historians who rely on the statements of theologians are not wrong in what they say about the contemporary understanding of technology, they do miss the powerful influence of changes in technology itself that affected views of technology. These in turn changed popular ideas about technology, ideas that were represented in art.

Pictures of Noah building the ark show that the comprehension of Noah, his function, his actions, his importance, and his value as a symbol may have changed over time, but that views about technology, as represented by Noah the technician, remained largely consistent throughout the Middle Ages. Classical ideas about technology that showed up in late antique works of art were carried on for centuries. Artists did not feel compelled, because of some new view of nature, to give Noah novel treatment.

In fact the force that apparently did lead at the end of the Middle Ages to a new approach to the patriarch in the act of building the ark was change in shipbuilding technology itself. Artistic representations of Noah have more to them than merely a shift in ideas about technology and the relationship of people to nature. Artists from the end of the Roman Empire through to the end of the seventeenth century relied on a variety of different sources of inspiration—intellectual, theological, artistic, and practical—and all in varying measure over time. That they could be original and inventive even within those constraints is made abundantly clear by the long catalogue of depictions of Noah building the ark, which shows both the evolution of style in medieval art and the skill and inventiveness of medieval artists. The depictions reveal in microcosm the development over the long term of both medieval art and medieval shipbuilding technology. They form a body of invaluable information in following the inventiveness of medieval technologists.

The representations of shipbuilding are the principal source recording the transformation of ship design from the late Roman Empire through the sixteenth century and more than by default. Artists throughout the Middle Ages felt obliged to reflect contemporary technology in their work. Consciously or unconsciously they also provided evidence of changes in the social and economic relations that prevailed in the workplace. The depictions of Noah building the ark show, if to a limited degree, the development over the long term of the changing status of craftsmen, and give the basis for explaining the change in that status. In depicting Noah artists also presented the historian with a great deal of data about technology and what that technology meant to society.

Noah served as a valuable symbol both in Christian thought and in art. The iconography of Noah never escaped that function, nor did the iconography of Noah the shipbuilder ever escape the question of the role of work, of labor in Christian life. An important aspect of the symbolic weight of Noah was his role as a craftsman, a creator. The depictions of Noah in various forms and in various media show the direct, intimate, and inseparable bond between art and technology. Not only did technology serve as an inspiration for artists and direct the shape of the society depicted in the works of artists, it also served to inform the entire approach and understanding of the artist. The artist created or recreated, for the education of Christian souls, a symbolic Noah. In so doing they were representing another craftsman working with tools in various way to create an object. The history of the way artists dealt with Noah as a shipbuilder may make obvious the close interdependence of the two worlds of art and technology.

Certainly the catalogue of the depictions of Noah the shipbuilder demonstrates the pitfalls and problems of exploring that interdependence. These depictions, in all their seeming variety, do prove to be a good example of the extent to which the history of art and its objects of study can be helpful in the study of the history of technology, and what in turn the history of technology can do to aid in understanding the art of medieval Europe.

Bibliography

Alexander, J.J.G., and C. M. Kauffmann. 1973. *English Illuminated Manuscripts 700–1500*. Brussels: Bibliotheque Royal Albert I er.

Allard, G. H. 1982. "Les Artes Mécaniques aux Yeux de L'Idéologie Médiévale." In *Les Arts Mécaniques au Moyen Âge*. Cahiers d'études médiévales, no. 7 : 13–31. Montréal: Bellarmin.

Allen, D. C. 1963. *The Legend of Noah. Renaissance Rationalism in Art, Science, and Letters*. Urbana: University of Illinois Press.

Ambrose. *De Noe et Arce. Patrologia Latina, (Patrologiae cursus completus)* ed. J. P. Migne, 14. 381–438. Paris: Garnier, 1844–1864.

Anderson, B. W. 1978. "From Analysis to Synthesis: The Intrepretation of Genesis 1–11." *Journal of Biblical Literature* 97, 1 : 23–39.

Anthony, E. W. 1927. *Early Florentine Architecture and Decoration*. Cambridge MA: Harvard University Press.

——. 1935. *A History of Mosaics*. Boston: Porter Sargent.

Arslan, E. 1960. *I Bassano*. 2 vols. Milan: Ceschina.

Asaert, G. 1974. *Westeuropese scheepvaart in de middeleeuwen*. Bussum: Unieboek.

Augustine. 1950. *The City of God*, trans. Marcus Dods. New York: The Modern Library.

——. *De Agone Christiano. Patrologia Latina (Patrologiae cursus completus)*, ed. J. P. Migne, 40. 289–310.

——. *De Catechizandis Rudibus. Patrologia Latina (Patrologiae cursus completus)*, ed. J. P. Migne, 40. 309–348.

Axton, R. 1974. *European Drama of the Early Middle Ages*. London: Hutchison University Library.

Babelon, J.-P. 1968. "Sainte-Chapelle (LA)." In *Ouest et Ile-De-France, Dictionnaire des Églises de France*, vol. 4 : c56–61. Paris: Robert Laffont.

Baccheschi, E. 1971. *L'Opera Completa di Guido Reni*. Milan: Rizzoli Editore.

Baker, M. 1585. *Fragments of English Shipwrightry*. Magdalene College, Cambridge University, Pepys Library, no. 2820.

Baldass, L. 1920. *Die Wiener Gobelinssammlung Dreihundert Bildtafeln mit Beschrei-*

bendem Text und Wissenschaftlichen Anmerkungen. Vienna: Österreichische Verlagsgesellschaft Ed. Hölzel und Co.

Basch, L. 1972. "Ancient wrecks and the archaeology of ships." *The International Journal of Nautical Archaeology,* 1 : 1–58.

Bass, G. F., and F. H. van Doorninck. 1978. "An 11th century shipwreck at Serçe Liman, Turkey." *The International Journal of Nautical Archaeology,* 7 : 119–132.

Beaujouan, G. 1975. "Réflexions sur les rapports entre théorie et pratique au moyen âge." In *The Cultural Context of Medieval Learning, Proceedings of the First International Colloquium on Philosophy, Science, and Theology in the Middle Ages,* ed. J. E. Murdoch and E. D. Sylla, 437–477. Dordrecht: D. Reidel Publishing Company.

Bechtel, F. 1911. "Noe." In *Catholic Encyclopedia.* New York: Robert Appleton.

Bell, D. 1976. *The Cultural Contradictions of Capitalism.* New York: Basic Books, Inc.

Belting, H. 1977. *Die Oberkirche von San Francesco in Assisi Ihre Dekoration als Aufgabe und die Genese einer neuen Wandmalerei.* Berlin: Mann Verlag.

Benesch, O. 1947. *The Art of the Renaissance in Northern Europe: Its Relation to the Contemporary Spiritual and Intellectual Movements.* 2d printing. Cambridge, MA: Harvard University Press.

Benzon, J. 1594. *Americae Pars Qvarta Insignis & Admiranda Historia de reperta primum Occidentali India a Christphoro Columbo Ann MCCCXCII. . . . Omnia elegantibus figuris in æs incisis expressa a Theodoro de Bry Leondiense.* Frankfurt: Theodore DeBry.

Berenson, B. 1957. *Italian Pictures of the Renaissance: Venetian School.* London: Phaidon Press.

Bergman, R. P. 1980. *The Salerno Ivories Ars Sacra from Medieval Amalfi.* Cambridge, MA: Harvard University Press.

Bergot, F. 1974. *Le dossier d'Un tableau Saint Luc peignant la Vierge de Martin van Heemskerck.* Rennes: Musée de Rennes.

Bettini, S. 1944(a). *Giusto De' Menabuoi e l'arte del trecento.* Padua: "Le Tre Venezie."

———. 1944(b). *Mosaici antichi de San Marco a Venezia.* Bergamo: Instituto Italian D'Arti Grafiche.

Beylen, J. van. 1961. "De Uitbeelding en de Dokumentaire Waarde van Schepen Bij Enkele Oude Meesters." *Bulletin Musées royaux des beaux-arts de Belgique,* 10 : 123–150.

Bise, G., and E. Irblich. 1979. *The Illuminated Naples Bible.* trans. G. Ivins and D. MacRae. New York: Crescent Books.

Boase, T. S. R. 1953. *English Art 1100–1216.* Oxford: Clarendon Press.

Bourguet, P. du. 1965. *Early Christian Painting.* trans. S. W. Taylor. London: Weidenfeld and Nicolson.

Branner, R. 1977. *Manuscript Painting in Paris During the Reign of Saint Louis: A Study of Styles.* Berkeley: University of California Press.

Bredius, A. 1969. *Rembrandt, The Complete Edition of the Paintings,* rev. H. Gerson. London: Phaidon Press.

Brion, M., and H. Heimann. 1956. *The Bible in Art Miniatures, Paintings, Drawings and Sculptures inspired by the Old Testament.* London: Phaidon.

Brøgger, A. W., and H. Shetelig. 1971. *The Viking Ships, Their Ancestry and Evolution.* Oslo: Dreyers Forlag.

Bucci, M., and L. Bertolini. 1960. *Camposanto monumentale di Pisa; affreschi e sinopie*, ed. G. Ramalli. Pisa: Opera della Primaziale.

Bucher, F. 1970. *The Pamplona Bibles*. New Haven: Yale University Press.

Buchthal, H. 1957. *Miniature Painting in the Latin Kingdom of Jerusalem*. Oxford: Clarendon Press.

Bynum, C. W. 1982. *Jesus as Mother: Studies in the Spirituality of the High Middle Ages*. Berkeley: University of California Press.

Calvin, J. 1863–1900. *Opera quae supersunt omnia*, ed. G. Baum, E. Cunitz and E. Reuss. 59 vols. Braunschweig and Berlin: C. A. Schwetschke et Filium.

Cantor, M. 1892. *Vorlesungen über Geschichte der Mathematik. Vol. 2, 1200–1668*. Leipzig: Verlag von B. G. Teubner.

Cartwright, J. 1895. *Raphael*. London: Seeley and Company.

Casson, L. 1959. *The Ancient Mariners: Seafarers and Sea Fighters of the Mediterranean in Ancient Times*. London: Victor Gollancz, Ltd.

———. 1971. *Ships and Seamanship in the Ancient World*. Princeton: Princeton University Press.

Cassuto, U. 1961. *A Commentary on the Book of Genesis*, trans. I. Abrahams. 2 vols. Jerusalem: The Magnes Press, The Hebrew University. First Hebrew edition 1944.

Chatterton, E. K. 1967. *Old Ship Prints*. 2d ed. London: Spring Books.

Chaucer, G. 1957. *The Works of Geoffrey Chaucer*, ed. F. N. Robinson. Boston: Houghton Mifflin Company.

Chenu, M.-D. 1968. *Nature, Man and Society in the Twelfth Century: Essays on New Theological Perspectives in the Latin West*. ed. and trans. J. Taylor and L. K. Little. Chicago: University of Chicago Press.

Christensen, A. E. 1973. "Lucien Basch: Ancient wrecks and the archaeology of ships: A Comment." *The International Journal of Nautical Archeology*, 2: 137–145.

Cipolla, C. M. 1980. *Before the Industrial Revolution: European Society and Economy, 1000–1700*. 2d ed. New York: W. W. Norton and Company.

Cockerell, S. C. 1907. *The Gorleston Psalter*. London: Chiswick Press.

Cockerell, S. C., and J. Plummer. 1969. *Old Testament Miniatures: A Medieval Picture Book with 283 Paintings, from the Creation to the Story of David*. New York: George Braziller.

Cohen, H. H. 1974. *The Drunkenness of Noah*. University, AL: The University of Alabama Press.

Crick-Kitzinger, M. 1930. "Bibliographie: Marjan Morelowski, Niezany karton do arasow serji "Potopu" a Coxyen i Tons. Krakow, 1930. 12 pages, 2 planches." Brussels. *Musées royaux d'art et d'histoire. Bulletin*, 3d ser., 2: 167–171.

———. 1947. "Une tapisserie Bruxelloise de l'historie de Noé." Brussels. *Musées royaux d'art et d'histoire*. Bulletin, 4th ser. 19: 20–25.

Crombie, A. C. 1980. "Science and the Arts in the Renaissance: The Search for Truth and Certainty, Old and New." *History of Science*, 18: 233–246.

Crumlin-Pederson, O. 1978. "The Ships of the Vikings." In *The Vikings*, ed. T. Anderson and K. I. Sandred, 32–41. Uppsala: Uppsala University.

Cyprian. 1958. *Treatises*. ed. and trans. R. J. Deferrari. New York: Fathers of the Church, Inc.

Dalton, O. M. 1911. *Byzantine Art and Archaeology*. Oxford: Clarendon Press.

Daniel, H. 1971. *Encyclopaedia of Themes and Subjects in Painting*. London: Thames and Hudson.

Daniélou, J. 1956. *The Bible and the Liturgy*. Notre Dame, IN: University of Notre Dame Press.

——. [1947]. "Déluge, baptême, jugement." *Dieu vivant*, 95–112.

——. 1957. *Holy Pagans of the Old Testament*. trans. Felix Faber. New York: Longmans Green and Co.

——. 1977. *The Origins of Latin Christianity: A History of Early Christian Doctrine Before the Council of Nicea*, vol. 3. trans. D. Smith and J. A. Baker. London: Darton, Longman and Todd.

——. 1958. *Philon D'Alexandre*. Paris: Librarie Arthème Fayard.

——. 1964. *Primitive Christian Symbols*. trans. D. Attwater. Baltimore: Helicon Press.

Daumas, M. 1976. "The History of Technology: its Aims, its Limits, its Methods," trans. A. R. Hall. *The History of Technology*, 1 : 85–112.

Daut, R., ed. 1972. "Noe (Noah)." *Lexikon der Christlichen Ikonographie*, ed. E. Kirschbaum, vol. 4: 611–614. Rome: Herder.

Davis, N., ed. 1970. *Non-Cycle Plays and Fragments*. London: Oxford University Press.

DeBry, T. 1976. *Discovering the New World*, ed. Michael Alexander. New York: Harper and Row.

Delaporte, Y. 1926. *Les Vitraux de la Cathédrale de Chartres*. 3 vols. Chartres: E. Houvet.

Demus, O. 1984. *The Mosaics of San Marco in Venice*. 2 vols. Chicago: University of Chicago Press.

DeRoover, R. 1942. "The Commercial Revolution of the 13th Century." *Bulletin of the Business Historical Society*, 16 : 34–39.

Deuchler, F. 1967. *Der Ingeborgpsalter*. Berlin: Walter de Gruyter and Co.

D'Hulst, R.-A. 1967. *Flemish Tapestries from the Fifteenth to the Eighteenth Century*. Brussels: Editions Arcade.

DiMarco, V. "Uxor Noah Rediviva: Some Comments on Her Creation and Development." *Literaturwissenschaftliches Jahrbuch*, New Series, 21 : 21–37.

Dodgson, C. 1929. "Holbein's Early Illustrations to the Old Testament." *Burlington Magazine*, 55 : 176–181.

Dodwell, C. R. 1911. "L'Originalité iconographique de plusieurs illustrations anglo-saxons de l'Ancien Testament." *Cahiers de civilisation médiévale Xe–XIIe siècles*, 14 : 319–328.

Doorninck, F. H. van. 1976. "The 4th century wreck at Yassi Ada. An interim report on the hull." *The International Journal of Nautical Archaeology*, 5 : 115–131.

Dresbeck, L. 1979. "Techne, Labor et Natura: Ideas and Active Life in the Medieval Winter." *Studies in Medieval and Renaissance History*, New Series, 2 : 81–119.

Drexel, J. 1646. *Noe, der Arche Bawmeister vnd des Sündfluss Schiff Herr*. Munich: N. Heinrich in Verlag J. Wagners.

Duniway, D. C. 1941. "A Study of the Nuremburg Chronicle." *Bibliographical Society of America*, 35 : 17–34.

Durliat, M. 1963. *Art Catalan*. Paris: Arthuad

Dussler, L. 1971. *Raphael. A Critical Catalogue of his Pictures, Wall-Paintings and Tapestries*. London and New York: Phaidon Press.

Ecclestone, E. 1679. *Noah's Flood or the Destruction of the World: An Opera*. London: M. Clerk.

Egbert, V. W. 1974. *On the Bridges of Mediaeval Paris. A Record of Early Fourteenth-Century Life*. Princeton: Princeton University Press.

Ehrenstein, T. 1923. *Das Alte Testament Im Bilde*. Vienna: Kunstverlag Albert Kande.

Ellul, J. 1979. "Remarks on Technology and Art." *Social Research*, 46:805–833.

Ewe, H. 1972. *Schiffe auf Siegeln*. Rostock: VEB Hinstorff Verlag.

Farrell, A. W. 1979. "The Use of Iconographic Material in Medieval Ship Archaeology." In *Medieval Ships and Harbours in Northern Europe*, ed. Sean McGrail, 227–246. Oxford: B. A. R.

Fernie, E. C. 1977. "Alexander's Frieze on Lincoln Minster." *Lincolnshire History and Archaeology*, 12:19–28.

Fink, J. 1955. *Noe der Gerechte in der frühchristlichen Kunst*. Münster/Köln: Böhlau-Verlag.

Folena, G., and G. L. Mellini. 1962. *Bibbia Istoriata Padovana Della Fine Del Trecento Pentateuco—Giosuè–Ruth*. Vicenza: Neri Pozza Editore.

Formaggio, D. 1958. *Basiliche di Assisi*. Noavara: Instituto Geografico de Agostini.

Franke, P. 1973. "Bemerkungen zur Frühchristlichen Noe-Ikonographie." *Revista di archaeologia cristiana*, Rome, 49:171–182.

Franklin, J. W. 1958. *The Cathedrals of Italy*. London: B. T. Batsford Ltd.

Friel, I. 1983. "England and the advent of the three-masted ship." In *Proceedings of the 4th International Congress of Maritime Museums, 1981*, 130–138. Paris.

Gardner, A. 1951. *English Medieval Sculpture*, rev. ed. Cambridge, England: Cambridge University Press

———. 1937. *A Handbook of English Medieval Sculpture*. Cambridge, England: Cambridge University Press.

Garff, J. 1971. *Tegninger of Maerten van Heemskerck*. Copenhagen: Museum for Kunst.

Garvin, K. 1934. "A Note on Noah's Wife." *Modern Language Notes*, 49, 1:88–90.

Gille, B. 1969(a). "The Fifteenth and Sixteenth Centuries in the Western World." In *A History of Technology and Invention Progress Through the Ages*, ed. M. Daumas, trans. E. B. Hennessy, vol. 2: 21–148. New York: Crown Publishers Inc.

———. 1969(b). "The Medieval Ages of the West (Fifth Century to 1350)." In *A History of Technology and Invention Progress Through the Ages*, ed. M. Daumas, trans. E. B. Hennessy, vol. 1: 422–574. New York: Crown Publishers Inc.

———. 1978. "Prolégomènes à une Histoire des Techniques." In *Histoire Des Techniques*, ed. B. Gille, 1–118. Paris: Éditions Gallimard.

Gimpel, J. 1976. *The Medieval Machine: The Industrial Revolution of the Middle Ages*. New York: Holt, Rinehard and Winston.

Göbel, H. 1924. *Tapestries of the Lowlands*. trans. Robert West. New York: Hacker Art Books.

Goldschmidt, A. 1975. *Die Elfenbeinskuplturen*. Berlin: Deutscher Verlag für Kunstwissenschaft.

Goodenough, E. R. 1962. *An Introduction to Philo Judaeus*. 2d rev. ed. New York: Barnes and Noble, Inc.

———. 1953. *Jewish Symbols in the Greco-Roman Period*. Vol. 2, *The Archaeological*

Evidence from the Diaspora. (Vol. 3 contains the plates.) New York: Pantheon Books.

Goodman, W. L. 1964. *The History of Woodworking Tools.* London: G. Bell and Sons, Ltd.

Grabar, A. 1951. "Images bibliques d'Apamée et fresques de la synagogue de Doura." *Cahiers Archéologiques,* 5:9–14.

Grabar, A., and C. Nordenfalk. 1958. *Romanesque Painting from the Eleventh to the Thirteenth Century.* Lausanne: SKIRA.

Greenhill, B. 1976. *Archaeology of the Boat. A new introductory study.* London: A. and C. Black Ltd.

Gudiol, J. 1937. "L'art roman." In *L'Art de la Catalogné de la second moitié du neuvième siècle à la fin du quinzième siècle,* ed. Christian Servos, 23–28. Paris: Éditions "Cahiers d'art."

Guillaume, P.-M. 1981. "Noé." *Dictionnaire de Spiritualité,* 378–385. Paris: Beauchesne.

Hagedorn, B. 1914. *Die Entwicklung der wichtigsten Schiffstypen bis ins 19. Jahrhundert.* Berlin: Verlag von Karl Curtis.

Hailperin, H. 1963. *Rashi and the Christian Scholars.* Pittsburgh: University of Pittsburgh Press.

Hall, B. S. 1979. "Der meister sol auch kennen schreiben und lesen: Writings about Technology ca. 1440–ca. 1600 A. D. and their Cultural Implications." In *Early Technologies,* ed. D. Schmandt-Besserat, 47–58. Malibu: Udena Publications.

Hall, B. S., and D. C. West. 1976. "Introduction: Scholarly Underdevelopment and the State of the Field." In *On Pre-Modern Technology and Science Studies in Honor of Lynn White, Jr.* ed. B. S. Hall and D. C. West, 1–8. Malibu: Udena Publications.

Harris, M., trans. 1969. *The Cornish Ordinalia. A Medieval Dramatic Trilogy.* Washington, D.C.: The Catholic University of America Press.

Harrison, F. 1937. *Treasure of Illumination; English Manuscripts of the Fourteenth Century (c. 1250–1400).* London: The Studio Ltd.

Hartt, F. 1950. "Lignum Vitae in Medio Paradisi: The Stanze D'Eliodoro and the Sistine Ceiling." *Art Bulletin,* 32:115–145, 181–218.

Hassall, W. O. 1954. *The Holkham Picture Book.* London: The Dropmore Press.

Hasslöf, O. 1972. "Main Principles in the Technology of Ship-Building." In *Ships and Shipyards, Sailors and Fishermen, Introduction to Maritime Ethnology.* ed. O. Hasslöf, H. Henningsen, A. E. Christensen, 27–72. Copenhagen: Rosenkilde and Baggcr.

———. 1963. "Wrecks, Archives and Living Traditions." *The Mariner's Mirror,* 49: 162–177.

Heinsius, P. 1956. *Das Schiff der Hansischen Frühzeit.* Weimar: Verlag Hermann Böhlaus Nachfolger.

Henderson, G. 1962. "Late Antique Influences in Some English Mediaeval Illustrations of Genesis." *Journal of the Warburg and Courtauld Institutes,* 25:172–198.

Henry, A. 1986. *Biblia Pauperum: A Facsimile and Edition.* Ithaca: Cornell University Press.

Herbert, J. A. 1911. *Illuminated Manuscripts.* London: Methuen and Co. Ltd.

Hohl, H. 1968. "Arche Noe." In *Lexikon der Christlichen Ikonographie,* ed. Engelbert Kirschbaum, 178–180. Rome: Herder.

Hollstein, F. W. H. 1949. *Dutch and Flemish Etchings, Engravings and Woodcuts.* 19 vols. Amsterdam: Menno Hertzberger.

———. 1977. *German Engravings, Etchings and Woodcuts.* 28 vols. Amsterdam: Van Gendt.

Hooyman, R. P. J. 1958. "Die Noe-Darstellung in der Frühchristlichen Kunst Eine christlich-archäologische Abhandlung zu J. Fink: Noe der Gerechte in der frühchristlichen Kunst." *Vigilae Christianae,* 12:113–135.

Hopper, V. F., and G. B. Lahey, eds. 1962. *Medieval Mystery Plays, Morality Plays and Interludes.* Great Neck, N.Y.: Barron's Educational Series, Inc.

Horrall, S. M. 1978. "'A Schippe Behoues de to Dight': Woven Arks of Noah in the Fourteenth Century." *Revue de l'Université d'Ottawa,* 48:202–209.

Hugh of Saint Victor. *De Arca Noe Morali. Patrologia Latina (Patrologiae cursus completus),* ed. J. P. Minge, 167. 617–704.

———. 1961. *The* Didascalicon *of Hugh St. Victor: A Medieval Guide to the Arts.* trans. J. Taylor. New York: Columbia University Press.

———. 1962. *Selected Spiritual Writings.* A Religious of the Community of Saint Mary the Virgin, trans. London: Faber and Faber.

Hughes, T. P. 1964. *The Development of Western Technology Since 1500.* New York: Macmillan Co.

Hülsen, C., and H. Egger. 1975. *Die Römischen Skizzenbücher von Marten van Heemskerck in Königlichen Kupferstichkabinet zu Berlin.* 2 vols. Berlin, 1913. Reprint. Soest: Davaco Publishers.

Husa, V. with Josef Petran and Alena Subrtova. 1967. *Homo Faber.* Prague: Artia Praha.

Jerome. *Dialogus Contra Luciferianos. Patrologia Latina (Patrologiae cursus completus),* ed. J. P. Minge, 23. 163–192.

Jordan, M. D. 1986. *Ordering Wisdom: The Hierarchy of Philosophical Discourses in Aquinas.* Notre Dame, IN: University of Notre Dame Press.

Junquera de Vega, P. "Les Séries de Tapisseries de 'Grotesques' et 'L'Histoire de Noé' De La Couronne D'Espagne." Brussels. *Musées royaux d'art et d'histoire. Bulletin,* 5th ser.: 143–171.

Kapp, F. 1886. *Geschichte der Deutschen Buchhandels bis in das 16. Jahrhundert.* Leipzig: Börsenvereins des Deutschen Buchhändler.

Katzenellenbogen, A. 1961. "Tympanum and Archivolts on the Portal of St. Honoré at Amiens." In *De Artibus Opuscula XL; Essays in Honor of Erwin Panofsky,* ed. M. Meiss, vol. 1: 280–290. New York: New York University Press.

Kendrick, T.D. 1949. *Late Saxon and Viking Art.* London: Methuen and Co. Ltd.

Kitzinger, E. 1966. "The Byzantine Contribution to Western Art of the Twelfth and Thirteenth Centuries." *Dumbarton Oaks Papers,* 20:25–50.

———. 1960. *I Mosaici di Monreale.* Palermo: S. F. Flaccovio.

Klingender, F. D. 1968. *Art and the Industrial Revolution,* ed. and rev. A. Elton. London: Evelyn, Adams and Mackay, Ltd.

Kloss, E., ed. 1925. Speculum Humanae Salvationis: *Ein Niederländisches Blockbuch.* Munich: R. Piper and Co.

Kolve, V. A. 1984. *Chaucer and the Imagery of Narrative: The First Five Canterbury Tales,* Stanford, CA: Stanford University Press.

Kracher, A. 1967. *Millstätter Genesis und Physiologus Handschrift. Vollständige Facsimileausgabe der Sammelhandschrift 6/19 des Geschichtsvereins für Kärnten im Kärntner Landesarchiv, Klagenfurt.* Graz: Akademische Druck- und Verlagsanstalt.

Kraeling, C. H. 1979. *The Synagogue.* New Haven: Ktav Publishing House, Inc.

Kreutz, B. M. 1976. "Ships, Shipping and the Implications of Change in the Early Medieval Mediterranean." *Viator,* 7 : 79–109.

Kunze, H. 1975. *Geschichte der Buchillustration in Deutschland: das 15. Jahrhundert.* 2 vols. Leipzig: Insel.

Küsel, M. 1679. *Icones Biblicae Veteris et Novi Testamenti. Figuren Biblischer Historien Alten und Neuen Testaments.* Augsburg.

Kvet, J. 1959. *Czechoslovakia Romanesque and Gothic Illuminated Manuscripts.* UNESCO World Art Series. New York: New York Graphic Society.

Landsberger, F. 1961. "The Illumination of Hebrew Manuscripts in the Middle Ages and Renaissance." In *Jewish Art An illustrated history,* ed. Cecil Roth, 374–454. Tel Aviv: Massadah-P. E. C. Press, Ltd.

Layton, E. T., Jr. 1974. "Technology as Knowledge." *Technology and Culture,* 15 : 31–41.

Leclerq, H. 1924. "Arche." In *Dictionnaire D'Archéologie Chrétienne et De Liturgie,* vol. 1, 2: 2709–2732. Paris: Librairie Letouzey et Ané.

LeGoff, J. 1980. *Time, Work, and Culture in the Middle Ages.* trans. A. Goldhammer. Chicago: University of Chicago Press.

Lessing, E. 1968. *The Story of Noah told in Photographs.* New York: Time-Life Books.

Levinson-Lessing, V. F. 1965. *The Hermitage, Leningrad: Baroque and Rococo Masters.* London: Paul Hamlyn.

Lewis, J. P. 1968. *A Study of the Interpretation of Noah and the Flood in Jewish and Christian Literature.* Leiden: E. J. Brill.

Liberani, M. 1967. "Noè: Iconografia." In *Bibliotheca Sanctorum,* 9: 1028–1041. Rome: Istituto Giovanni XXIII della Pontificia Università Lateranense.

Lopez, R. S. 1971. *The Commercial Revolution of the Middle Ages, 950–1350.* Englewood Cliffs, N.J.: Prentice-Hall, Inc.

Lusignan, S. 1982. "Les Arts Mécaniques dans le *Speculum Doctrinale* de Vincent de Beauvais." In *Les Arts Mécaniques au Moyen Âge.* Cahiers d'études médiévales, no. 7: 33–48. Montréal: Bellarmin

Luther, M. 1911. *Werke Kritische Gesamtausgabe.* Weimar: Hermann Böhlaus Nachfolger.

Lutz, J., and P. Perdrizet. 1907. Speculum Humanae Salvationis: *Kritische Ausgabe Übersetzung von Jean Mielot (1448), De Quellen des Speculums und seine Bedeutung in der Ikonographie besonders in der elsässische Kunst des XIV Jahrhunderts.* Mulhouse: Buchdruckerei Ernest Meininger.

Mahony, J. H. 1967. "Nicholas of Lyra." In *New Catholic Encyclopedia,* vol. 10: 453–454. New York: McGraw-Hill Book Company.

Mangenot, E. 1912. "Arche de Noé." In *Dictionnaire De La Bible.* ed. F. Vigouroux, vol. 1, 1: 923–926. Paris: Letouzey et Ané.

Marabottini, A. 1969. "Raphael's Collaborators." In *The Complete Work of Raphael,* 199–301. New York: Reynal and Company.

Marsden, P. 1976. "A boat of the Roman period found at Bruges, Belgium, in 1899, and related types." *The International Journal of Nautical Archaelogy,* 5 : 23–56.

——. 1972. "Ships of the Roman period and after in Britain." In *A History of Seafaring based on Underwater Archaeology*, ed. George Bass, 113–132. London: Thames and Hudson.

Meiss, M. 1972. *The De Lévis Hours and the Bedford Workshop*. New Haven: Yale University Press.

——. 1974. *French Painting in the Time of Jean De Berry: The Limbourgs and Their Contemporaries*. 2 vols. London: Thames and Hudson.

Mellinkoff, R. 1970. *The Horned Moses in Medieval Art and Thought*. Berkeley: University of California Press.

——. 1981. *The Mark of Cain*. Berkeley: University of California Press.

Mercer, H. C. 1960. *Ancient Carpenters' Tools. Illustrated and Explained with the Implements of the Lumberman, Joiner and Cabinetmaker in Use in the Eighteenth Century*. Doylestown, PA: The Bucks County Historical Society.

Millar, E. G. 1928. *La Miniature Anglaise au XIVe et XVe Siècles*, trans. Jean Buhot, Paris: Les Éditions G. Van Oest.

Misiag-Bochenska, Anna. 1972. "Tapisseries historiées: scènes de la Genèse." In *Les Tapisseries Flammandes au Chateau du Wawel à Cracovie Trésors du roi Sigismond II Auguste Jagellon*, ed. Jerzy Szablowski, 73–187. Antwerp: Fonds Mercator S.A.

Moll, F. 1929. *Das Schiff in der Bildenden Kunst vom Altertum bis zum Ausgang des Mittelalters*. Bonn: Kurt Schroeder.

——. 1930. "Der Schiffbauer in der bildenden Kunst." *Deutsches Museum Abhandlungen und Berichte*, :153–177.

Morey, C. R. 1953. *Early Christian Art. An Outline of the Evolution of Style and Iconography in Sculpture and Painting from Antiquity to the Eighth Century*. Princeton: Princeton University Press.

——. 1959. *The Gold-Glass Collection of the Vatican Library, with additional catalogues of other gold-glass collections*. Vatican City: Biblioteca Apostolica Vaticana.

Morgan, N. 1982. *Early Gothic Manuscripts [I] 1190–1250*. Oxford: Oxford University Press.

Müller, D. H., and J. v. Schlosser. 1898. *Die Haggadah von Sarajevo: Eine Spanisch-Jüdische Bilderhandschrift des Mittelalters*. Vienna: Alfred Hölder.

Multhauf, R. P. 1974. "Some Observations on the State of the History of Technology." *Technology and Culture*, 15: 1–12.

Mumford, L. 1986. "Art and Technics." In *The Lewis Mumford Reader*. ed. Donald L. Miller, 348–361. New York: Pantheon Books.

Murphy, C. C. R. 1946. "What Is Gopher Wood?" *Asiatic Review*, 42, 149:79–81.

Musper, H. T. 1961. *Die Urausgaben der holländischen Apokalypse und Biblia pauperum*. Munich: Prestel-Verlag.

Mussini, M. 1979. *La Bibbie di Raffaello: Suenza e Scrittura vella Stampa di riproduzioni die XVI et XVII*. Brescia: Paideia.

Nance, R. M. 1955. "The Ships of the Renaissance." *The Mariner's Mirror*, 41: 180–192, 281–298.

Nelson, A. H. 1974. *The Medieval English Stage. Corpus Christi Pageants and Plays*. Chicago: The University of Chicago Press.

Oakeshott, W. 1972. *Sigena; Romanesque Paintings in Spain and the Winchester Bible Artists*. London: Harvey Miller and Medcalf.

Omer, M. 1975. "Turner and 'The Building of the Ark' from Raphael's Third Vault of the Loggia." *Burlington Magazine,* 117:694–702.

Oppé, A. P. 1970. *Raphael.* ed. Charles Mitchell. London: Elek Books.

Ovitt, G., Jr. 1987. *The Restoration of Perfection: Labor and Technology in Medieval Culture.* New Brunswick, N.J.: Rutgers University Press.

Pächt, O. 1961. "A Cycle of English Frescoes in Spain." *Burlington Magazine,* 103: 166–175.

——. 1943. "A Giottesque Episode in English Mediaeval Art." *Journal of the Warburg and Courtauld Institutes,* 6:51–70.

——. 1962. *The Rise of Pictorial Narrative in Twelfth-Century England.* Oxford: Clarendon Press.

Pächt, O. and J. J. G. Alexander. 1966–1973. *Illuminated Manuscripts in the Bodleian Library Oxford.* 3 vols. Oxford: Clarendon Press.

Panofsky, E. 1962. "Artist, Scientist, Genius: Notes on the 'Renaissance-Dämmerung'." In *The Renaissance: Six Essays, 121–182.* New York: Harper and Row.

Parrot, A. 1955. *The Flood and Noah's Ark.* London: SCM.

Petit de Julleville, L. 1880. *Les Mystères.* 2 vols. Paris: Librairie Hachette et Cie.

Petkovic, V. R., and G. Boskovic. 1941. *Decani.* Belgrade: Academie Raeglis Serbica.

Pfister, K. 1924. *Katakomben Malerei.* Potsdam: Gustav Kiepenheuer Verlag.

Pianzola, M. 1961. *Bauern und Künstler die Künstler der Renaissance und der Bauern-krieg von 1525.* Berlin: Henschelverlag.

Pillet, C.-M. [n.d.]. "Buteo(Jean)." *Biographie Universalle Ancienne et Moderne.* ed. Louis Gabriel Michaud, vol. 6: 250. Paris: Madame C. Desplaces.

Pope-Hennessy, J. 1970. *Raphael.* New York: New York University Press.

Porter, A. K. 1923. *Romanesque Sculpture of the Pilgrimage Roads.* Boston: Marshall Jones.

Portmann, P. 1963. *Meister Bertram.* Zurich: rabe verlag.

——. 1961. *The Nativity Master Bertram.* Berne: Hallweg.

Preibisz, L. 1911. *Martin v. Heemskerck: Ein Beitrag zur Geschichte des Romanismus in der Niederländischen Malerei Des XVI Jahrhunderts.* Leipzig: Klinkhardt und Biermann.

Price, D. D. 1974. "On the Historiographic Revolution in the History of Technology." *Technology and Culture,* 15: 42–48.

Prior, E. S., and A. Gardner. 1912. *An Account of Medieval Figure-Sculpture in England.* Cambridge: Cambridge University Press.

Pryor, J. H. 1984. "The Naval Architecture of Crusader Transport Ships: Reconstruction of some Archetypes for Round-hulled Sailing Ships." *The Mariner's Mirror,* 70: 171–219, 275–292, 363–388.

Pudelko, G. 1935. "The Minor Mastters of the Chiostro Verde." *The Art Bulletin,* 17: 71–89.

Purvis, J. S. 1962. *The York Cycle of Mystery Plays. A Complete Version.* London: SPCK.

Ramalli, G. 1960. *Camposanto Monumentale di Pisa.* Pisa: Opera della Prinaziale.

Réau, L. 1946. *Histoire de la Peinture au Moyen-Âge. La miniature.* Melun: Librairie d'Argences.

——. 1956. *Iconographie de L'Art Chrétien*. Paris: Presses Universitaires de France.

Reinhardt, H. 1972. *La Cathédrale De Strasbourg*. Paris: B. Arthaud.

Rice, D. T. 1952. *English Art 870–1100*. Oxford: Clarendon Press.

Rickert, M. 1954. *Painting in Britain: The Middle Ages*. London: Penguin Books.

Rifkin, B. A. 1973. Introduction to *The Book of Trades [Ständebuch]*, by Jost Amman and Hans Sachs, ix–xlviii. New York: Dover Publications Inc.

Rinaldi, G. 1948. "Arca di Noè." In *Enciclopedia Cattolici*, vol. 1: 1785–1787. Vatican City: Ente Per L'Enciclopedia Cattolica E Per Il Libro Cattolico.

Röhrich, L. 1972. "Noah und die Arche in der Volkskunst." In *Volkskunde Fakten und Analysen Festgabe für Leopold Schmidt zum 60. Geburtstag*, ed. K. Beitl, 433–442. Vienna: Verein für Volkskunde.

Roth, C. 1963. "The Sarajevo Haggadah and its Significance in the History of Art." In *The Sarajevo Haggadah*, 7–45. London: W. H. Allen and Company.

Salmi, M. 1957. *Italian Miniatures*. London: Collins.

Saxl, F. 1954. *English Sculptures of the Twelfth Century*. London: Faber and Faber.

Schapiro, M. 1942. "Cain's Jaw-Bone that Did The First Murder." *The Art Bulletin*, 24: 207–212.

Schedel, H. 1493. *Buch der Chroniken*. trans. Georg Alt, Nuremburg: Anthonien Koberg.

Schmidt, P. 1962. *Die Illustration der Lutherbibel 1522–1700. Ein Stück abendländische Kultur- und Kirchengeschichte Mit Verzeichnissen der Bibeln, Bilder und Künstler*. Basel: Verlag Friedrich Reinhardt.

Schnier, J. 1951. "The symbol of the ship in art, myth and dreams." *The Psychoanalytic Review*, 38: 53–65.

Schofield, R. E. 1983. "The Eye of the Beholder: A Critical Examination of Some Cultural Aspects of Scientific Creativity." *Journal of the International Society Leonardo*, 16: 133–137.

Schramm, A. 1922–1940. *Der Bilderschmucke der Frühdrucke*. 22 vols. Leipzig: Verlag von Karl W. Hiersemann.

Schubring, P. 1908. "Bartolo di Fredi Battilori." In *Allgemeines Lexikon der Bildenden Kunstler*, ed. U. Thieme and F. Becker, vol. 2: 558–560. Leipzig: Verlag von E. A. Seemann.

Scribner, R. W. 1981. *For the Sake of Simple Folk. Popular Propaganda for the German Reformation*. Cambridge: Cambridge University Press.

Smart, A. 1971. *The Assisi Problem and the Art of Giotto. A Study of the Legend of St. Francis in the Upper Church of San Francesco, Assisi*. Oxford: Clarendon Press.

Smith, C. S. 1970. "Art, Technology, and Science: Notes on Their Historical Interaction." *Technology and Culture*, 11: 493–549.

——. 1979. "Remarks on the Discovery of Techniques and on Sources for the Study of Their History." In *The History and Philosophy of Technology*, ed. G. Burliarello and D. B. Doner, 31–37. Urbana: University of Illinois Press.

——. 1981. *A Search for Structure: Selected Essays on Science, Art and History*. Cambridge, MA: The MIT Press.

Soto, J. L. C. 1975. "Arqitectura naval en el Cantabrico durante el siglo XIII." *Altamira* (Santandar), 23–56.

Southern, R. W. 1970. *Medieval Humanism and Other Studies*. Oxford: Basil Blackwell.

Sparrow, W. S. 1905–1907. *The Old Testament in Art from the creation of the world to the death of Moses*. London: Hodder and Stoughton.

Spencer, E. P. 1965. "Master of the Duke of Bedford: The Bedford Hours." *Burlington Magazine,* 107: 495–502.

Squires, L. 1982. "Law and Disorder in Ludus Coventriae." In *The Drama of the Middle Ages: Comparative and Critical Essays,* ed. C. Davidson, C. J. Gianakaris, and J. H. Stroupe, 272–285. New York: AMS Press, Inc.

Stern, H. 1958. "Les Mosaiques de L'Église De Sainte-Constance à Rome." *Dumbarton Oaks Papers,* 12: 157–218.

Stewart, C. 1959. *Serbian Legacy*. London: George Allen and Unwin Ltd.

Stichel, R. 1979. *Die Namen Noes, seines Bruders und seiner Frau. Ein Beitrag zum Nachleben jüdischer Überlieferungen in der ausserkanonischen und gnosticschen Literatur und in Denkmälern der Kunst*. Göttingen: Vendenhoeck und Ruprecht.

Stiefel, T. 1985. "'Impious Men': Twelfth-Century Attempts to Apply Dialectic to the World of Nature." In *Science and Technology in Medieval Society,* ed. P. O. Long. Annals of the New York Academy of Sciences, 1541: 187–203. New York.

Stillwell, M. B. 1942. *Noah's Ark in Early Woodcuts and Modern Rhymes*. New York: Edmond Byrne Hackett, The Brick Row Bookshop, Inc.

Stock, B. 1972. *Myth and Science in the Twelfth Century: A Study of Bernard Silvester*. Princeton: Princeton University Press.

Stone, L. 1955. *Sculpture in Britain: The Middle Ages*. Harmondsworth, Middlesex: Penguin Books.

Storm, M. 1987. "Uxor and Alison: Noah's Wife in the Flood Plays and Chaucer's Wife of Bath." *Modern Language Quarterly,* 48, 4: 303–319.

Strauss, W. L., general ed. 1983. *The Illustrated Bartsch*. Vol. 38, *Italian Artists of the Sixteenth Century,* ed. S. Buffa. New York: Abaris Books.

——, general ed. 1982. *The Illustrated Bartsch*. Vol. 40, *Italian Masters of the Sixteenth and Seventeenth Centuries,* ed. V. Birke. New York: Abaris Books.

Szablowski, Jerzy. 1975. *Collections of the Royal Castle of Wawel*. Warsaw: Arkady.

Tate, V. D. 1941. "The Instrvcion Nauthica of 1587." *The American Neptune,* 1: 191–195.

Temple, E. 1976. *Anglo-Saxon Manuscripts 900–1066*. London: Harvey Miller.

Theophilus. 1963. *On Divers Arts: The Foremost Medieval Treatise on Painting, Glassmaking and Metalwork,* trans., intro., and notes J. G. Hawthorne and C. S. Smith. Chicago: University of Chicago Press.

Thomas Aquinas. 1963. *The Division and Methods of the Sciences*. ed. and trans. A. Maurer. Toronto: The Pontifical Institute of Medieval Studies.

Thomas, M. 1979. *The Golden Age: Manuscript Painting at the Time of Jean Duke of Berry*. New York: Braziller.

Thomas, R. G., ed. 1966. *Ten Miracle Plays*. London: Edward Arnold Ltd.

Thoss, D. 1978. *Französische Gotik und Renaissance in Meisterwerken der Buchmalerei: Ausstellung der Handschriften- und Inkunabelsammlung der Österreichischen Nationalbibliothek*. Vienna: Österreichische Nationalbibliothek.

Tietze-Courat, E. 1908. "Melchior Küsels Bilderbibel." In *Mitteilungen der Gesellschaft Für Vervielfältigende Kunst,* Jahrgang 1908, Beilage Der "Graphischen Künste," 41–47. Vienna: Gesellschaft für Vervielfältigende Kunst.

Tikkanen, J. J. 1889. *Die Genesis Mosaiken van S. Marco in Venedig und ihr Verhältnis zu den Miniaturen der Cottonbibel nebst einer untersuchung über den Ursprung der mittelalterlichen Genesisdarstellung besonders in der Byzantinischen und Italienischen Kunst.* Helsinki: Acta Societatis Scientiarum Fennicae, 17.

Timmerman, G. 1963. "Das Eindringen der Naturwissenschaft in das Schiffbauhandwerk." *Deutsches Museum, Abhandlungen und Berichte*, 30, 3: 3–53.

Tintori, L., and M. Meiss. 1967. *The Painting of the Life of St. Francis in Assisi, with Notes on the Arena Chapel.* New York: W. W. Norton and Company.

Tonsing, E. F. 1978. *The Interpretation of Noah in Early Christian Art and Literature.* Ph.D. diss., University of California, Santa Barbara.

Torselli, G. 1969. *La Galleria Doria.* Rome: Fratelli Palombi.

Turner, D. H. 1979. *Early Gothic Illuminated Manuscripts.* 2d ed. London: The British Library.

Twycross, M., ed. 1983. *The Chester Noah's Flood. Medieval English Theatre Modern Spelling Texts*, no. 3. Lancaster: Medieval English Theatre.

Ullendorff, E. 1954. "The Construction of Noah's Ark." *Vetus Testamentus*, 4: 95–96.

Unger, R. W. 1986. "Design and Construction of European Warships in the Seventeenth and Eighteenth Centuries." In *Les Marines de Guerre Europénnes XVII–XVIIIe Siècles*, ed. M. Acerra, J. Merino and J. Meyer, 21–34. Paris: Presses de l'Université de Paris-Sorbonne.

——. 1978. *Dutch Shipbuilding before 1800. Ships and Guilds.* Assen: Van Gorcum.

——. 1980. *The Ship in the Medieval Economy, 600–1600.* London: Croom Helm Ltd.

——. 1981. "Warships and Cargo Ships in Medieval Europe." *Technology and Culture*, 22: 233–252.

Vasari, G. 1912–1914. *Lives of the Most Eminent Painters, Sculptors and Architects*, trans. G. DuC. DeVere. 10 vols. London: Macmillan and Co.

Verdonk, J. J. 1970. "Buteo, Johannes." *Dictionary of Scientific Biography*, vol. 2: 618. New York: Charles Scribner's Sons.

Vitzthum, G. G., and W. F. Volbach-Berlin. 1924. *Die Malerei und Plastik des Mittelalters in Italien.* Potsdam: Akademische Verlagsgesellschaft Athenaion M. B. H.

Vondel, J. van. 1867. "Noah of Ondergang der Eerste Weerelt Treurspel 1667," *De Werken van Vondel*, ed. J. Van Lennep, vol. 11: 21–78. Amsterdam: Gebroeders Binger.

von Euw, A., and J. M. Plotzek. 1979–1985. *Die Hanschriften der Sammlung Ludwig.* Cologne: Schnütgen-Museum.

Vopel, H. 1899. *Die altchristlichen Goldgläser. Ein Beitrag zur altchristlichen Kunst- und Kulturgeschichte.* Archäologische Studien zum christlichen Altertum und Mittelalter, Heft 5. Freiburg im Breisgau: Verlag von J. C. B. Mohr.

Voss, H. 1962. *Studien zur Illustrierten Millstätter Genesis.* Munich: C. H. Beck'sche Verlagsbuchhandlung.

Warner, G. F. 1903. *Illuminated Manuscripts in the British Museum.* London: British Museum.

——. 1912. *Queen Mary's Psalter. Miniatures and Drawings by an English Artist of the 14th Century. Reproduced from Royal MS. 2 B. VII in the British Museum.* London: British Museum.

Watson, A. 1934. *The Early Iconography of the Tree of Jesse.* London: Oxford University Press.

Weisheipl, J. A. 1978. "The Nature, Scope, and Classification of the Sciences." In *Science in the Middle Ages*, ed. D. C. Lindberg, 461–482. Chicago: University of Chicago Press.

Weitzmann, K. 1984. "The Genesis Mosaics of San Marco and the Cotton Genesis Miniatures." In *The Mosaics of San Marco in Venice*, ed. O. Demus, vol. 2: 105–142, 253–257. Chicago: University of Chicago Press.

Weitzmann, K., and H. L. Kessler. 1986. *The Cotton Genesis: British Library Codex Cotton Otho B. VI*. Princeton: Princeton University Press.

Westermann, C. 1974. *(Biblischer Kommentar: Altes Testament) Genesis*. Vol. 1, *Genesis 1–11* Neukirchen-Vluyn: Neukirchener Verlag des Erziehungsvereins.

White, E. W. 1983. *A History of English Opera*. London: Faber and Faber.

White, J. 1956. "Cavallini and the Lost Frescoes in S. Paolo." *Journal of the Warburg and Courtauld Institutes*, 19: 84–95.

White, L. jr. 1978. *Medieval Religion and Technology: Collected Essays*. Los Angeles: University of California Press.

Wieck, R. S. 1988. *Time Sanctified: The Book of Hours in Medieval Art and Life*. New York: George Braziller, Inc.

Wilkins, E. H. 1927. "Dante and the Mosaics of his Bel San Giovanni." *Speculum*, 2: 1–10.

Wilpert, J. 1916. *Die Römischen Mosaiken und Malereien der kirchlichen Bauten von IV.–XIII. Jahrhundert*. Freiburg im Breisgau: Herdersche Verlagshandlung.

Wilson, A. 1975(a). "The Early Drawings for the Nuremburg Chronicle." *Master Drawings*, 12: 115–130.

——. 1975(b). *The Making of the Nuremburg Chronicle*. Amsterdam: Nico Israel.

Wilson, A., and J. L. Wilson. 1984. *A Medieval Mirror:* Speculum humanae salvationis *1324–1500*. Berkeley: University of California Press.

Wind, E. 1950. "The Ark of Noah: A Study in the Symbolism of Michelangelo." *Measure*, 1(Fall): 411–421.

Witsen, N. 1690. *Architectura Navalis et Regimen Nauticum ofte Aaloude en Hedendaagsche Scheeps-bouw en Bestier*. Amsterdam: Pieter en Joan Blaeu, (1st ed., 1671).

Witt, A. De. 1954. *I Mosaici Del Battistero Di Firenze*. 5 vols. Florence: Cassa Di Risparmio.

Yk, C. van. 1697. *De Nederlandsche Scheeps-bouw-konst Open Gestelt*. Amsterdam: Jan ten Hoorn.

Zahn, P. 1973. "Neue Funder Zur Enstehung Der Schedelschen Weltchronik 1493." *Stadt Nürnberg Museen, Renaissance Vorträge*, 2/3: 2–27.

Zampetti, P. 1970. *A Dictionary of Venetian Painters*. 4 vols. Leigh-on-Sea: F. Lewis, Publishers, Limited.

Zarnecki, J. 1953. *Later English Romanesque Sculpture, 1140–1210*. London: Alec Tiranti.

Index

Illustrations

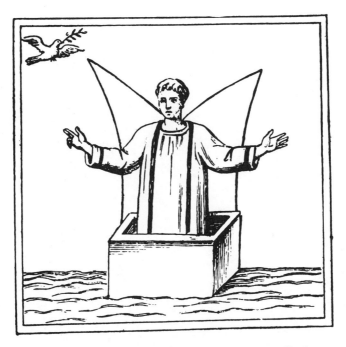

1. Noah emerging from a sarcophagus. Rome, from the Domitilla Catacomb, possibly third century. *From Ehrenstein 1923: 99, fig. 5.*

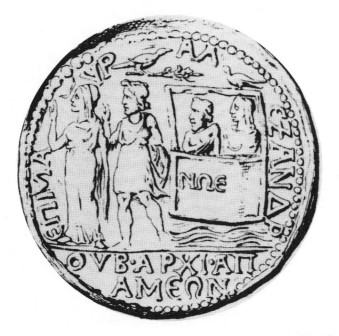

2. Apamea coin with Noah emerging from a sarcophagus, first half of the third century. *From Goodenough 1953: vol. 3, fig. 700. Reprinted by permission of Princeton University Press.*

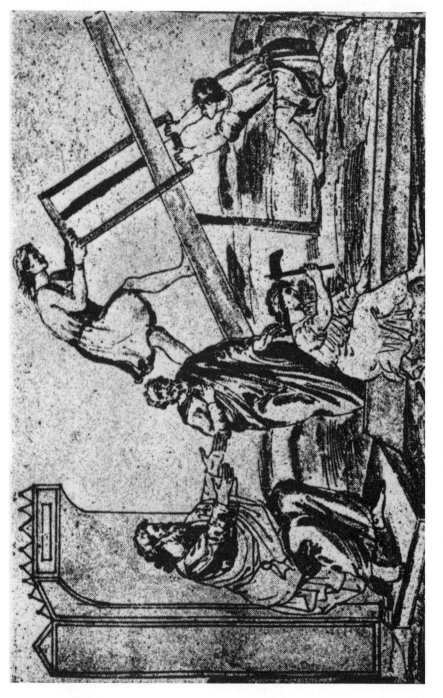

3. Noah directing the building of the ark by three workmen, from Saint Peter's Outside the Walls, fifth century. *From Stern 1958, fig. 19.*

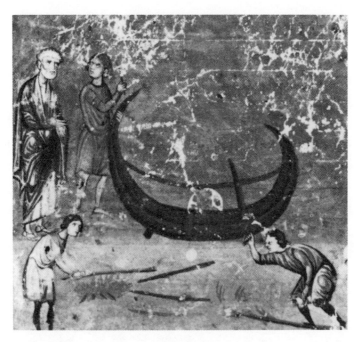

4. Noah and workmen, from the Octateuch tradition, twelfth century. *Rome Lib., Bibl. Vaticana, gr. 746, fol. 53v. From Bergman 1980, fig. 70.*

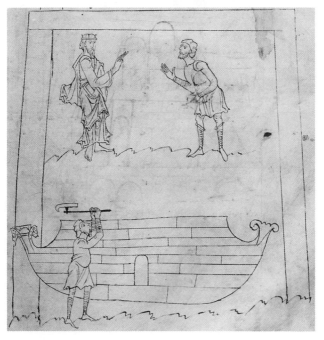

5. The construction of the ark, from the Caedmon Manuscript, probably second quarter of the eleventh century. *Bodleian Library, Ms. Junius 11, p. 65.*

6. Noah shaping a plank, from the Aelfric Paraphrase, about 1000. *B.M. Cotton Claudius B.IV. By permission of the British Library.*

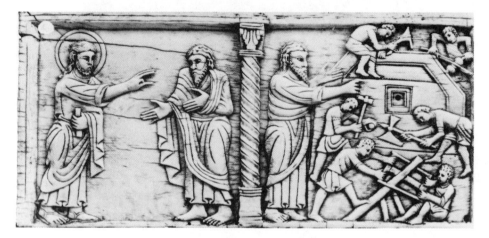

7. Two panels from the Salerno Ivories. Salerno, Museo del Duomo, eleventh century. *From Bergman 1980, fig. 8.*

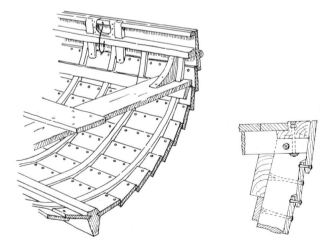

8. Shell construction with clinker-building as practiced in northern Europe. *From Hasslöf 1972: 54.*

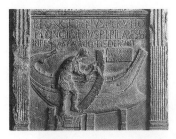

9. Inserting a rib in a shell-built Roman vessel, late second or early third century. *From Casson 1959: 15a. Photograph courtesy of the Deutsches Archaeologisches Institut Rom.*

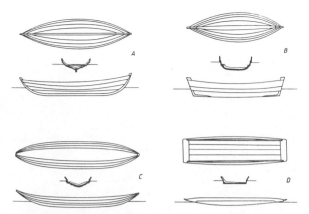

10. Structural characteristics of four principal types of northern European ships in the early Middle Ages. A = Viking ship; B = cog; C = hulk; D = punt. *From Crumlin-Pedersen 1978: 39, fig. 6, revised by the author.*

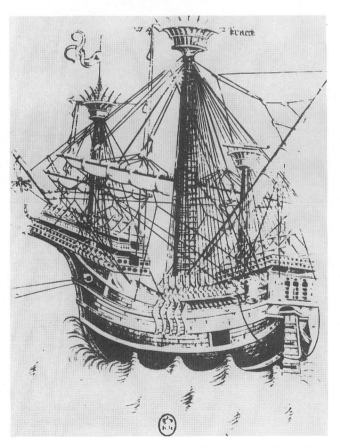

11. A fifteenth-century carrack. A full-rigged ship from the Low Countries as illustrated by Master W. A. *Photograph courtesy of the Bibliothèque Nationale, Paris.*

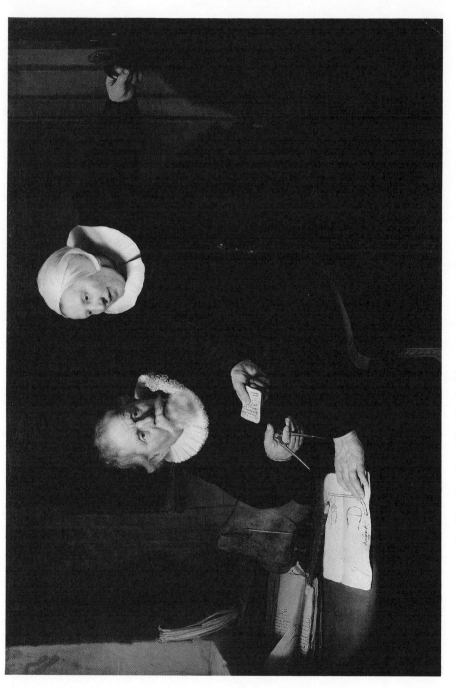

12. Rembrandt's "The Shipbuilder and His Wife," 1633. *Buckingham Palace.*

geran el gerö in non berbſen. ſere begund
ſmerzen die er geſchuf reden eren. dal die den
teuil ſolden werden. do wart im zemüte. daz
er mit der ſinulüte. die werde wolde uirſen
unde ſinen zorn alſo uerchieſen bot yot gebot
daz er die archen zimberor. und dar mit
behulte. alles des er wielte.

hie gungen ſi in die arke. die ſinulüt uorh
tin ſi ſtarchе.

hie breut ſich daz ander büch
Noe was ein gůt man. des ſin er gewan. den ebo
in got zerore. uz andern luten. dem ſlagter

13. Noah shaping a plank, from the Millstätter Genesis, 1160s. *Kärntner Landesarchiv, GV-Hs. 6/19, fol. 21r, 22r; Rücksendung der ausgefüllten "Rechtsverbindlichen Erklärung."*

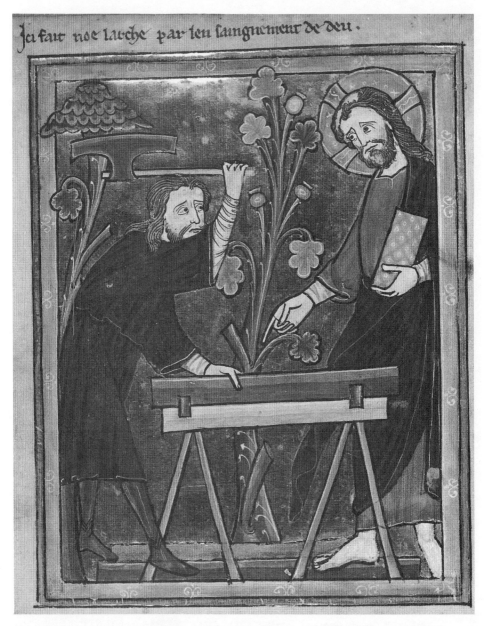

14. Noah listening to God while shaping a plank, from a thirteenth-century Bible. *John Rylands University Library of Manchester.*

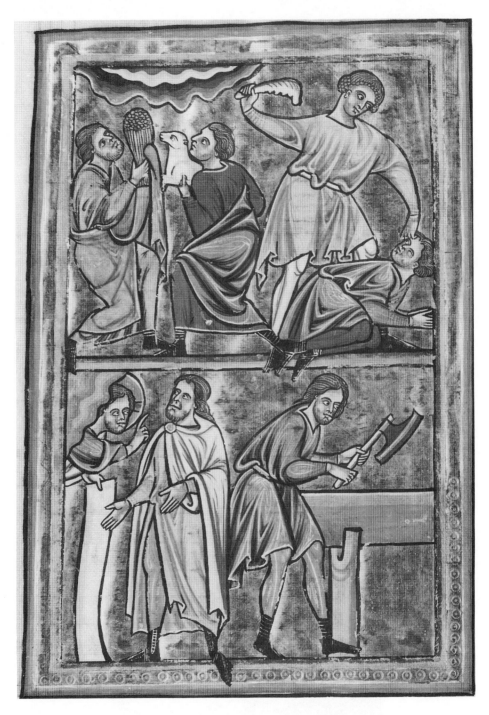

15. Noah listening and working, from the Saint Louis Psalter, around 1200. *Leiden University Library, Ms. BPL 76A, fol. 10v. © Copyright Leiden University Library.*

16. The shipbuilder working on a plank for a vessel under construction, from the beginning of Psalm 27 in the Morgan Psalter, probably from the 1180s. *The Pierpont Morgan Library, New York, M338, fol. 105r.*

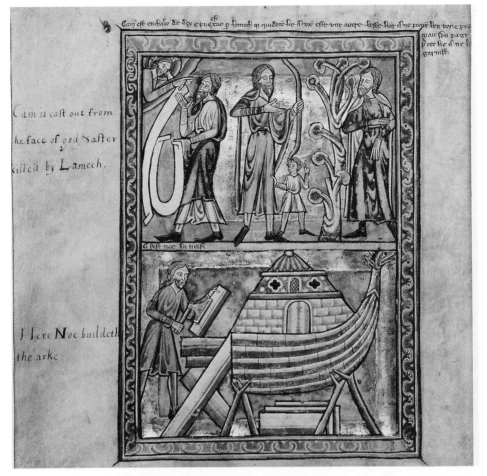

Cain is cast out from
the face of god & after
killed by Lamech.

Here Noe buildeth
the arke

17. "Here Noe buildeth the arke," in the Huntingfield Manuscript, about 1210–1220.
The Pierpont Morgan Library, New York, M43, fol. 8v.

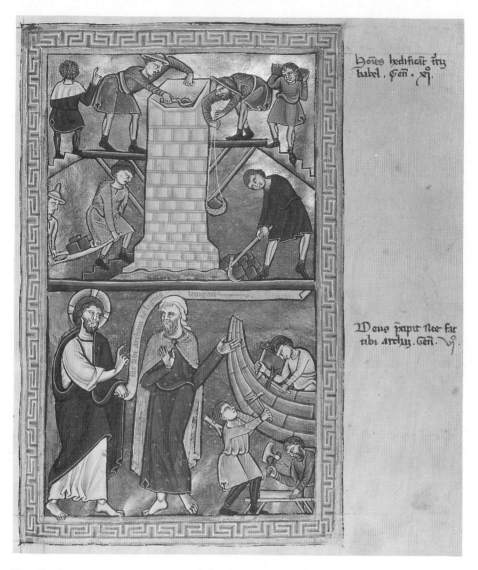

18. Noah receiving instruction while three men build the ark, from the Munich Psalter, before 1222. *Clm. 835, fol. 10r. Bayerische Staatsbibliothek, München.*

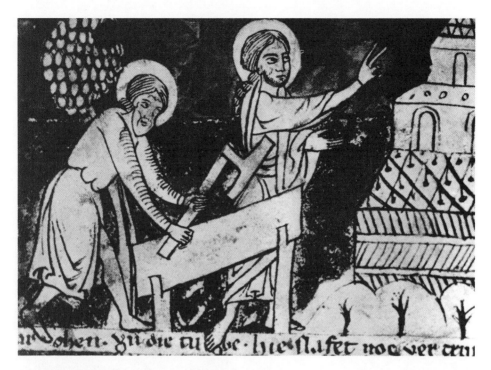

19. Noah working on a plank and looking at the ark, from the *Codex Cursus Sancta Maria* in the Monastery at Louka, Moravia, between 1200 and 1230. *From Husa 1967, fig. 85.*

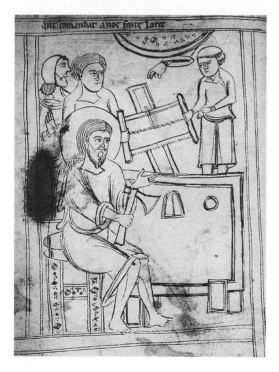

20. A box-like ark with Noah seated, ax in hand, from the thirteenth-century Oxford Psalter. *Courtauld Institute of Art (Conway Library), negative 20/31(3B). Manuscript at the Bodleian Library, Oxford.*

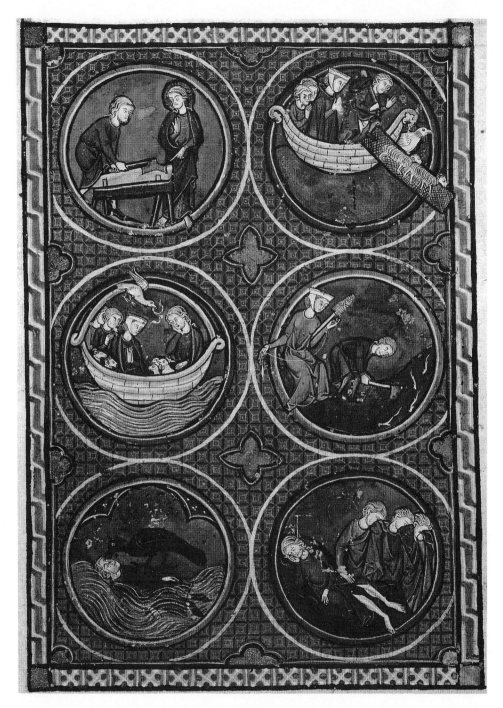

21. The story of the Flood in six illustrations, from a French psalter of about 1235. *Österreichische Nationalbibliothek 2611 fol. 6.*

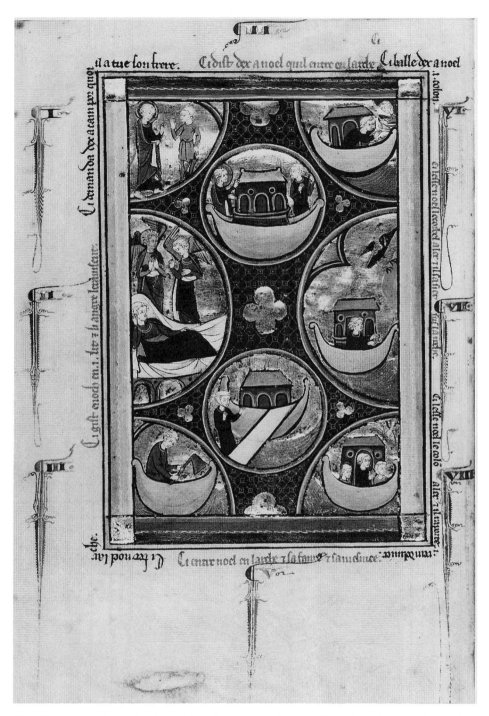

22. The story of the flood in eight illustrations, from a French psalter of after 1253. *Wenscelas Psalter, fol. 9v. The J. Paul Getty Museum, 83.MK.95, ms. Ludwig VIII, 4 (ex-Dyson Perrins 32).*

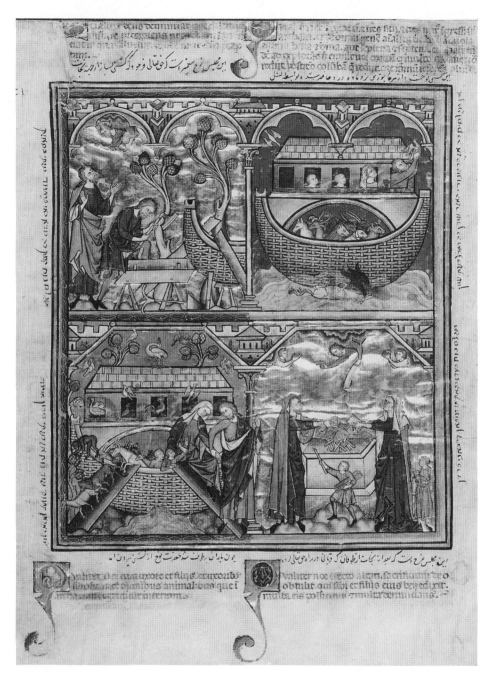

23. Noah building a woven ark, from a mid thirteenth-century French manuscript. *The Pierpont Morgan Library, New York, M638, f. 2v.*

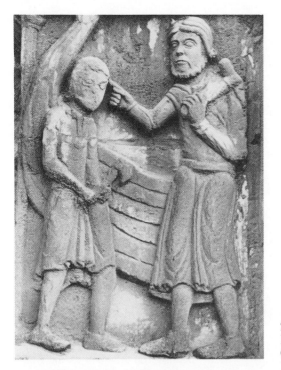

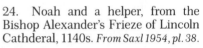

24. Noah and a helper, from the Bishop Alexander's Frieze of Lincoln Cathderal, 1140s. *From Saxl 1954, pl. 38.*

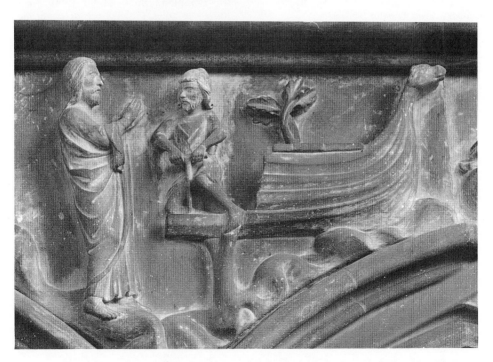

25. Noah using an auger while listening to God, from an arch spandrel in the Chapter House of Salisbury Cathedral, last quarter of the thirteenth century.

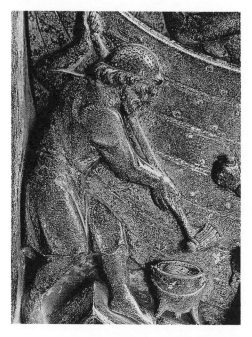

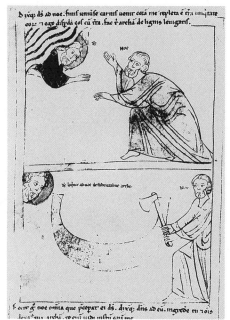

26. Noah covering the ark with pitch with a brush, from a quatrefoil in Sainte Chapelle, Paris, second half of the thirteenth century. *From Lessing 1968: 21.*

27. Noah first receiving his orders and then finishing the ark with an ax, from the Pamplona Bible, about 1200. *From Bucher 1970, pl. 16. With permission of the author.*

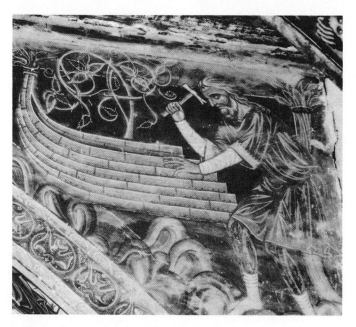

28. Noah wielding a hammer and nailing planks in place, from a fresco in the Sigena Monastery, early thirteenth century. *From Oakeshott 1972, fig. 26.*

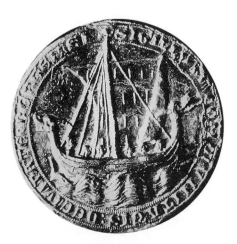

29. A keel as shown in the town seal of Bergen, Norway, thirteenth century. *From Ewe 1972: 52.*

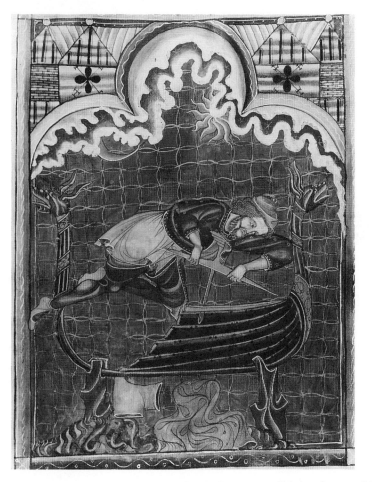

30. Noah using a breast auger to drill a hole in a small boat, from a thirteenth-century English psalter. *By permission of the Master and Fellows of St. John's College, Cambridge.*

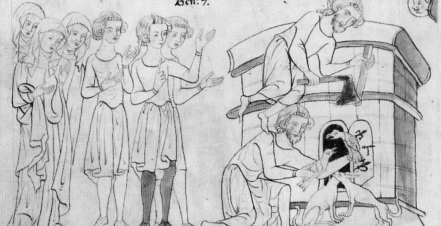

Fec uve vña ẽ pricp̃ eiỹs vovĩ ad eũ dñ̃s tuã mar tlã re u mdi usñu tota me iguãcũ hãc ex vtbõ aĩantlbõ
muñdis tolle septenã ẽ septena mañlũ ẽ femã d aĩantlbõ ũ ũõ muñdis duo ẽ duo maſñ ẽ femñiũ ẽ femã ẽ uine
Gen: 7.

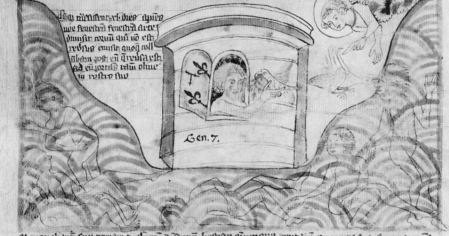

Fattlã uẽ falues setũ fup iñuerſã faṽe dve cñẽ iguſñus fuiſſ tartlã noe ruptẽ ſẽ ores foñes abyſſy
magne ẽ catẽraẽ̃ veh apti ſẽ ẽtſã eſñ pluñã meſña fup ẽ̃raĩ xl dieŝ xl noctlbõ cõſṽaẽ ẽ ẽ̃ vñs rã

dũt nummentr̃ xl dies ẽ pvee
noe ſoueflã ſoueflã arce ẽ
muñ̃ſ cozũ quñ̃ uõ eſñ
vñ̃us cuñ̃ſñ quoẽ̃ volt
libam poſñ̃ cũ deuvſa eſñ
ſed cñ̃ozñs̃ rãm oluñe
u roſñ̃v ſuo

Gen. 7.

qẽ mouebñ̃t fup ñ̃rañ voluñẽ aĩñaũ beſñãŝ õmũ̃que rephñũ ẽ qñe rephñt̃ fuper tñ̃rã
uñuſ qñe homñ̃es ẽ tñ̃ta viſñ̃uŝ ſpiẽ̃ñ̃añ̃ uñ̃ eſñ̃ ñ̃ tñ̃rã uñ̃zñ̃a ſuñt

31. Noah building the ark and putting the animals in the ark, from a Bible made in
Prague around 1340. *Velislav Bible. Prague, The State Library of the ČSR, Ms. XXIII C 24, f. 9v.*

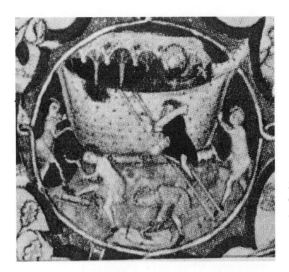

32. Noah fitting frames inside a clinker-built ship, from an East Anglian psalter of the early fourteenth century. *Saint Omer Psalter. BL, Add. Ms. 39810. By permission of the British Library.*

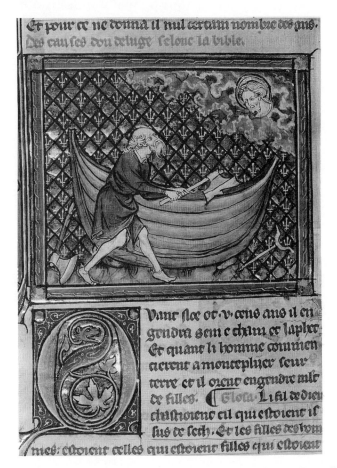

33. Noah using one of his two axes while listening to God, from a Paris Bible of 1317. *Jean de Papeleu Bible. Paris, Bibliothèque de l'Arsenal.*

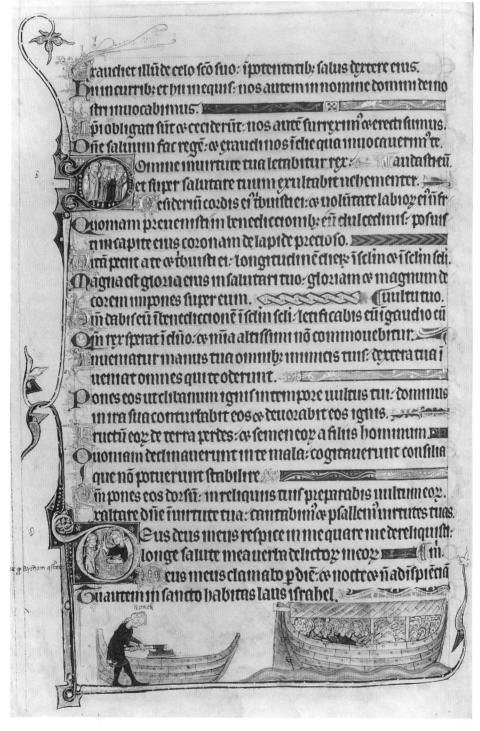

rauchet illud de celo sco suo: spotentatib; salus dextere eius.
Hii in curribz: et hii in equis: nos autem in nomine domini dei no
stri inuocabimus.
Ipi obligati sunt ce ceciderut: nos aute surrexim ce erecti sumus.
Dne saluum fac rege: ce exaudi nos i die qua inuocauerim te.
Omne inuirtute tua letabitur rex: laudas deu.
et super salutare tuum exultabit uehementer.
Desideriu cordis ei tbuisti ei: ce uolutate labior eii ñ fr
Quoniam preuenisti in benedicctionib; eii dulcedinis: posuis
ti in capite eius coronam de lapide precioso.
Uitam petiit a te ce tbuisti ei: longitudine dier; i selm ce i selm seli.
Magna est gloria eius in salutari tuo: gloriam ce magnum de
corem impones super eum. Cuultu tuo.
Dabis eii ibenedictione i selin seli: letificabis eii i gaudio cu
Qin rex sperat i duo: ce mia altissimi no commouebitur.
Inueniatur manus tua omnib; inimicis tuis: dextera tua i
ueniat omnes qui te oderunt.
Pones eos ut clibanum ignis in tempore uultus tui: dominus
in ira sua conturbabit eos ce deuorabit eos ignis.
ructu eor de terra perdes: ce semen eor a filiis hominum.
Quoniam declinauerunt in te mala: cogitauerunt consilia
que no potuerunt stabilire.
in pones eos dorsu: in reliquiis tuis preparabis uultum eor.
altare dñe i uirtute tua: cantabim ce psallem uirtutes tuas.
Eus deus meus respice in me quare me dereliquisti:
longe salute mea uerba delictor meor. m.
eus meus clamabo p die ce nocte ce ñ adispietia
Tu autem in sancto habitas laus israhel.

34. Noah wielding a two-handed ax, from an English psalter of about 1305. *Munich, Bayerische Staatsbibliothek, gall. 16, fol. 21v.*

li remanure ou on eſt toun ſiere. ayin li reſpuno temore eſt teute
noir ſeis ni e kauns q̃ tei reſemble il las oms vo viutes eſtie cuſemble

oment le viable voint en ſeune te ſeme u la ſeme ꝛ̃e e tonantu v ſon mari ꝑ
e te viſort qe te ne ſont on il eſt ale piir toi reꝛiꝛ ꝛ toie le munt. pꝛeꝑne as gꝛeb
e ſere. vn aboꝛnaon e le ꝛouꝛa a voꝑw e il te viꝛa voꝛe. E ſunt hſt ele

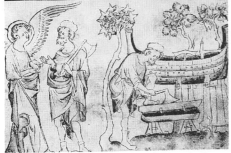

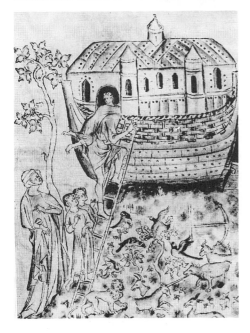

35, 36, 37. The story of Noah building the ark and of his wife consorting with the devil, from an English psalter of the early fourteenth century. *From Warner 1912, pls. 9, 10. Queen Mary Psalter. BL, Ms. Roy. 2B. VII, F.6ro. By permission of the British Library.*

38, 39. Noah, wearing a Jew's hat, builds the ark under God's direction, from a fourteenth-century English picture Bible. *From Hassall 1954: 7, 8. Holkham Picture Bible. BL, Add. Ms. 47680, ff. 7vo–7ro. By permission of the British Library.*

40. Noah and his wife, Phurphura, addressed by God before Noah begins work on an ark in the shape of a cog, from a late fourteenth-century English illustrated Genesis. *Egerton Manuscript. BL, Egerton Ms., 1894, f. 2vo. By permission of the British Library.*

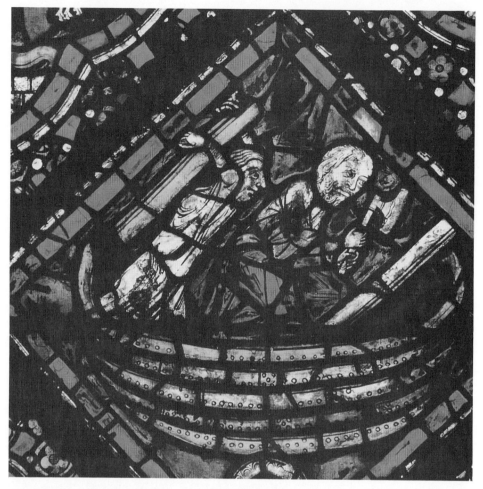

41. The shipbuilder shaping ribs inside the hull, from a stained glass window in Chartres Cathedral, thirteenth century. *From Lessing 1968: 20.*

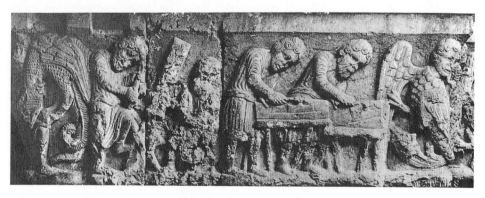

42. Noah felling a tree and then dressing a plank, from a capital in the cloister of Gerona Cathedral, twelfth century. *From Porter 1923, vol. V, pl. 598.*

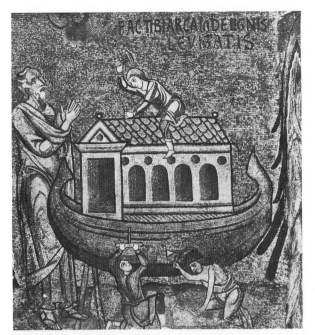

43. Three workmen completing the ark with Noah on the left, from a mosaic in the Capella Palatina, Palermo, around 1160. *From Kitzinger 1960, fig. 23.*

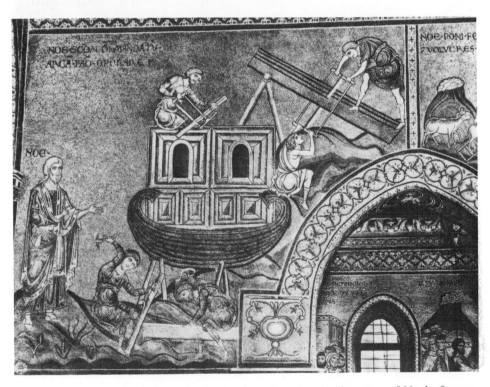

44. Five workmen preparing planks for the ark under the direction of Noah, from a mosaic in Monreale Cathedral, last quarter of the twelfth century. *From Kitzinger 1960, fig. 24.*

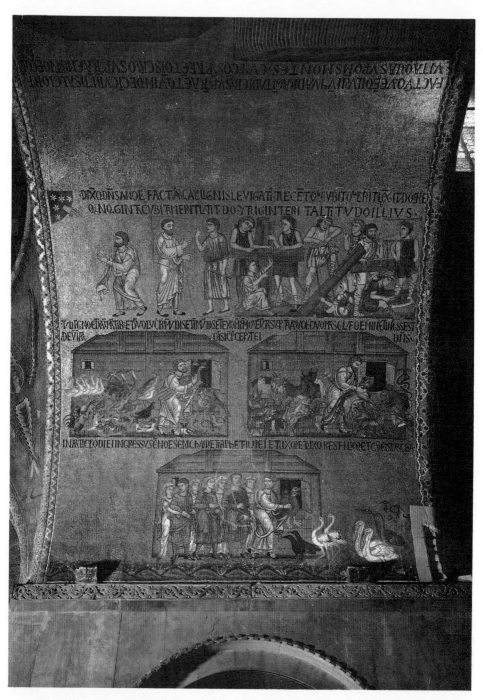

45. The story of Noah beginning with the construction of the ark, from a mosaic in the atrium of Saint Mark's Cathedral, Venice, thirteenth century. *From Demus 1984, fig. 144. Photograph courtesy of the National Gallery of Art, Photographic Archives.*

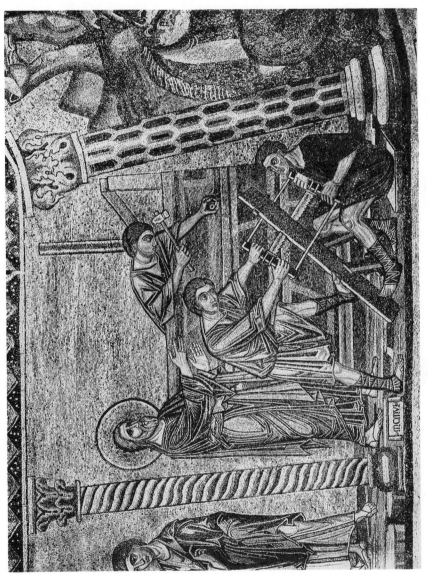

46. Noah, crowned with a nimbus, directs three workmen, from a mosaic in the baptistry at Florence, late thirteenth century. *Alinari/Art Resource, 58083.*

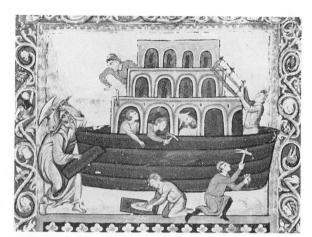

47. Noah oversees seven workmen and also wields an ax, from a Universal History done at Acre about 1225. *From Buchthal 1957, pl. 85. BL, Add Ms. 15268, f. 7vo. By permission of the British Library.*

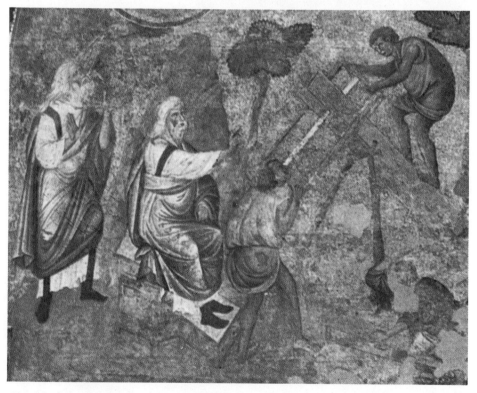

48. Noah in the fresco of the Upper Church of Saint Francis, Assisi, late thirteenth century. *From Belting 1977: 97, pl. 4. Reprinted by permission of the publisher.*

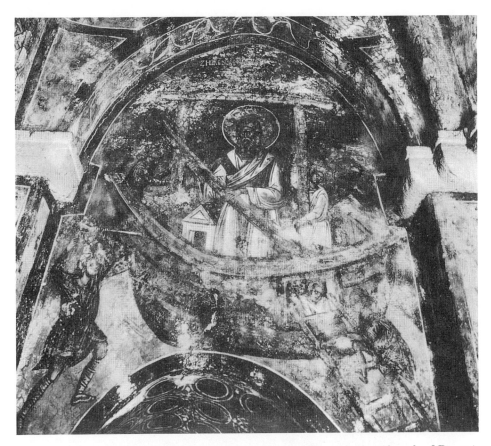

49. A massive Noah standing inside the ark, from a fresco in the Church of Decani, Serbia, mid fourteenth century. *From Petkovic and Boskovic 1941, pl. 259.*

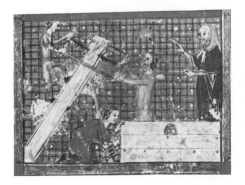

50. The construction of a box-like ark, from a Spanish Haggadah manuscript of about 1350. *From Roth 1963. Zemaljski Muzej Bosne o Hercogovine, Sarajevo.*

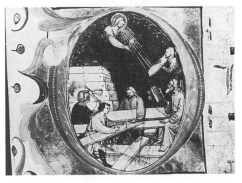

51. Four workers complete the ark while Noah listens to God, from an Antiphonary probably from Padua, late fourteenth century. *From Folena and Mellini 1962, fig. 11.*

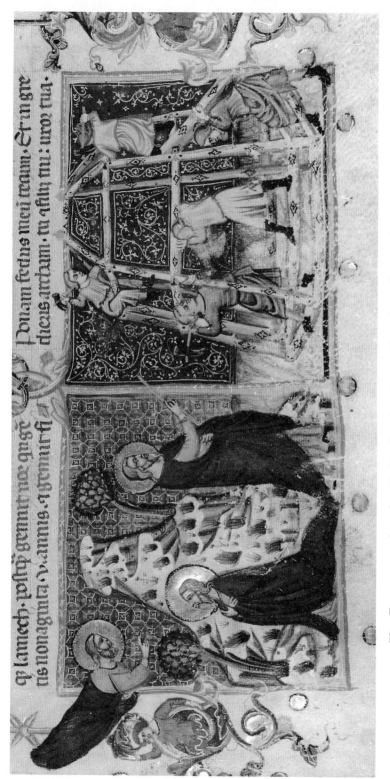

52. Five men work under Noah's direction, from a Neapolitan illustrated Bible of about 1360. *From Bise and Irblich 1979: 23. Vienna Nat. Bib., Lat. Ms. 1191, fol. 6r. By permission of the Österreichische Nationalbibliothek, Vienna.*

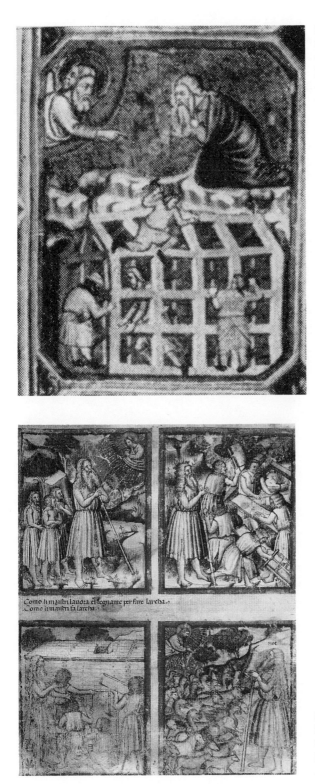

53. Noah listens to God and four men build the ark, from another fourteenth-century Neapolitan Bible. *Hamilton Bible. From M. Salmi 1957: 38, fig. 47. Berlin, Kupperstich Kabinett, fo. 4.*

54. The story of the Flood, from a Paduan picture Bible of the fourteenth century. *Rovigo Bible. From Folena and Mellini 1962, pl. 8.*

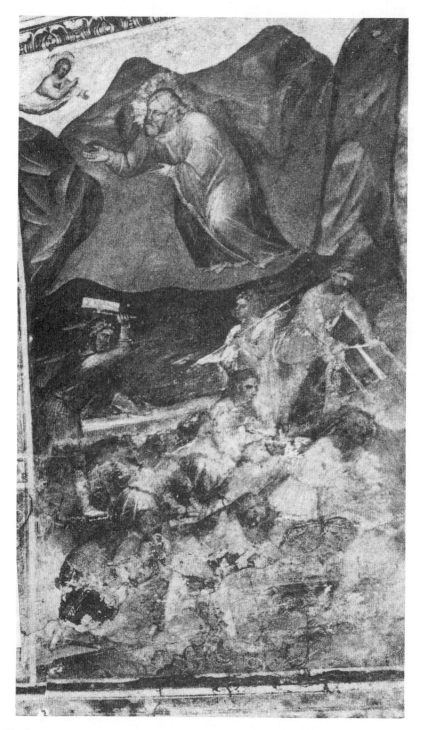

55. Noah receiving instructions and the building of the ark, from a fresco in the Baptistry at Padua, before 1393. *From Bettini 1944a, figs. 75, 76.*

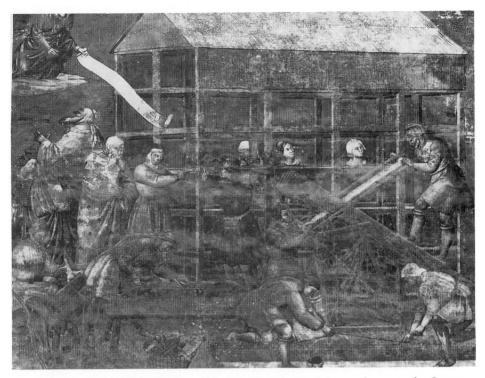

56. Noah commands a large crew after hearing from God, from a fresco in the Campo-santo Cemetery, Pisa, 1390. *Alinari/Art Resource, 8849.*

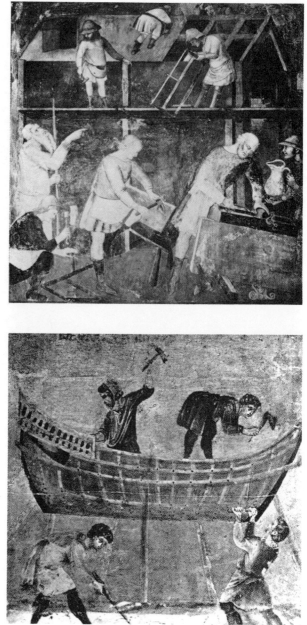

57. A bearded and aged Noah discusses the project with one of the workmen, from a fresco in the Collegiate Church of Saint Augustine, San Gimignano, 1367. *From Meiss 1972, fig. 54.*

58. A shipyard in Italy in the early fourteenth century by Paolo Veneziano. *From Basch 1972: 40.*

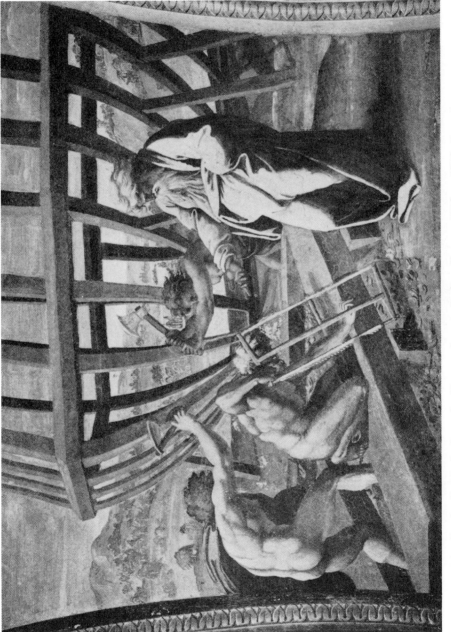

59. Raphael's Noah, from the Vatican Loggia Ceiling Fresco, 1518 or 1519. *From Sparrow 1905–1907: 55.*

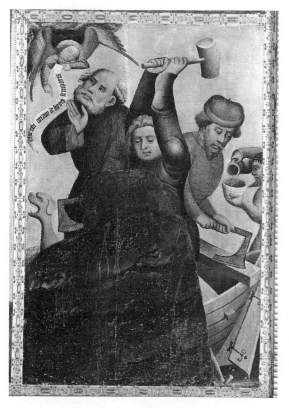

60. Meister Bertram's Noah, from the Grabov Altarpiece, 1383. *Hamburger Kunsthalle.*

61. The single illustration of Noah and the ark from a *Speculum humanae salvationis,* second half of the fifteenth century. *Bibliothèque Municipale de Saint-Omer, 184, fol. 4r.*

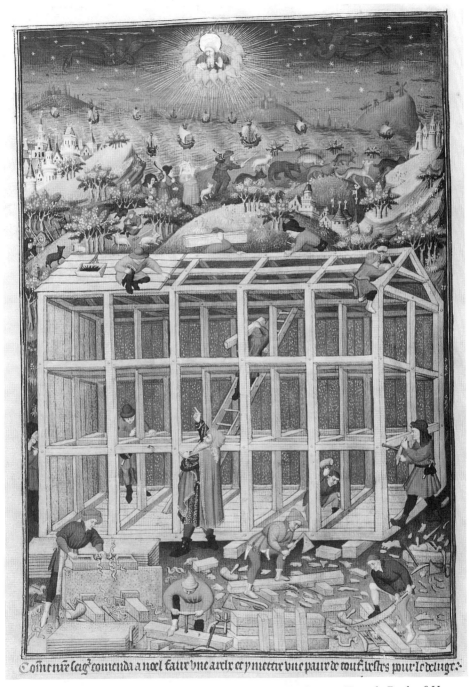

Coment̃ n̄re seig̃ comenda a noel faur vne aurk et y mettie vne paur de tout̃ lestr̃s pour le deluge.

62. Noah commands twelve men at work on the ark, from a French Book of Hours, 1423. *From Meiss 1972, fig. 56. Bedford Hours. BL, Add. Ms. 18850, f. 15vo. By permission of the British Library.*

63. Noah directs four work-men, from an illustrated Bible done in Paris around 1412. *From Mesis 1972, fig. 55. Photograph courtesy of the Bibliothèque Nationale, Paris.*

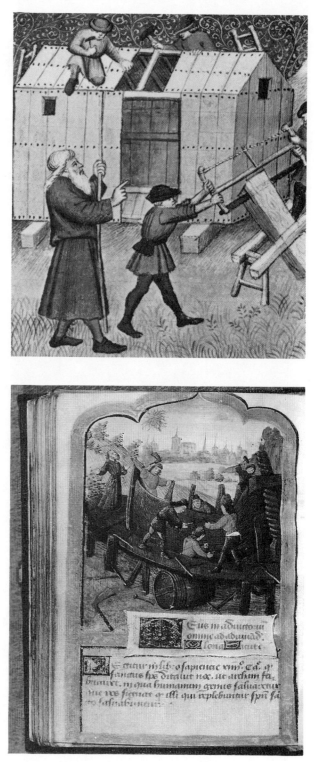

64. A shipbuilding yard with Noah on the left, from a French Book of Hours done in the 1480s. *Walters Art Gallery, Baltimore, Ms. W. 445 f. 67v.*

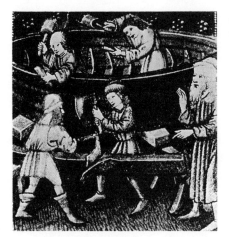

65. A ship under construction, from the Gotha Bible of around 1460. *From Basch 1972: 28.*

66. Noah with wand in hand oversees the dressing of a plank, from the illustrated *Nuremburg Chronicles* of 1493. *From Schedel 1493, 2o inc. c.a. 2922, fol. XIr. Bayerische Staatsbibliothek, München.*

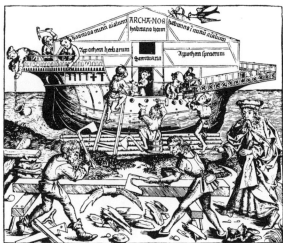

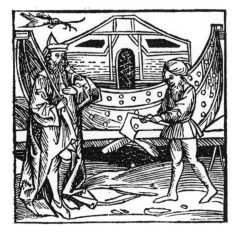

67. Noah in the modestly illustrated *Augsburg Chronicles* of 1496. *From Kunze 1975, fig. 105.*

68. "The Building of Noah's Ark," by Guido Reni, probably 1608. *From Levinson-Lessing 1965: 6.*

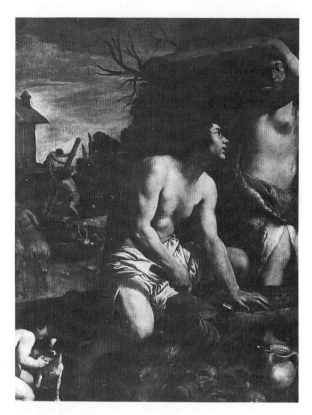

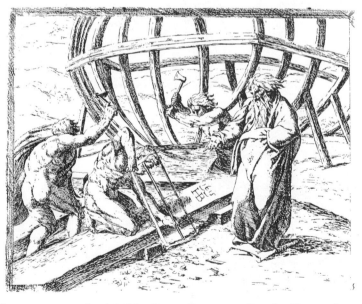

69. "Noah constructing the Ark," by Orazio Borgiani, after the Vatican Loggia Painting of Raphael, 1615. *From Strauss 1983.*

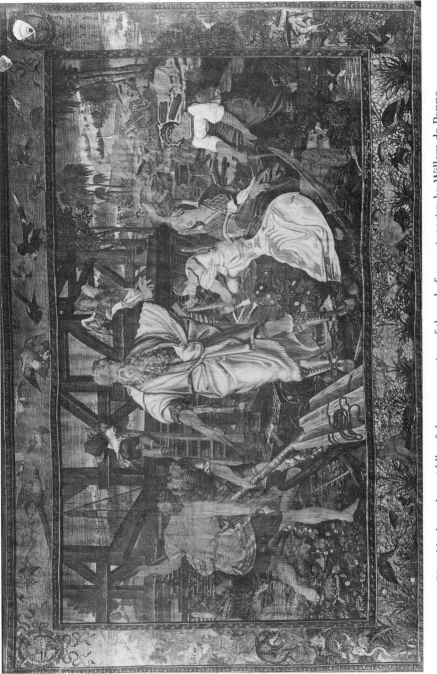

70. Noah in the middle of the construction of the ark, from a tapestry by Willem de Panne-maker at Brussels, 1563–1566. *From Junquera de Vega 1973, fig. 15.*

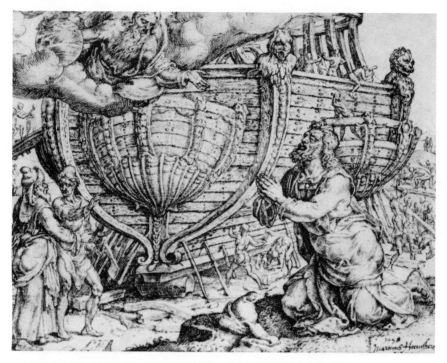

71. God speaking to Noah while work proceeds on the ark, from an engraving by Maerten van Heemskerck, 1558. *From Garff 1971: 50.*

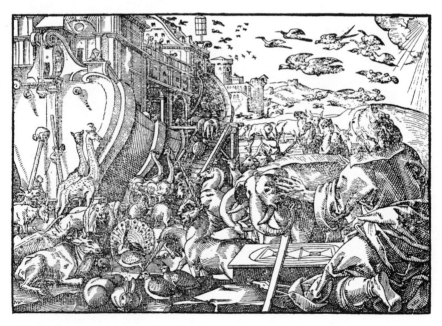

72. Noah designs the ark while animals enter, from a woodcut by Joost Amman in the Bible of Feyerabend, 1583. *From Schmidt 1962, fig. 191.*

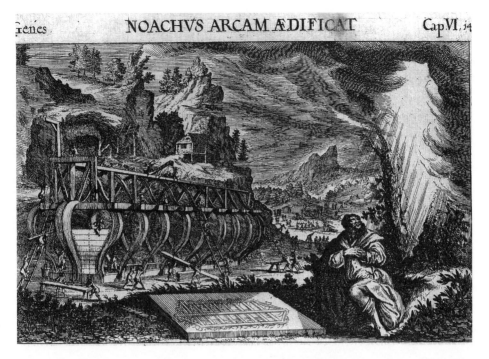

73. "Noachus Arcam Aedificat," complete with draught, from a picture Bible illustrated with engravings by Melchior Küsel, 1679: 8. *The Beinecke Rare Book and Manuscript Library, Yale University.*

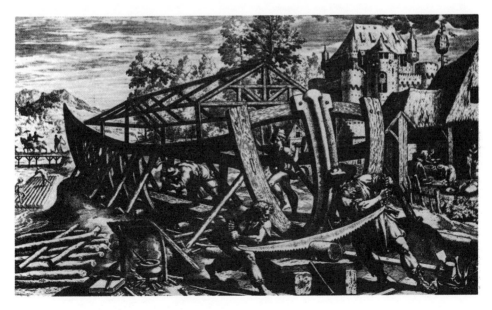

74. "Building the Ark," an engraving by DeVos, 1646. *From Allen 1963, fig. 11.*

75. Olando building a ship in Panama in 1509. *From Benzon 1594, pl. 19. The Beinecke Rare Book and Manuscript Library, Yale University.*

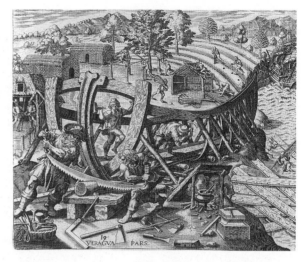

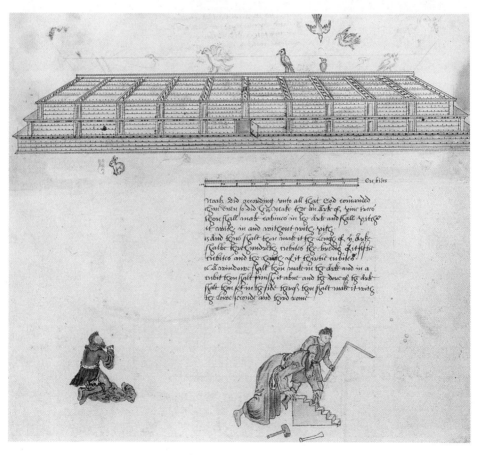

76. The ark in Mathew Baker's *Fragments of English Shipwrightery* of 1585. *By permission of the Master and Fellows, Magdalene College, Cambridge University.*

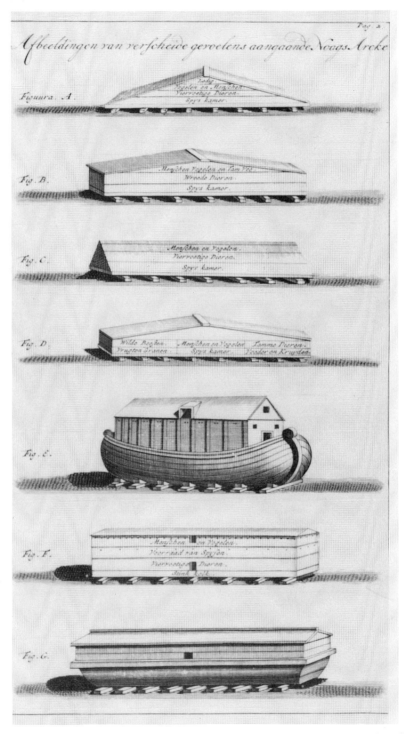

77. Arks as described by six different authors, depicted by Cornelius Van Yk in his *De Nederlandsche Scheeps-bouw-konst Open Gestelt. Amsterdam, 1697.*